(A BOOK) DESIGNED TO HELP

One of my close friends was in Thailand when the tsunami struck the western coast. I had no idea whereabouts, just that her last message had said she was heading south. It was days before I received the brief email confirming that she was safe and well. It was the simplest of communications and of the same kind that so many thousands of people would still hope to receive from friends and family who remain unaccounted for. In times of disaster and not knowing, it's ultimately communication that people hope for. It's communication, too, that brought this book together.

The morning of December 26th 2004 saw the most devastating natural disaster in living memory occur in Asia; as a result of which nearly a quarter of a million people lost their lives. The earthquake and ensuing tsunami affected such large numbers of people in Indonesia, Sri Lanka, Thailand and south-east India, that the scale of the disaster is still difficult to comprehend. Yet the people who need immediate help are those who have actually survived: those who are injured, homeless, orphaned. As I write, it's estimated that five million people now need help to stay alive.

In the first days after the catastrophe, as the search for survivors began, people anxiously awaited information on families and friends who were in the hardest hit areas. In the West, the full extent of the devastation only slowly became clear. We live in such a visual culture, one so dependent on imagery, that the lack of video footage, photography even - when the first news reports came in - seemed to delay any proper comprehension of what had happened. Yet it arrived soon enough and, gradually, the footage made its way onto the airwaves, still images into newspapers and the world woke up.

In the UK, as in most other countries, the response from the public was overwhelming. While governments pledged aid and promised to lessen the burdens of international debts, it became clear that the generosity of everyday people was going to be unprecedented - a united act of generosity. Your purchasing of this book represents the final gesture in one particular chain of charitable actions, stretching back to the beginning of the year when this project was begun.

iLovedust, a graphic design studio in southern England, had an idea of how they might be able to help the victims of the disaster: create a book featuring new work by a range of international graphic designers that could be sold to generate money for the charities in charge of the relief effort.

In early January, they began to gauge what the level of interest from the design community would be in the project. Within 24 hours they had 50 artists willing to commit and contribute work, all of whom had found out about the book through word of mouth. The final results, as you can see over the following 304 pages, show the contributions of hundreds of designers, illustrators and photographers from all over the world.

Support from publishers Die Gestalten Verlag, printers Engelhardt & Bauer, paper manufacturer Scheufelen and bookbinder Spinner brought iLovedust's idea into actuality. With their reputation for publishing challenging, innovative work and their knowledge of the art and design book market, dgv's involvement has been invaluable. What started as a single idea to help contribute to the aid work in Asia, has resulted in a timely snapshot of our design culture - a visual map reassuring us that communication remains at the heart of great design.

Whilst this book is testament to how quickly things can progress when people put their collective minds to a cause, the effects of the tsunami cannot be put right overnight - they will be in evidence for generations to come. Therefore, in order to highlight the ongoing nature of this project, all donations will be recorded online, with the progress of the work updated regularly at www.designedtohelp.com. The site and the book are designed to help. As with the best design, its essence is a simple idea. The book works like the simplest of equations: buy it and you'll help someone.

Mark Sinclair
Creative Review, London

Natural Disasters Naturkatastrophen

Natural disasters are an ongoing threat. There were about 100 earthquakes, floods, major storms, volcano eruptions and droughts in the last century, killing more than six million people.

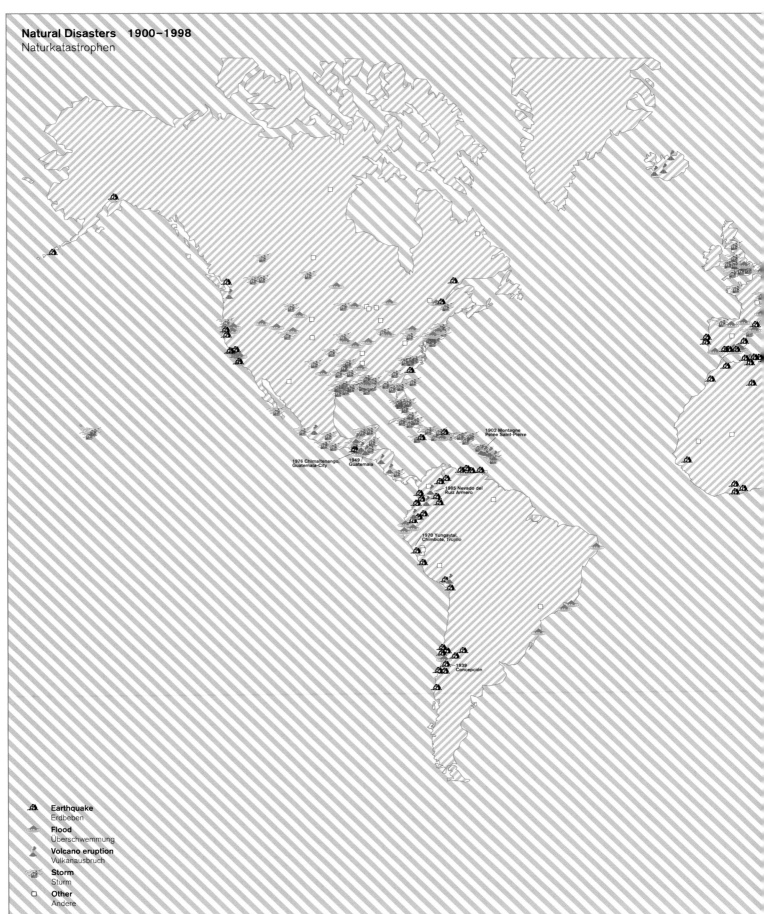

Natural Disasters 1900–1998
Naturkatastrophen

1902 Montagne
Pelée Saint-Pierre

1976 Chimaltenango,
Guatemala-City

1949
Guatemala

1985 Nevado del
Ruiz Armero

1970 Yungaytal,
Chimbote, Trujillo

1939
Concepción

🐚 **Earthquake**
Erdbeben
Flood
Überschwemmung
Volcano eruption
Vulkanausbruch
Storm
Sturm
☐ **Other**
Andere

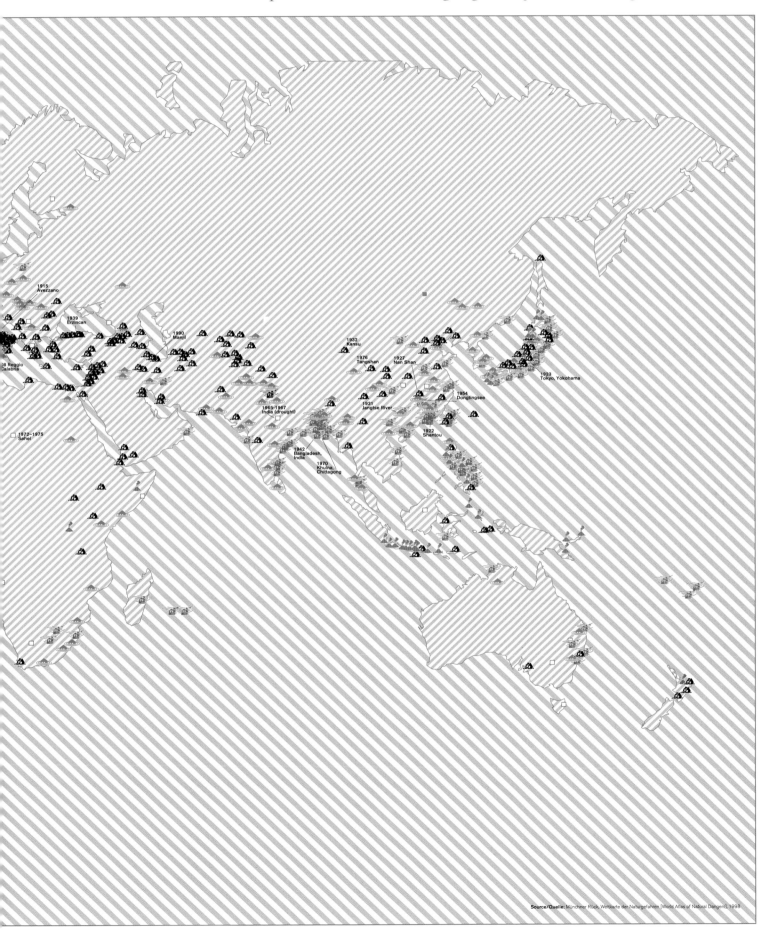

Naturkatastrophen sind eine bleibende Bedrohung. Rund 100 Erdbeben, Überschwemmungen, Stürme, Vulkanausbrüche und Dürren mit mehr als 6 Millionen Opfern wurden im vergangenen Jahrhundert gezählt.

1915 Avezzano

1939 Erzincan

1990 Manjil

8 Reggio Calabria

1972–1975 Sahel

1932 Kansu

1976 Tangshan

1927 Nan Shan

1923 Tokyo, Yokohama

1954 Dongtingsee

1931 Jangtse River

1965–1967 India (drought)

1922 Shantou

1942 Bangladesh, India

1970 Khulna, Chittagong

Source/Quelle: Münchner Rück, Weltkarte der Naturgefahren (World Atlas of Natural Dangers), 1998

Human habitats are increasingly exposed to ecological degradations. Millions of people are fleeing from their consequences. Their number could rise to 150 million by 2050.

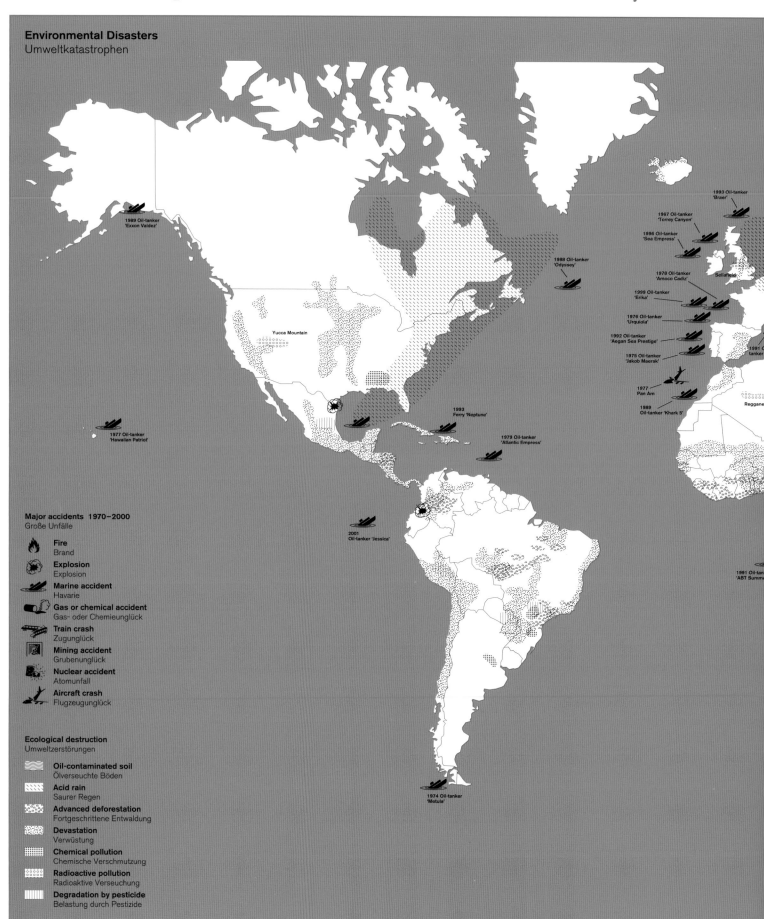

Environmental Disasters
Umweltkatastrophen

Major accidents 1970–2000
Große Unfälle

- **Fire** / Brand
- **Explosion** / Explosion
- **Marine accident** / Havarie
- **Gas or chemical accident** / Gas- oder Chemieunglück
- **Train crash** / Zugunglück
- **Mining accident** / Grubenunglück
- **Nuclear accident** / Atomunfall
- **Aircraft crash** / Flugzeugunglück

Ecological destruction
Umweltzerstörungen

- **Oil-contaminated soil** / Ölverseuchte Böden
- **Acid rain** / Saurer Regen
- **Advanced deforestation** / Fortgeschrittene Entwaldung
- **Devastation** / Verwüstung
- **Chemical pollution** / Chemische Verschmutzung
- **Radioactive pollution** / Radioaktive Verseuchung
- **Degradation by pesticide** / Belastung durch Pestizide

1989 Oil-tanker 'Exxon Valdez'

1988 Oil-tanker 'Odyssey'

1993 Oil-tanker 'Braer'
1967 Oil-tanker 'Torrey Canyon'
1996 Oil-tanker 'Sea Empress'
1978 Oil-tanker 'Amoco Cadiz'
Sellafield
1999 Oil-tanker 'Erika'
1976 Oil-tanker 'Urquiola'
1992 Oil-tanker 'Aegan Sea Prestige'
1975 Oil-tanker 'Jakob Maersk'
1991 Oil-tanker
1977 Pan Am
1989 Oil-tanker 'Khark 5'
Reggane

Yucca Mountain

1977 Oil-tanker 'Hawaiian Patriot'

1993 Ferry 'Neptune'

1979 Oil-tanker 'Atlantic Empress'

2001 Oil-tanker 'Jessica'

1991 Oil-tanker 'ABT Summer'

1974 Oil-tanker 'Metule'

Menschlicher Lebensraum ist zunehmend ökologischen Zerstörungen ausgesetzt. Millionen Menschen befinden sich auf der Flucht vor den Folgen. Bis 2050 könnte ihre Zahl auf 150 Millionen steigen.

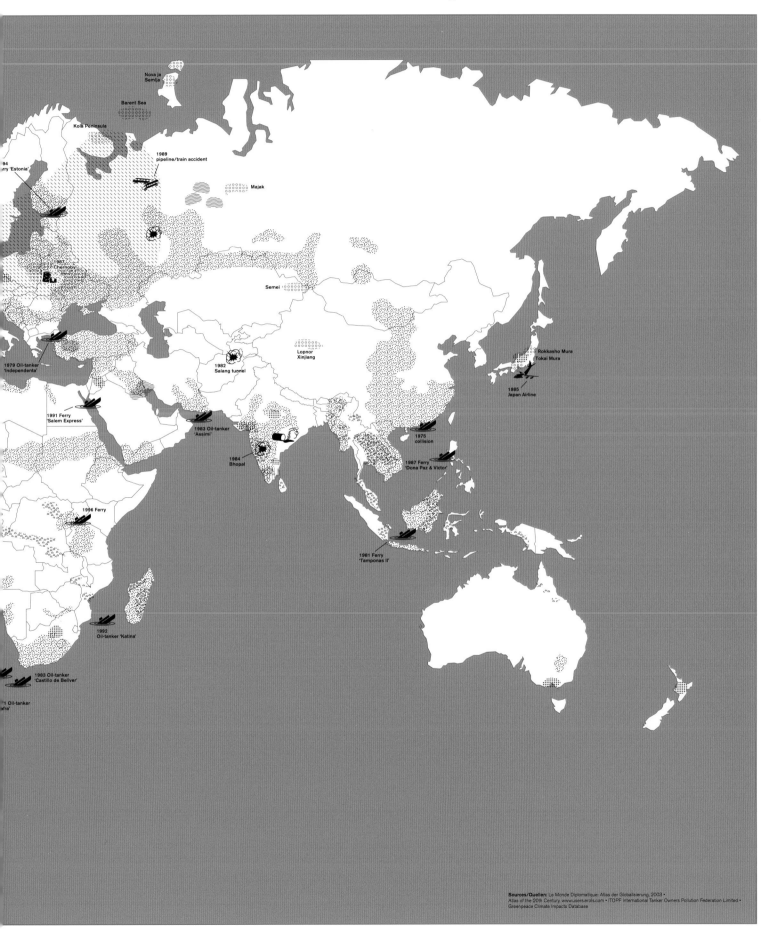

Nova ja Semlja

Barent Sea

Kola Peninsula

1989 pipeline/train accident

Majak

94 rry 'Estonia'

1987 Chernobyl

Semei

Rokkasho Mura
Tokai Mura

1979 Oil-tanker 'Independenta'

Lopnor Xinjiang

1982 Salang tunnel

1985 Japan Airline

1991 Ferry 'Salem Express'

1983 Oil-tanker 'Assimi'

1975 collision

1984 Bhopal

1987 Ferry 'Dona Paz & Victor'

1996 Ferry

1981 Ferry 'Tamponas II'

1992 Oil-tanker 'Katina'

1983 Oil-tanker 'Castillo de Bellver'

'1 Oil-tanker afra'

Sources/Quellen: Le Monde Diplomatique: Atlas der Globalisierung, 2003 •
Atlas of the 20th Century, www.users.erols.com • ITOPF International Tanker Owners Pollution Federation Limited •
Greenpeace Climate Impacts Database

Historical Examples Historische Beispiele

History shows a great number of examples of shrinking cities, which often were isolated cases. Their inhabitants were decimated mostly by violent events.

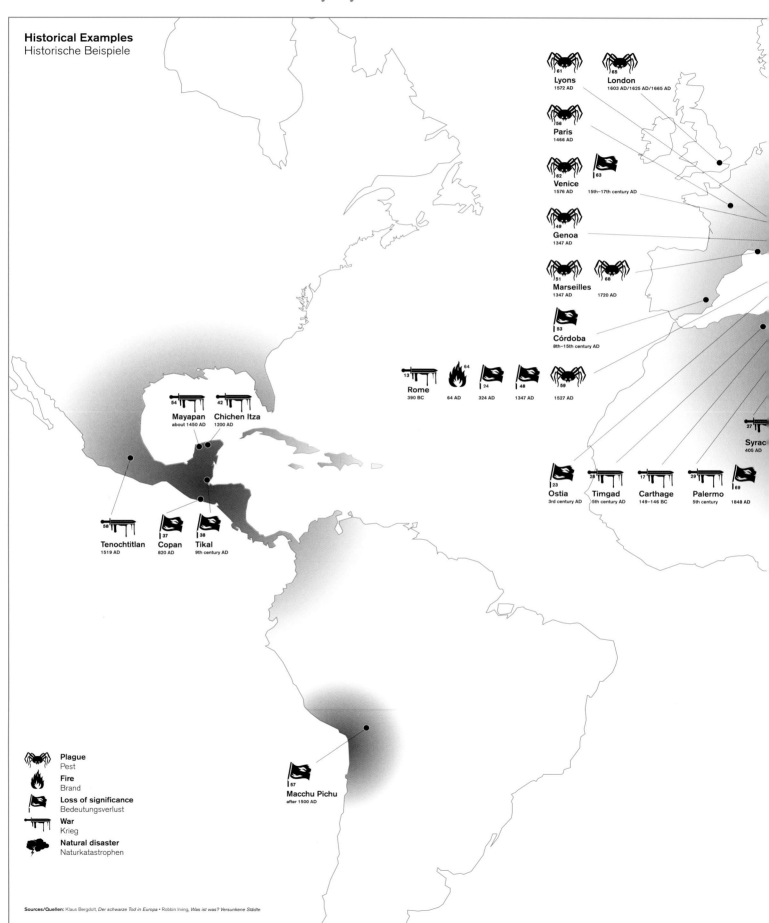

Historical Examples
Historische Beispiele

Lyons
1572 AD

London
1603 AD/1625 AD/1665 AD

Paris
1466 AD

Venice
1576 AD

15th–17th century AD

Genoa
1347 AD

Marseilles
1347 AD

1720 AD

Córdoba
8th–15th century AD

Rome
390 BC

64 AD

324 AD

1347 AD

1527 AD

Syrac
405 AD

Ostia
3rd century AD

Timgad
5th century AD

Carthage
149–146 BC

Palermo
5th century

1848 AD

Mayapan
about 1450 AD

Chichen Itza
1200 AD

Tenochtitlan
1519 AD

Copan
820 AD

Tikal
9th century AD

Macchu Pichu
after 1500 AD

Plague
Pest

Fire
Brand

Loss of significance
Bedeutungsverlust

War
Krieg

Natural disaster
Naturkatastrophen

Sources/Quellen: Klaus Bergdolt, *Der schwarze Tod in Europa* • Robbin Irving, *Was ist was? Versunkene Städte*

In der Geschichte findet man zahlreiche Beispiele schrumpfender Städte.
Im Gegensatz zu heute waren es häufig Einzelfälle. Die Stadtbevölkerung wurde
meist durch gewaltsame Einflüsse dezimiert.

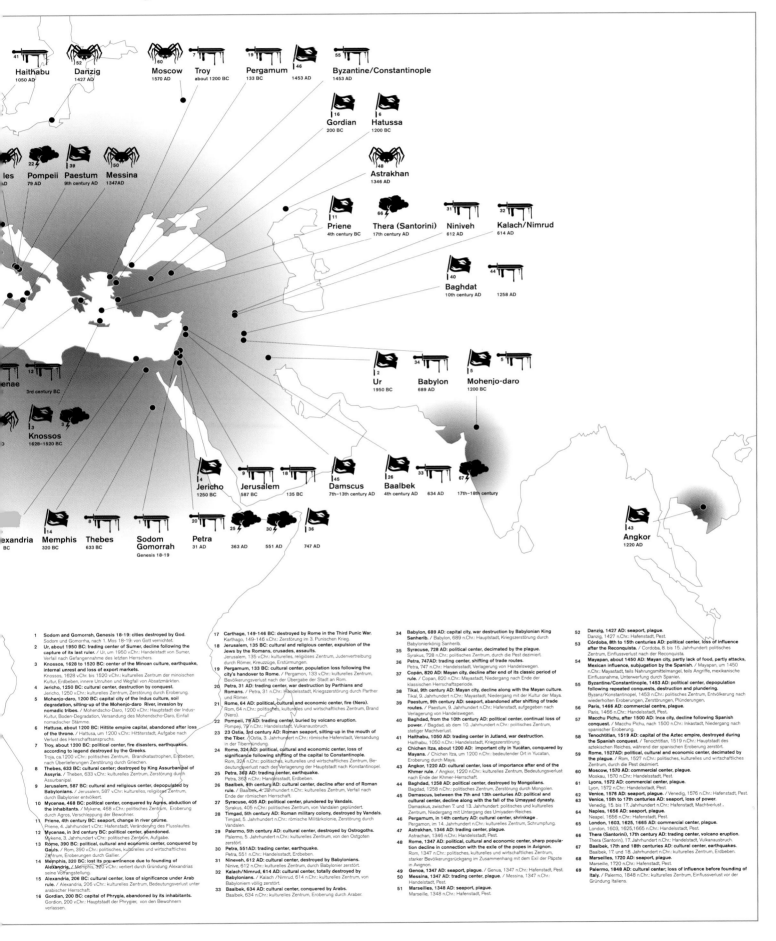

Haithabu 1050 AD — Danzig 1427 AD — Moscow 1570 AD — Troy about 1200 BC — Pergamum 133 BC — 46 1453 AD — Byzantine/Constantinople 1453 AD

16 Gordian 200 BC — 6 Hatussa 1200 BC

48 Astrakhan 1346 AD

11 Priene 4th century BC — 66 Thera (Santorini) 17th century AD — 31 Niniveh 612 AD — 32 Kalach/Nimrud 614 AD

40 Baghdat 10th century AD — 44 1258 AD

...les AD — 22 Pompeii 79 AD — 39 Paestum 9th century AD — 50 Messina 1347AD

2 Ur 1950 BC — 34 Babylon 689 BC — 5 Mohenjo-daro 1200 BC

...enae 3rd century BC

3 Knossos 1628–1520 BC

4 Jericho 1250 BC — 9 18 Jerusalem 587 BC 135 BC — 45 Damscus 7th–13th century AD — 26 Baalbek 4th century AD — 33 634 AD — 67 17th–18th century

43 Angkor 1220 AD

14 ...exandria ...BC — Memphis 320 BC — Thebes 633 BC — Sodom Gomorrah Genesis 18-19 — 20 Petra 31 AD — 25 363 AD — 30 551 AD — 36 747 AD

1 Sodom and Gomorrah, Genesis 18-19: cities destroyed by God.
Sodom und Gomorrha, nach 1. Mos 18-19: von Gott vernichtet.

2 Ur, about 1950 BC: trading center of Sumer, decline following the
capture of its last ruler. / Ur, um 1950 v.Chr.: Handelsstadt von Sumer,
Verfall nach Gefangennahme des letzten Herrschers.

3 Knossos, 1628 to 1520 BC: center of the Minoan culture, earthquake,
internal unrest and loss of export markets.
Knossos, 1628 v.Chr. bis 1520 v.Chr.: kulturelles Zentrum der minoischen
Kultur, Erdbeben, innere Unruhen und Wegfall von Absatzmärkten.

4 Jericho, 1250 BC: cultural center, destruction by conquest.
Jericho, 1250 v.Chr.: kulturelles Zentrum, Zerstörung durch Eroberung.

5 Mohenjo-daro, 1200 BC: capital city of the Indus culture, soil
degradation, silting-up of the Mohenjo-daro River, invasion by
nomadic tribes. / Mohendscho-Daro, 1200 v.Chr.: Hauptstadt der Indus-
Kultur, Boden-Degradation, Versandung des Mohendscho-Daro, Einfall
nomadischer Stämme.

6 Hattusa, about 1200 BC: Hittite empire capital, abandoned after loss
of the throne. / Hattusa, um 1200 v.Chr.: Hittiterstadt, Aufgabe nach
Verlust des Herrschaftsanspruchs.

7 Troy, about 1200 BC: political center, fire disasters, earthquakes,
according to legend destroyed by the Greeks.
Troja, ca.1200 v.Chr.: politisches Zentrum, Brandkatastrophen, Erdbeben,
nach Überlieferungen Zerstörung durch Griechen.

8 Thebes, 633 BC: cultural center, destroyed by King Assurbanipal of
Assyria. / Theben, 633 v.Chr.: kulturelles Zentrum, Zerstörung durch
Assurbanipal.

9 Jerusalem, 587 BC: cultural and religious center, depopulated by
Babylonians. / Jerusalem, 587 v.Chr.: kulturelles Zentrum, Entvölkerung
durch Babylonier.

10 Mycenae, 468 BC: political center, conquered by Argos, abduction of
the inhabitants. / Mykene, 468 v.Chr.: politisches Zentrum, Eroberung
durch Argos, Verschleppung der Bewohner.

11 Priene, 4th century BC: seaport, change in river course.
Priene, 4. Jahrhundert v.Chr.: Hafenstadt, Veränderung des Flusslaufes.

12 Mycenae, in 3rd century BC: political center, abandoned.
Mykene, 3. Jahrhundert v.Chr.: politisches Zentrum, Aufgabe.

13 Rome, 390 BC: political, cultural and economic center, conquered by
Gauls. / Rom, 390 v.Chr.: politisches, kulturelles und wirtschaftliches
Zentrum, Eroberungen durch Gallier.

14 Memphis, 320 BC: lost its pre-eminence due to founding of
Alexandria. / Memphis, 320 v.Chr.: verliert durch Gründung Alexandrias
seine Vorrangstellung.

15 Alexandria, 206 BC: cultural center, loss of significance under Arab
rule. / Alexandria, 206 v.Chr.: kulturelles Zentrum, Bedeutungsverlust unter
arabischer Herrschaft.

16 Gordian, 200 BC: capital of Phrygia, abandoned by its inhabitants.
Gordion, 200 v.Chr.: Hauptstadt der Phrygier, von den Bewohnern
verlassen.

17 Carthage, 149-146 BC: destroyed by Rome in the Third Punic War.
Karthago, 149-146 v.Chr.: Zerstörung im 3. Punischen Krieg.

18 Jerusalem, 135 BC: cultural and religious center, expulsion of the
Jews by the Romans, crusades, assaults.
Jerusalem, 135 v.Chr.: kulturelles, religiöses Zentrum, Judenvertreibung
durch Römer, Kreuzzüge, Erstürmungen.

19 Pergamum, 133 BC: cultural center, population loss following the
city's handover to Rome. / Pergamon, 133 v.Chr.: kulturelles Zentrum,
Bevölkerungsverlust nach der Übergabe der Stadt an Rom.

20 Petra, 31 AD: trading center, war destruction by Parthians and
Romans. / Petra, 31 n.Chr.: Handelsstadt, Kriegszerstörung durch Parther
und Römer.

21 Rome, 64 AD: political, cultural and economic center, fire (Nero).
Rom, 64 n.Chr.: politisches, kulturelles und wirtschaftliches Zentrum, Brand
(Nero).

22 Pompeii, 79 AD: trading center, buried by volcano eruption.
Pompeji, 79 n.Chr.: Handelsstadt, Vulkanausbruch.

23 Ostia, 3rd century AD: Roman seaport, silting-up in the mouth of
the Tiber. / Ostia, 3. Jahrhundert n.Chr.: römische Hafenstadt, Versandung
in der Tibermündung.

24 Rome, 324 AD: political, cultural and economic center, loss of
significance following shifting of the capital to Constantinople.
Rom, 324 n.Chr.: politisches, kulturelles und wirtschaftliches Zentrum, Be-
deutungsverlust nach der Verlagerung der Hauptstadt nach Konstantinopel.

25 Petra, 363 AD: trading center, earthquake.
Petra, 363 n.Chr.: Handelsstadt, Erdbeben.

26 Baalbek, 4th century AD: cultural center, decline after end of Roman
rule. / Baalbek, 4. Jahrhundert n.Chr.: kulturelles Zentrum, Verfall nach
Ende der römischen Herrschaft.

27 Syracuse, 405 AD: political center, plundered by Vandals.
Syrakus, 405 n.Chr.: politisches Zentrum, von Vandalen geplündert.

28 Timgad, 5th century AD: Roman military colony, destroyed by Vandals.
Timgad, 5. Jahrhundert n.Chr.: römische Militärkolonie, Zerstörung durch
Vandalen.

29 Palermo, 5th century AD: cultural center, destroyed by Ostrogoths.
Palermo, 5. Jahrhundert n.Chr.: kulturelles Zentrum, von den Ostgoten
zerstört.

30 Petra, 551 AD: trading center, earthquake.
Petra, 551 n.Chr.: Handelsstadt, Erdbeben.

31 Niniveh, 612 AD: cultural center, destroyed by Babylonians.
Ninive, 612 n.Chr.: kulturelles Zentrum, durch Babylonier zerstört.

32 Kalach/Nimrud, 614 AD: cultural center, totally destroyed by
Babylonians. / Kalach/Nimrud, 614 n.Chr.: kulturelles Zentrum, von
Babyloniern völlig zerstört.

33 Baalbek, 634 AD: cultural center, conquered by Arabs.
Baalbek, 634 n.Chr.: kulturelles Zentrum, Eroberung durch Araber.

34 Babylon, 689 AD: capital city, war destruction by Babylonian King
Sanherib. / Babylon, 689 n.Chr.: Hauptstadt, Kriegszerstörung durch
Babylonierkönig Sanherib.

35 Syracuse, 728 AD: political center, decimated by the plague.
Syrakus, 728 n.Chr.: politisches Zentrum, durch die Pest dezimiert.

36 Petra, 747AD: trading center, shifting of trade routes.
Petra, 747 n.Chr.: Handelsstadt, Verlagerung von Handelswegen.

37 Copán, 820 AD: Mayan city, decline after end of its classic period of
rule. / Copan, 820 n.Chr.: Mayastadt, Niedergang nach Ende der
klassischen Herrschaftsperiode.

38 Tikal, 9th century AD: Mayan city, decline along with the Mayan culture.
Tikal, 9. Jahrhundert n.Chr.: Mayastadt, Niedergang mit der Kultur der Maya.

39 Paestum, 9th century AD: seaport, abandoned after shifting of trade
routes. / Paestum, 9. Jahrhundert n.Chr.: Hafenstadt, aufgegeben nach
Verlagerung von Handelswegen.

40 Baghdad, from the 10th century AD: political center, continual loss of
power. / Bagdad, ab dem 10. Jahrhundert n.Chr.: politisches Zentrum,
stetiger Machtverlust.

41 Haithabu, 1050 AD: trading center in Jutland, war destruction.
Haithabu, 1050 n.Chr.: Handelsstadt, Kriegszerstörung.

42 Chichen Itza, about 1200 AD: important city in Yucatán, conquered by
Mayans. / Chichen Itza, um 1200 n.Chr.: bedeutender Ort in Yucatan,
Eroberung durch Maya.

43 Angkor, 1220 AD: cultural center, loss of importance after end of the
Khmer rule. / Angkor, 1220 n.Chr.: kulturelles Zentrum, Bedeutungsverlust
nach Ende der Khmer-Herrschaft.

44 Baghdad, 1258 AD: political center, destroyed by Mongolians.
Bagdad, 1258 n.Chr.: politisches Zentrum, Zerstörung durch Mongolen.

45 Damascus, between the 7th and 13th centuries AD: political and
cultural center, decline along with the fall of the Umayyad dynasty.
Damaskus, zwischen 7. und 13. Jahrhundert n.Chr.: politisches und kulturelles
Zentrum, Niedergang mit Untergang des Umiyaden-Reiches.

46 Pergamum, in 14th century AD: cultural center, shrinkage .
Pergamon, im 14. Jahrhundert n.Chr.: kulturelles Zentrum, Schrumpfung.

47 Astrakhan, 1346 AD: trading center, plague.
Astrachan, 1346 n.Chr.: Handelsstadt, Pest.

48 Rome, 1347 AD: political, cultural and economic center, sharp popula-
tion decline in connection with the exile of the popes in Avignon.
Rom, 1347 n.Chr.: politisches, kulturelles und wirtschaftliches Zentrum,
starker Bevölkerungsrückgang im Zusammenhang mit dem Exil der Päpste
in Avignon.

49 Genoa, 1347 AD: seaport, plague. / Genua, 1347 n.Chr.: Hafenstadt, Pest.

50 Messina, 1347 AD: trading center, plague. / Messina, 1347 n.Chr.:
Handelsstadt, Pest.

51 Marseilles, 1348 AD: seaport, plague.
Marseille, 1348 n.Chr.: Hafenstadt, Pest.

52 Danzig, 1427 AD: seaport, plague.
Danzig, 1427 n.Chr.: Hafenstadt, Pest.

53 Córdoba, 8th to 15th centuries AD: political center, loss of influence
after the Reconquista. / Córdoba, 8. bis 15. Jahrhundert n.Chr.: politisches
Zentrum, Einflussverlust nach der Reconquista.

54 Mayapan, about 1450 AD: Mayan city, partly lack of food, partly attacks,
Mexican influence, subjugation by the Spanish. / Mayapan, um 1450
n.Chr.: Mayastadt, teils Nahrungsmittelmangel, teils Angriffe, mexikanische
Einflussnahme, Unterwerfung durch Spanier.

55 Byzantine/Constantinople, 1453 AD: political center, depopulation
following repeated conquests, destruction and plundering.
Byzanz/Konstantinopel, 1453 n.Chr.: politisches Zentrum, Entvölkerung nach
wiederholten Eroberungen, Zerstörungen, Plünderungen.

56 Paris, 1466 AD: commercial centre, plague.
Paris, 1466 n.Chr.: Handelsstadt, Pest.

57 Macchu Pichu, after 1500 AD: Inca city, decline following Spanish
conquest. / Macchu Pichu, nach 1500 n.Chr.: Inkastadt, Niedergang nach
spanischer Eroberung.

58 Tenochtitlan, 1519 AD: capital of the Aztec empire, destroyed during
the Spanish conquest. / Tenochtitlan, 1519 n.Chr.: Hauptstadt des
aztekischen Reiches, während der spanischen Eroberung zerstört.

59 Rome, 1527AD: political, cultural and economic center, decimated by
the plague. / Rom, 1527 n.Chr.: politisches, kulturelles und wirtschaftliches
Zentrum, durch die Pest dezimiert.

60 Moscow, 1570 AD: commercial center, plague.
Moskau, 1570 n.Chr.: Handelsstadt, Pest.

61 Lyons, 1572 AD: commercial center, plague.
Lyon, 1572 n.Chr.: Handelsstadt, Pest.

62 Venice, 1576 AD: seaport, plague. / Venedig, 1576 n.Chr.: Hafenstadt, Pest.

63 Venice, 15th to 17th centuries AD: seaport, loss of power.
Venedig, 15. bis 17. Jahrhundert n.Chr.: Hafenstadt, Machtverlust .

64 Naples, 1656 AD: seaport, plague.
Neapel, 1656 n.Chr.: Hafenstadt, Pest.

65 London, 1603, 1625, 1665 AD: commercial center, plague.
London, 1603, 1625, 1665 n.Chr.: Handelsstadt, Pest.

66 Thera (Santorini), 17th century AD: trading center, volcano eruption.
Thera (Santorini), 17. Jahrhundert n.Chr.: Handelsstadt, Vulkanausbruch.

67 Baalbek, 17th and 18th centuries AD: cultural center, earthquakes.
Baalbek, 17. und 18. Jahrhundert n.Chr.: kulturelles Zentrum, Erdbeben.

68 Marseilles, 1720 AD: seaport, plague.
Marseille, 1720 n.Chr.: Hafenstadt, Pest.

69 Palermo, 1848 AD: cultural center; loss of influence before founding of
Italy. / Palermo, 1848 n.Chr.: kulturelles Zentrum, Einflussverlust vor der
Gründung Italiens.

9

fig 7

Montenegro 2004

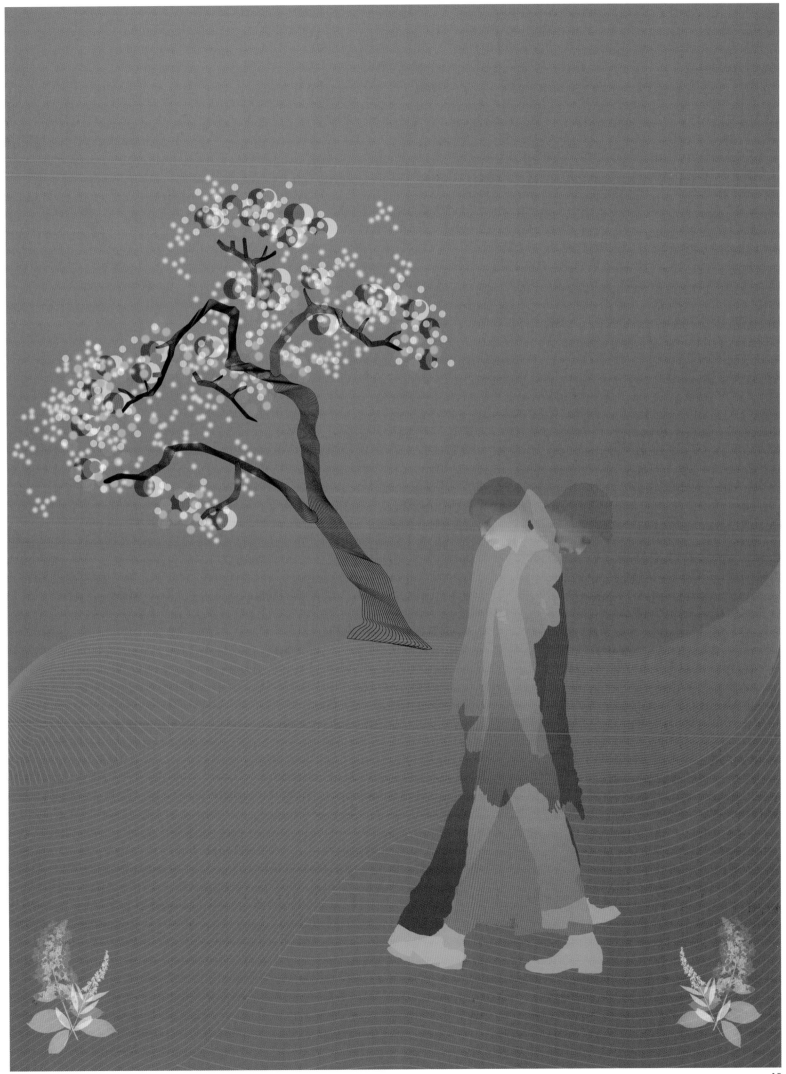

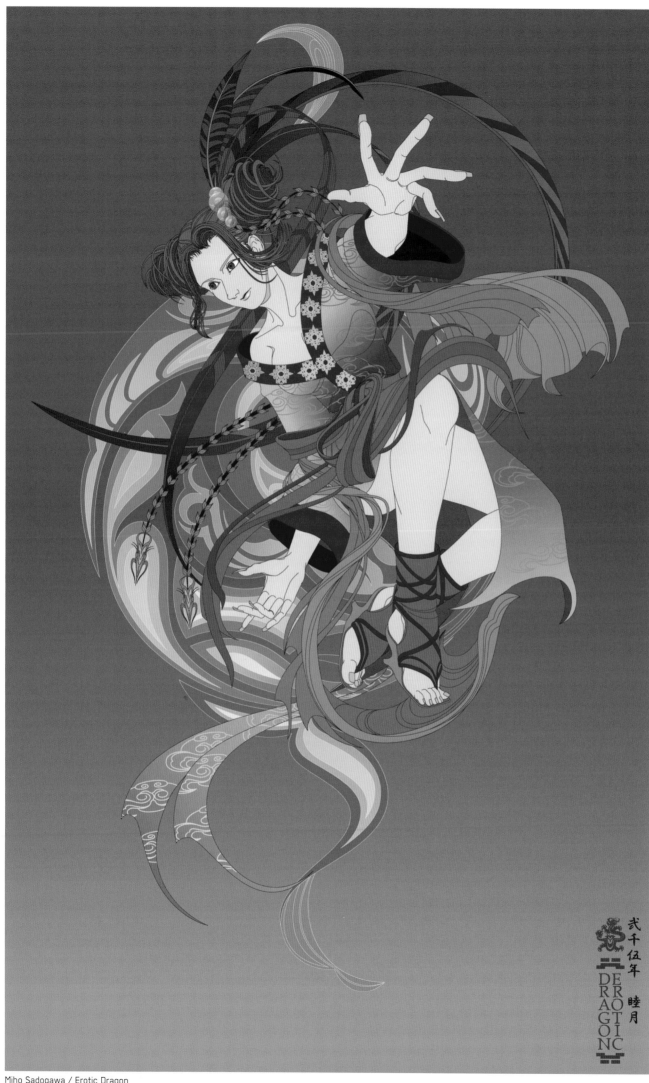

Miho Sadogawa / Erotic Dragon

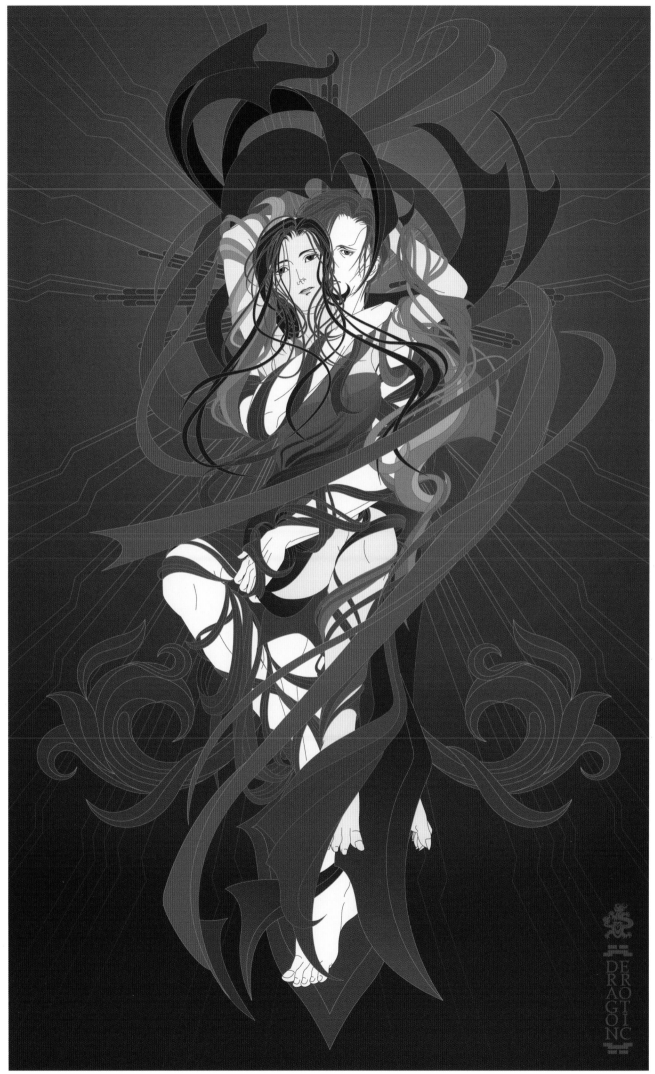

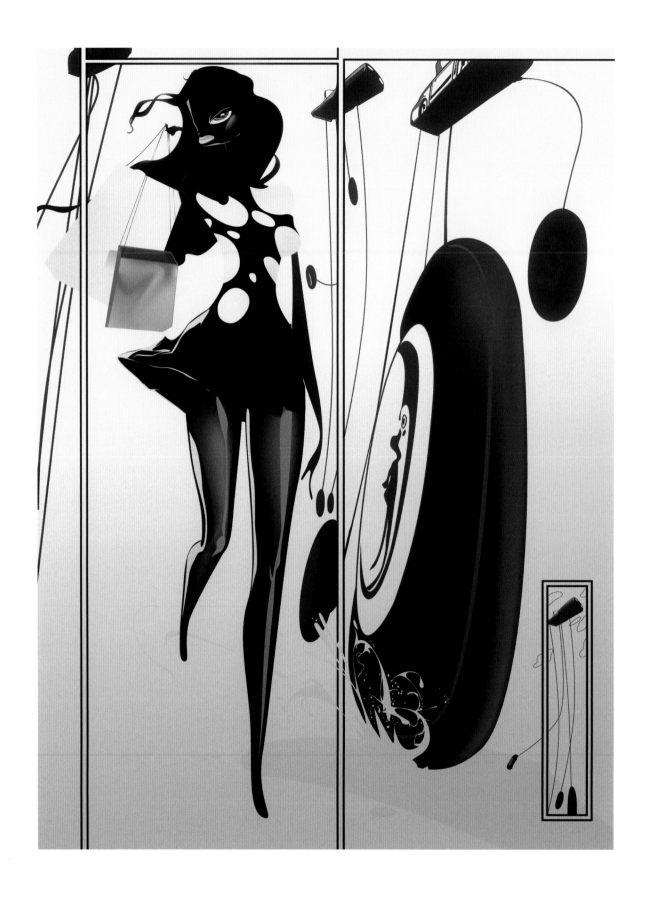

FROM THE *The Nation Of Angels* NOA
MAMMAL001 GENERIC
142.5 x 206

FROM THE *The Nation Of Angels* NOA
OVIPARUS002 GENERIC
675 x 587

FROM THE *The Nation Of Angels* NOA
MAMMAL004 GENERIC
8775' x 1287'

FROM THE *The Nation Of Angels* NOA
MAMMAL005 GENERIC
5175' x 3287'

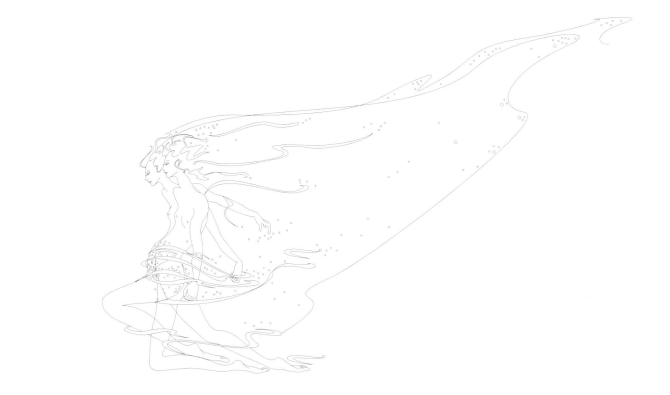

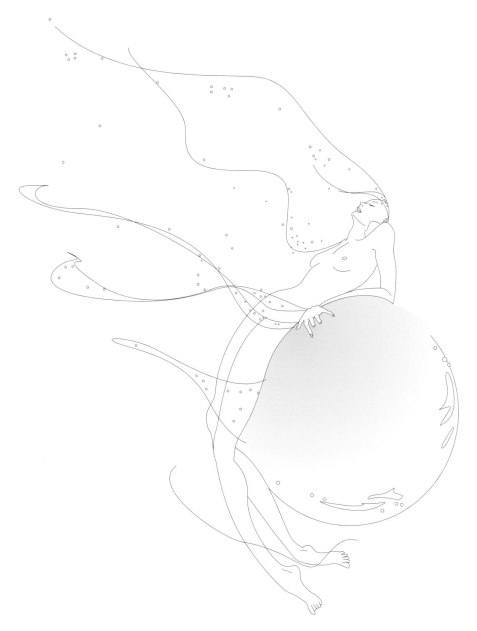

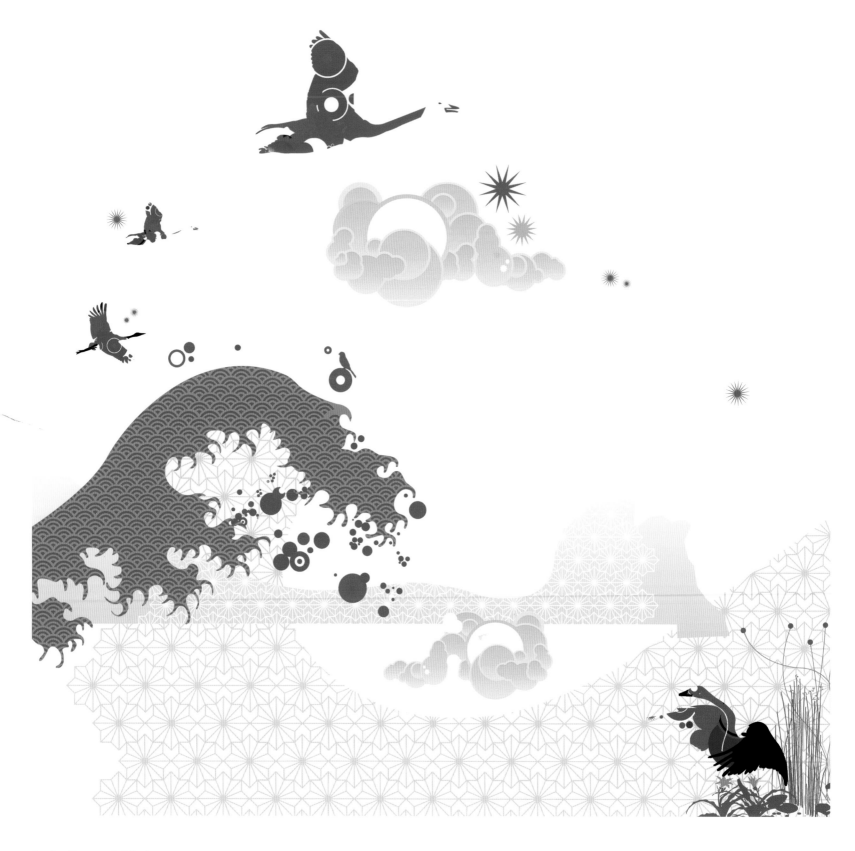

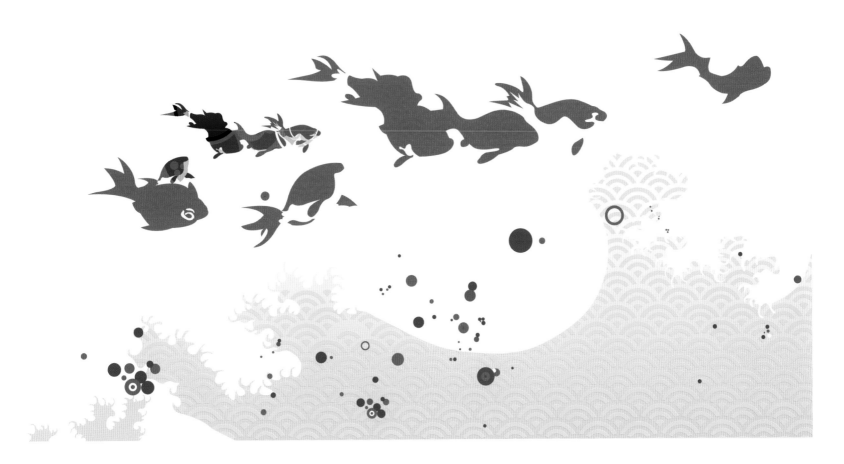

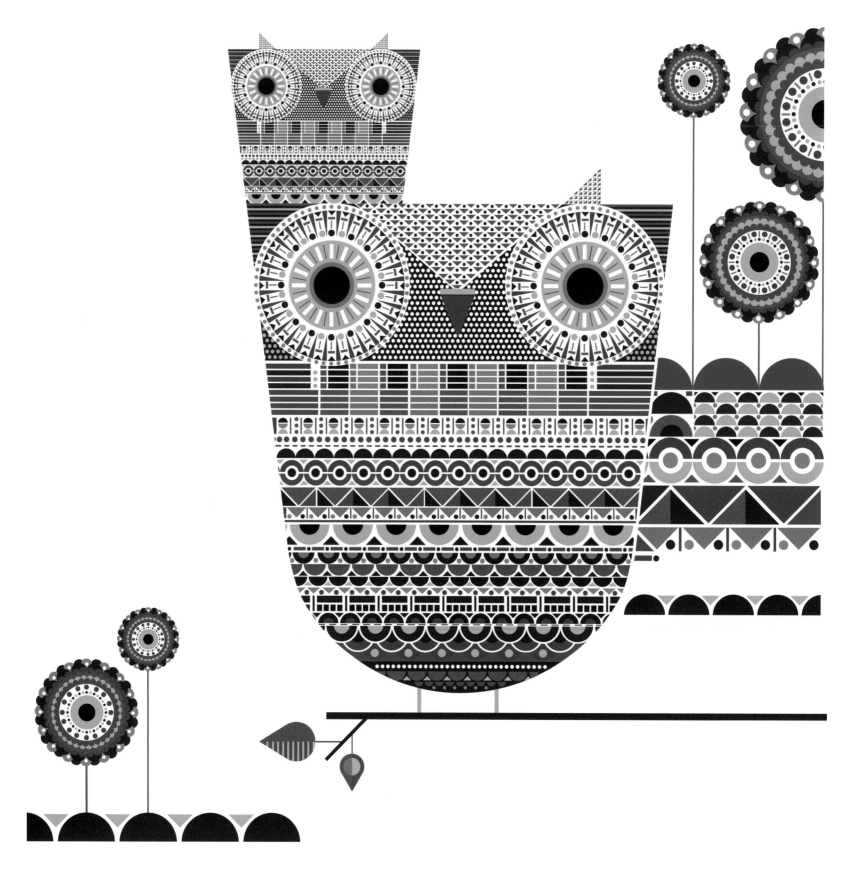

Christian Gabriel Montenegro

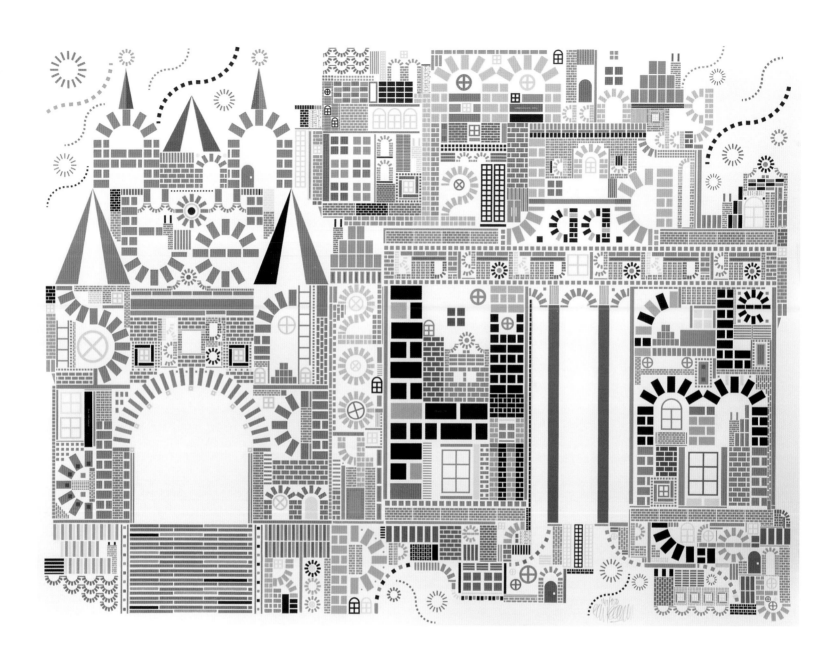

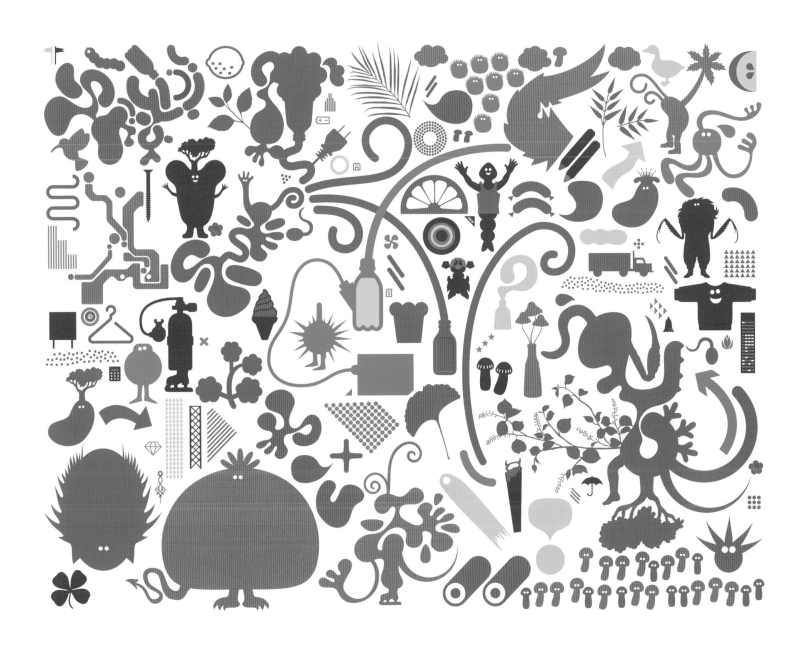

Genevieve Gauckler

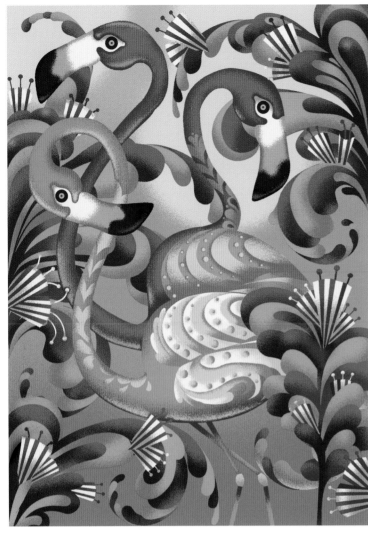
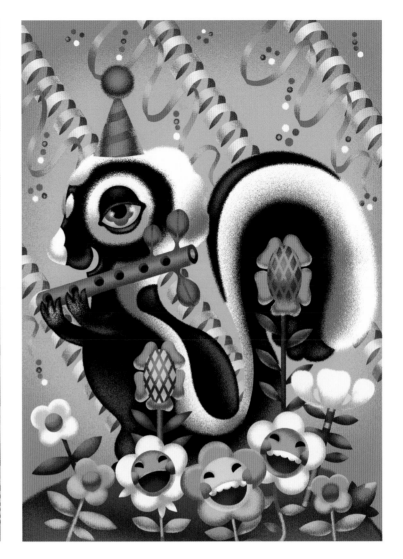
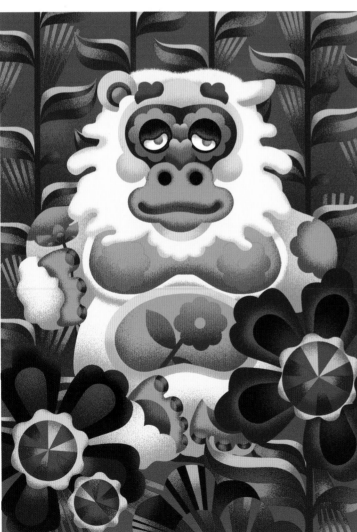

Klaus Haapaniemi

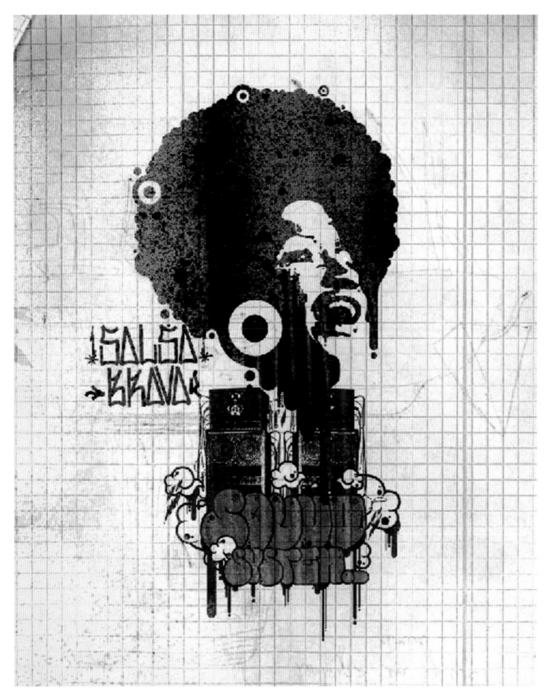

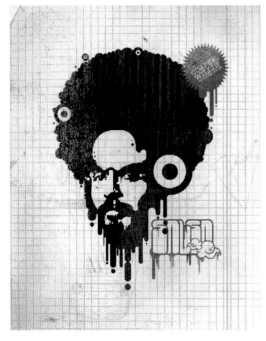

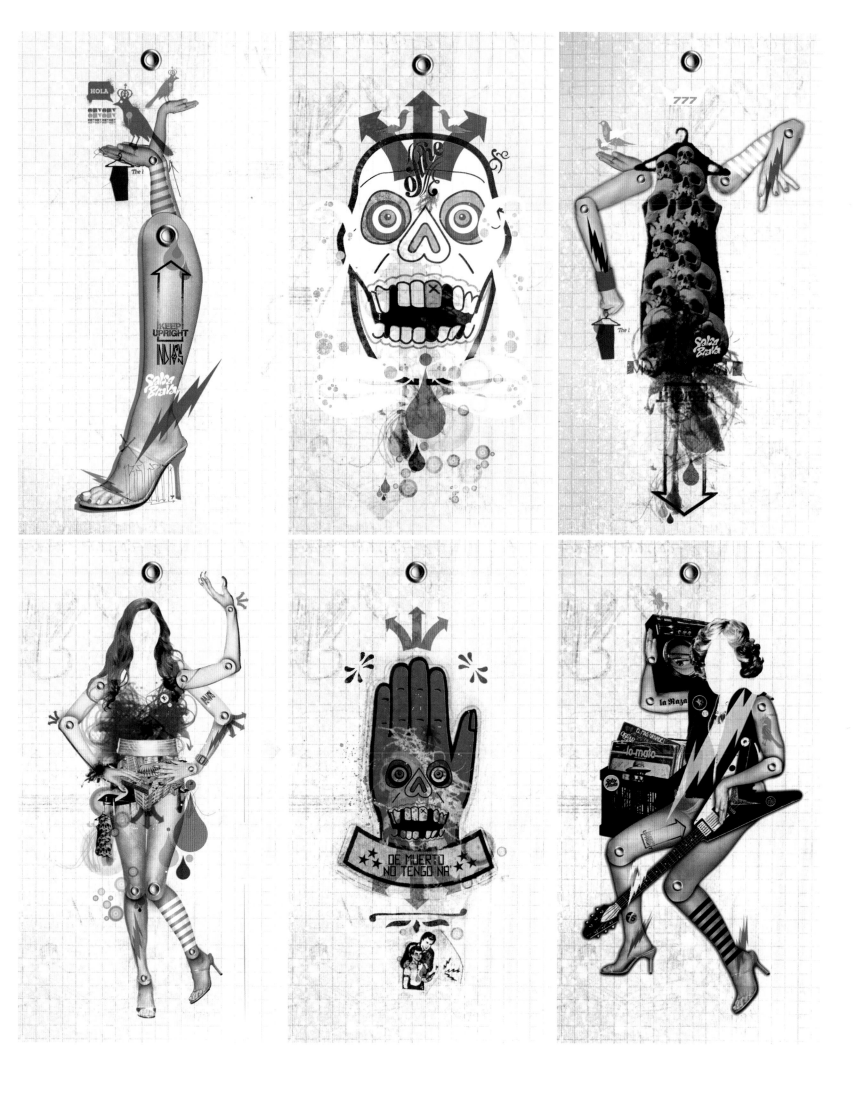

Masa

33

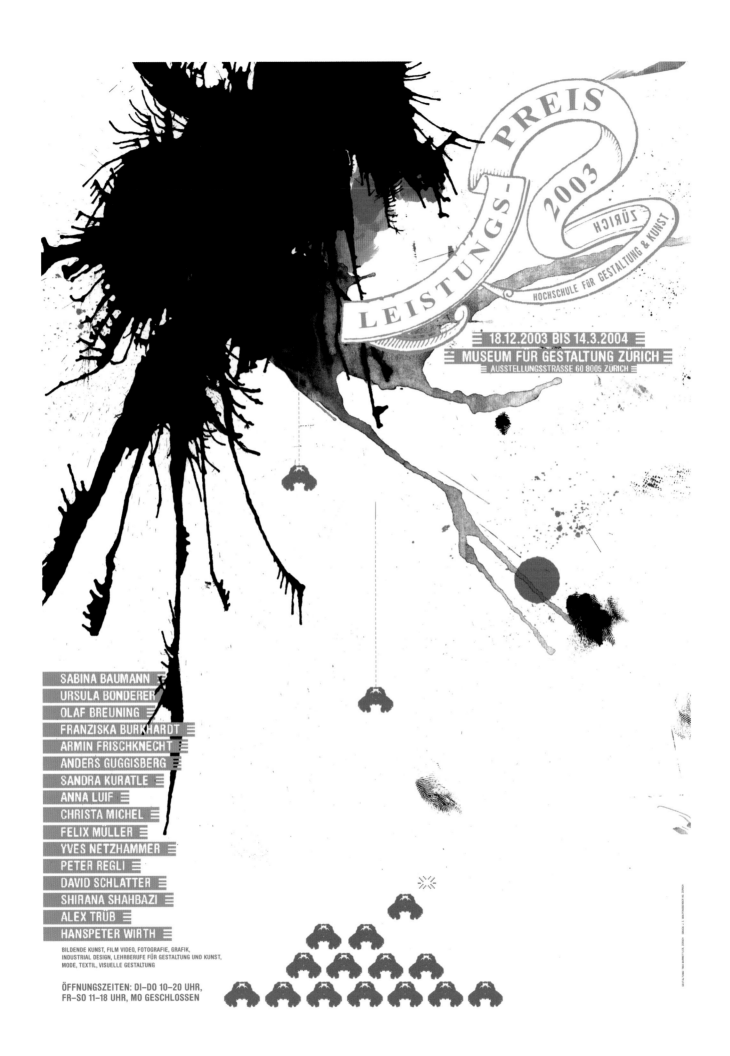

PREIS

LEISTUNGS-

2003

ZÜRICH

HOCHSCHULE FÜR GESTALTUNG & KUNST

18.12.2003 BIS 14.3.2004
MUSEUM FÜR GESTALTUNG ZÜRICH
AUSSTELLUNGSSTRASSE 60 8005 ZÜRICH

SABINA BAUMANN
URSULA BONDERER
OLAF BREUNING
FRANZISKA BURKHARDT
ARMIN FRISCHKNECHT
ANDERS GUGGISBERG
SANDRA KURATLE
ANNA LUIF
CHRISTA MICHEL
FELIX MÜLLER
YVES NETZHAMMER
PETER REGLI
DAVID SCHLATTER
SHIRANA SHAHBAZI
ALEX TRÜB
HANSPETER WIRTH

BILDENDE KUNST, FILM VIDEO, FOTOGRAFIE, GRAFIK,
INDUSTRIAL DESIGN, LEHRBERUFE FÜR GESTALTUNG UND KUNST,
MODE, TEXTIL, VISUELLE GESTALTUNG

ÖFFNUNGSZEITEN: DI–DO 10–20 UHR,
FR–SO 11–18 UHR, MO GESCHLOSSEN

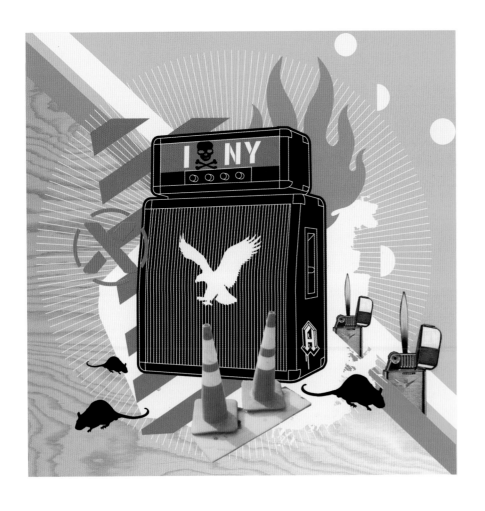

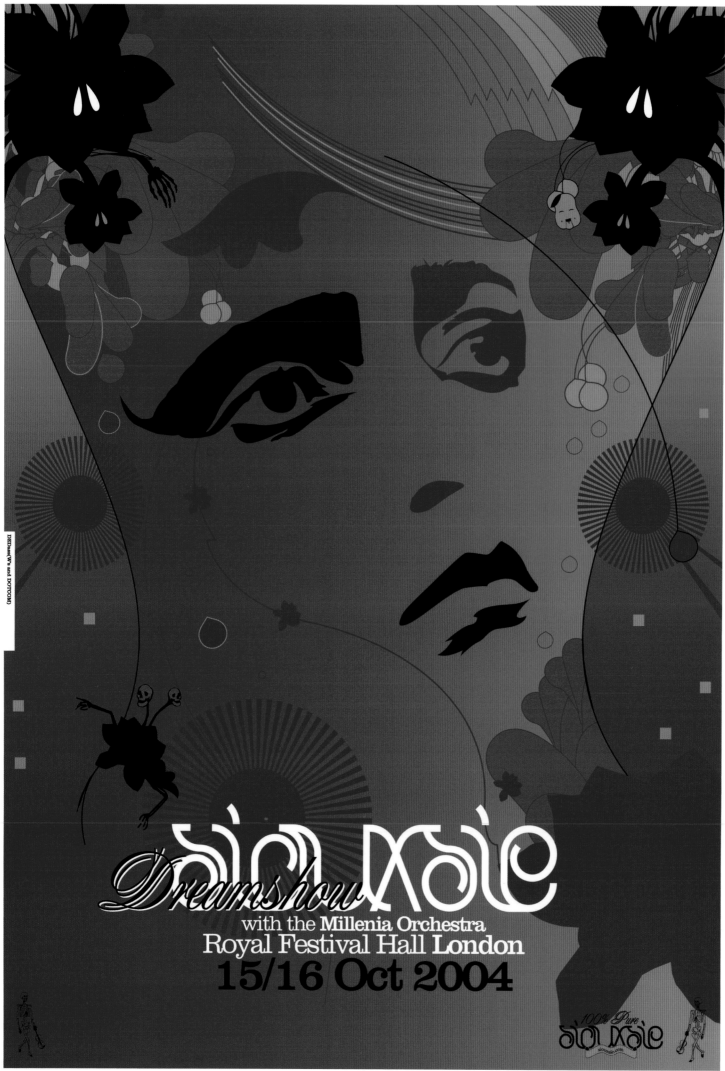

Dreamshow Siouxsie
with the **Millenia Orchestra**
Royal Festival Hall London
15/16 Oct 2004

100% Pure
siouxsie
siouxsie.com

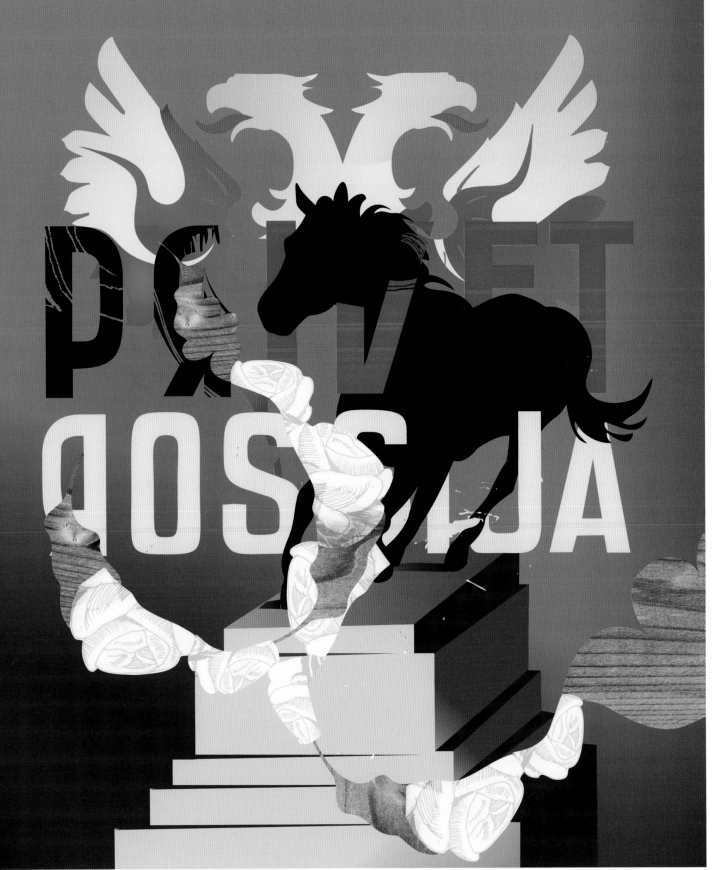

Inga Liksaite

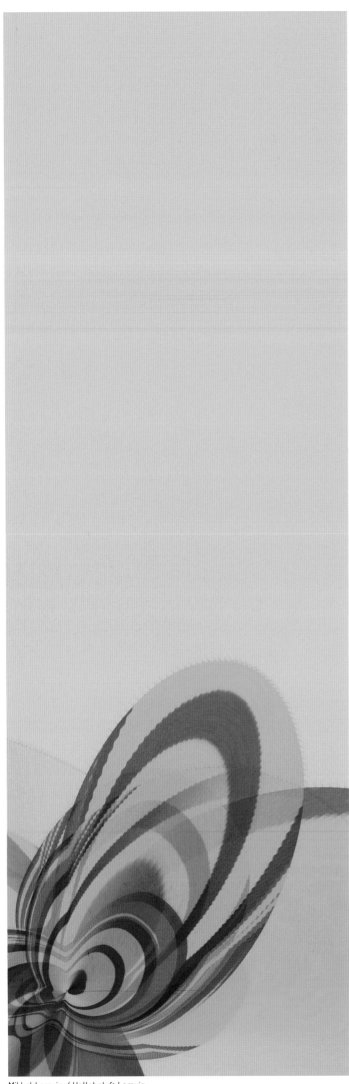
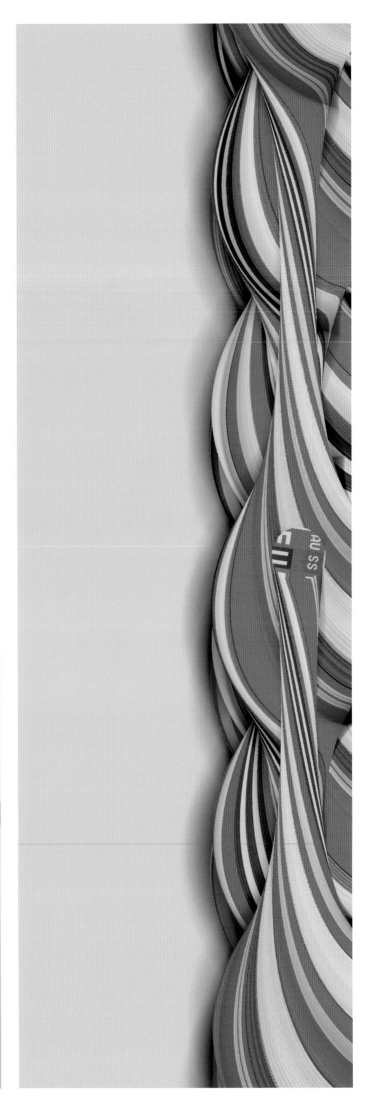

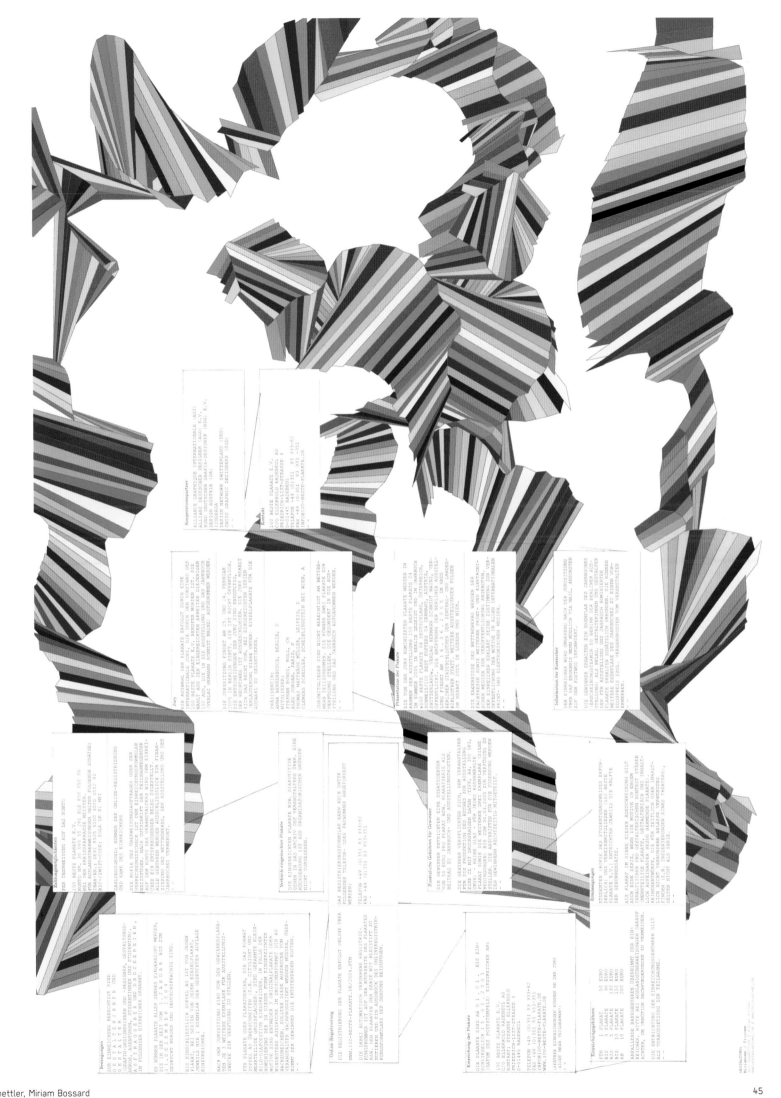

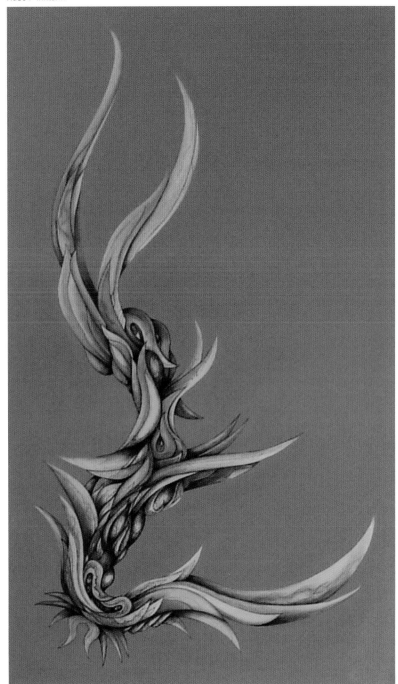

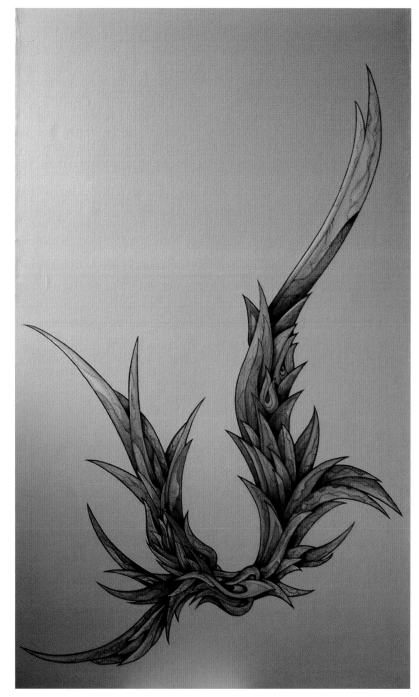

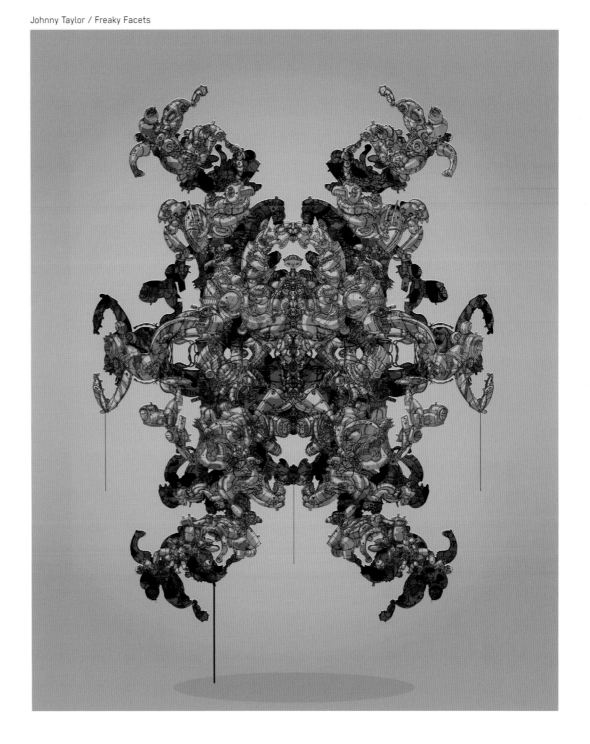

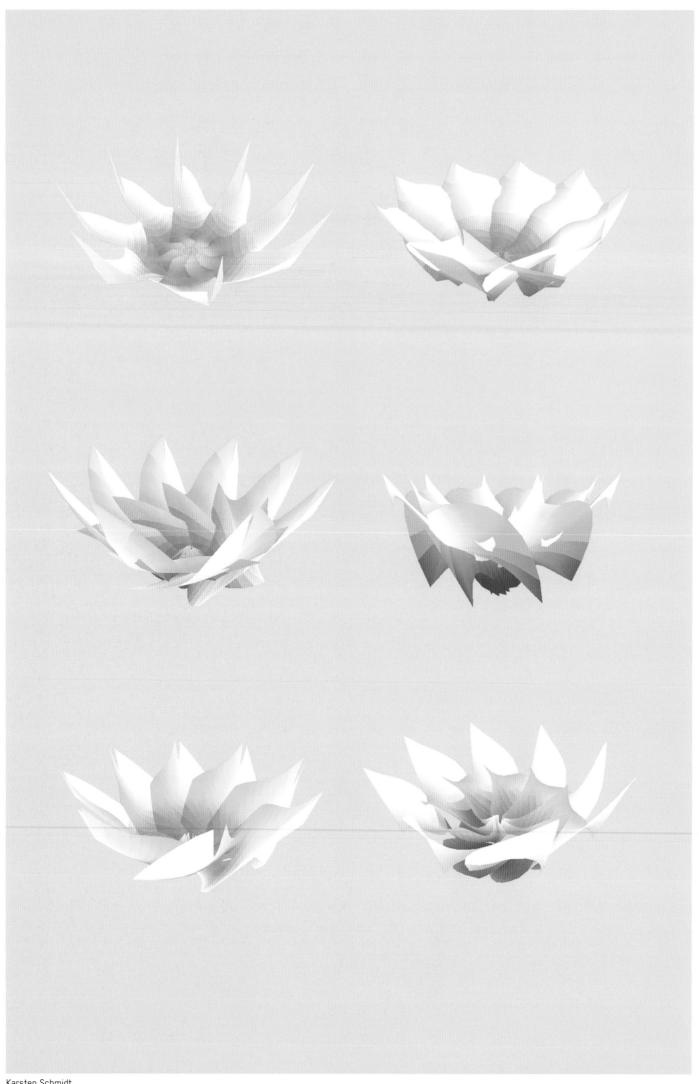

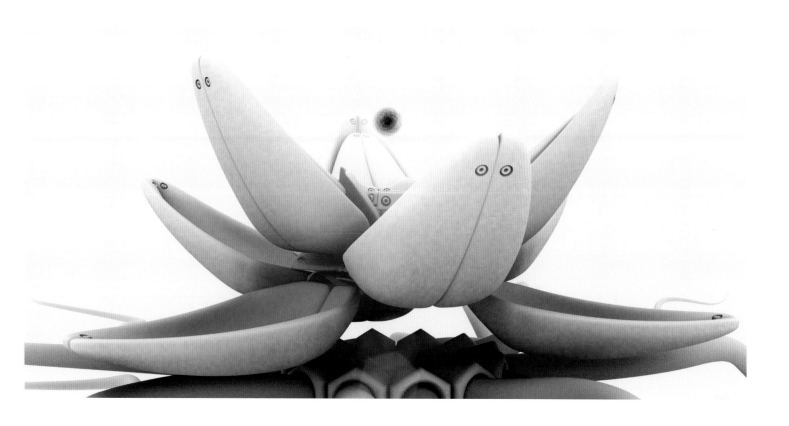

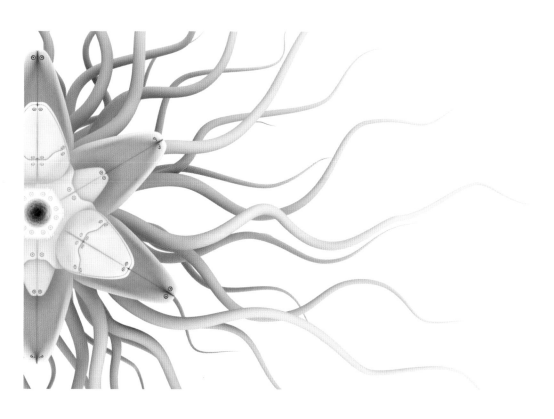

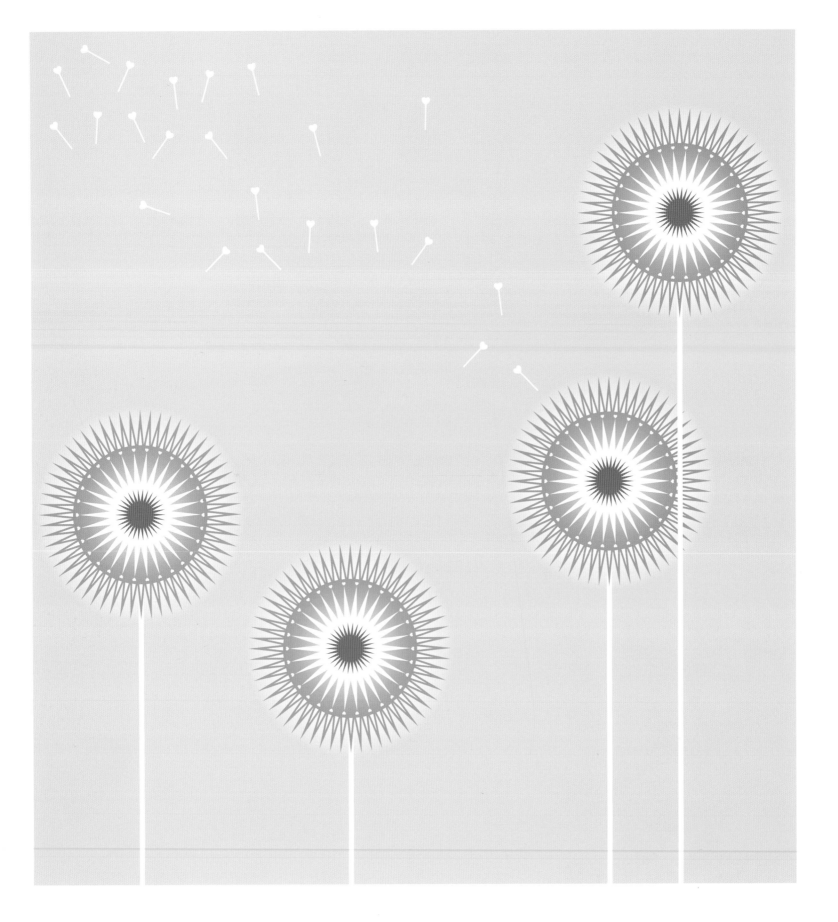

a thousand wishes floating in the air

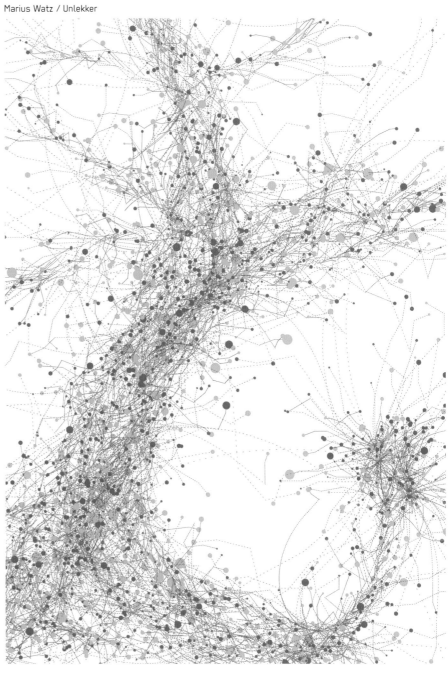

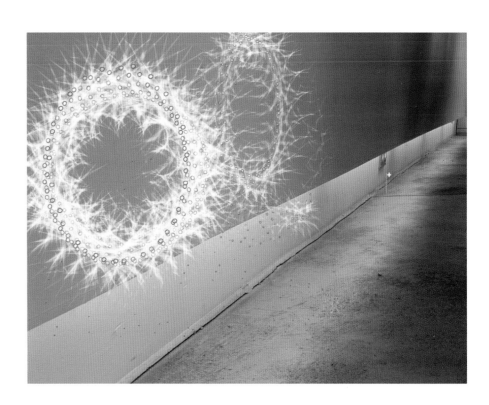

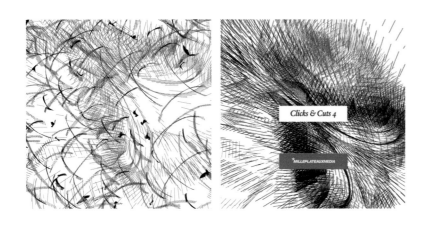

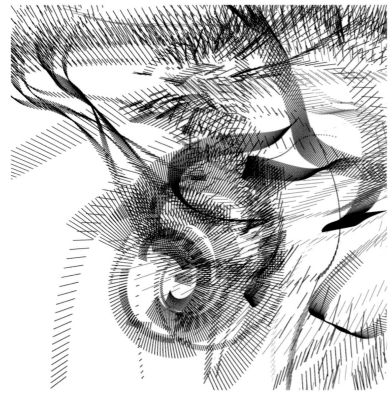

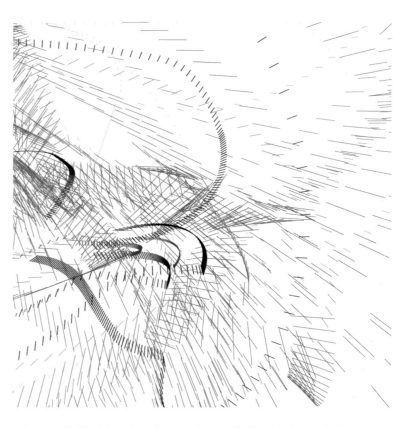

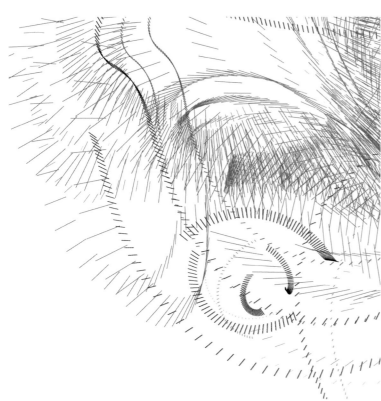

a twist and turn
a lie since burned
an opened sight
and you're to blame

contorted, distorted
writhing and maligned
but still the same

enough is enough
but your kiss isn't

wings of ether
veins of sand
glyphs and relics
songs of...

leave the scene before we're caught
it never happened

a house of cards
of brick and straw
ignore the obvious
call it a fluke
make the bed

write for your public
sell for the fans
they're waiting
they're wishing
washing windows with memories
an hourglass stolen
mud instead of...

whiskers on kittens
bleeding and smitten
teardrops on screenshots
blacked out inceptions

dive in and drink
flaunt the data
later you'll make it up
it's expected and anticipated
retrospected and delegated

logic: the dominate factor
undeniable evidence
lackluster
haphazard
reverted
blasphemous

this life is made of handjobs and rimshots

fuck your logic
fuck your dna
one pair
shared blame
lost claim
stock aimed

you're there
you've noted
you've payed
dissed
illed
fucked
and
hanged

adored
desired
requested
loved

cant help it
it's there
nothing i can do
se is get
love is loath
bliss is love
loath is heath
riss creg meve
sense make heve
 blech
it,s nothing
_R(ª)w#{(&5[w03975

{ELPKF
)#ª%{)#(ª5-0395
{PEW598
{PE
{P#e58
 #"p95
PT9I

6t_...0I
{P$OIt
";]gPW<$
6p[48f?
-4-9
6)GFT?:9 #$w
?![(<
?!p(#$^5
 34[-p96\

we have come to terms _

Oligarch / Ablute

h e a a | Haute école d'arts appliqués
Genève | *discours*

h e a a | Haute école d'arts appliqués
Genève | *point de vue*

HAUNCH OF VENISON

6 Haunch of Venison Yard
off Brook Street
London W1K 5ES
England

T+ 44 (0) 20 7495 5050
F+ 44 (0) 20 7495 4050
info@haunchofvenison.com
www.haunchofvenison.com

SHEFFIELD SKI VILLAGE
15TH BIRTHDAY
SATURDAY 11TH OCTOBER 03
20:00 TO 02:00AM
FREE!

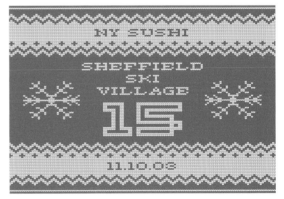

FREESTYLE MUSICALITY INSIDE THE SKI LODGE
HIP HOP / ELECTRONIC / BREAKS /
2STEP / D&B / & SOME!

SPRITE FREESTYLE MASTERS SHOWCASE
ON THE SLOPES 20:00 TO 22:00

RECORDED LIVE!
& BROADCAST TO SOUTH YORKSHIRE & BEYOND ON

NY SUSHI FM
EVERY SATURDAY NIGHT / SUNDAY MOURNING 2–4AM HALLAM FM 97.4/102.9/103.4
SUSHI ON YOUR STEREO : LISTEN AGAIN @ WWW.NYSUSHI.CO.UK

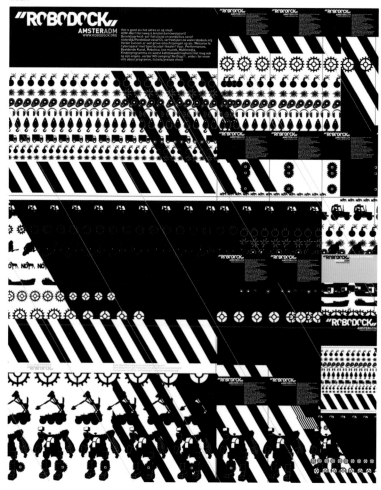

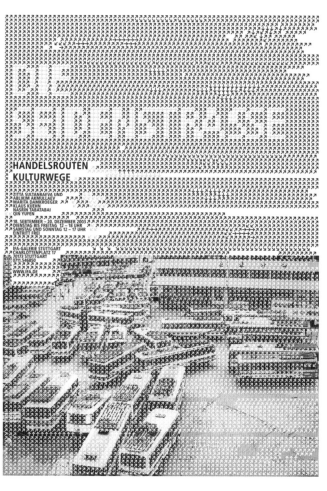

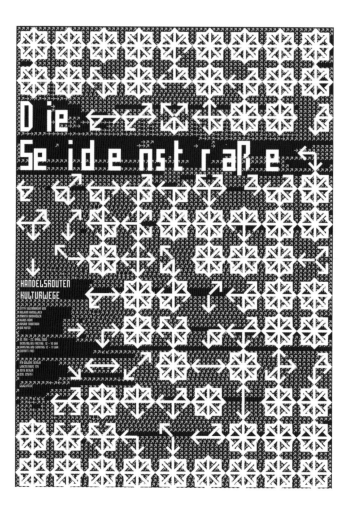

Melanie Sramek, Rosie Traina

Red Design

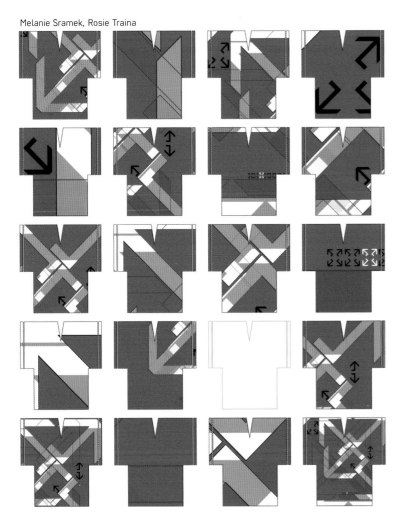

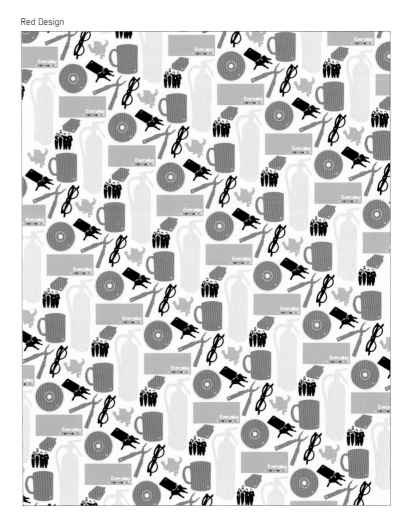

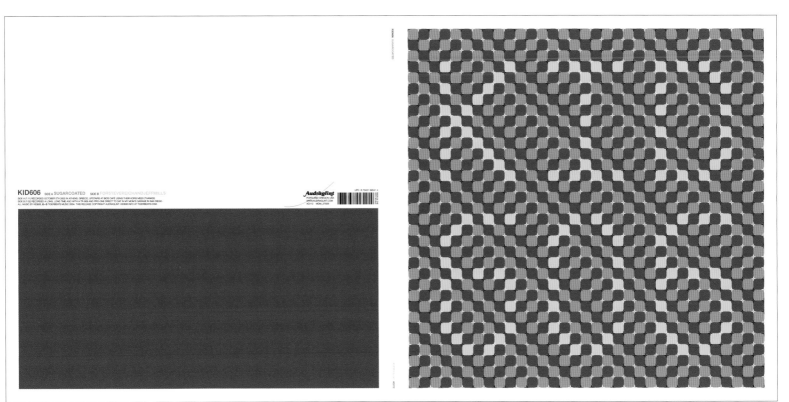

David Nakamoto

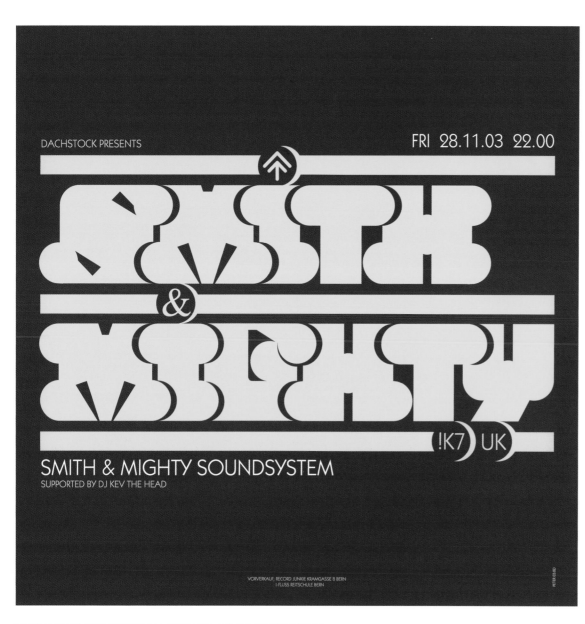

DACHSTOCK PRESENTS

FRI 28.11.03 22.00

SMITH & MIGHTY

!K7 UK

SMITH & MIGHTY SOUNDSYSTEM
SUPPORTED BY DJ KEV THE HEAD

VORVERKAUF; RECORD JUNKIE KRAMGASSE 8 BERN
I-FLUSS REITSCHULE BERN

20 08 04

PRIMAL GRUNT PRESENTS

FLEVO AFTER PARTY

THE VIOLET BURNING

VRIJDAG 20 AUGUSTUS
AANVANG 20.00 UUR
PARADISO AMSTERDAM

SATELLITE 7

(USA)

&

(NL)

ENTREE 8 EURO
VVK GROTERE POSTKANTOREN

ROKIN#120

DWING GELUK AF.

'T WORNIKS

STEENBERGEN

Reto Gehrig, Ryosuke Kawaguchi Zopfi / CODE

EXPERIMENTAL
TURNTABLISM
ON 5 DECKS
+ MPC

21.01.

CAFE MUFFATHALLE

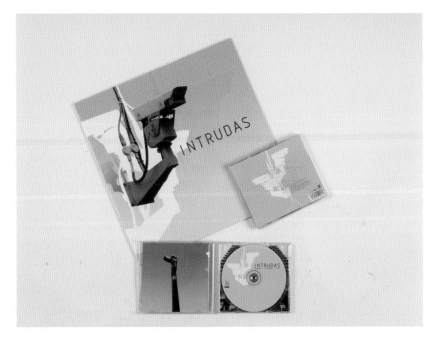

INTRUDAS

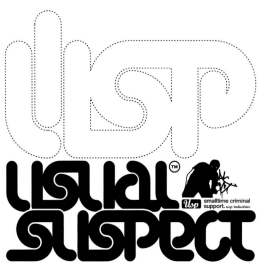

Melanie Sramek, Rosie Traina

Annika Kaltenthaler / AKA

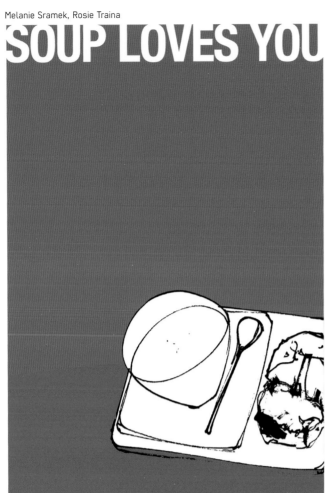

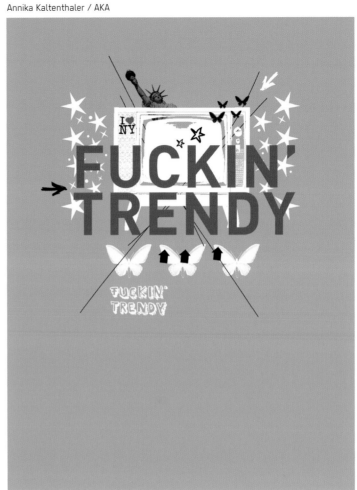

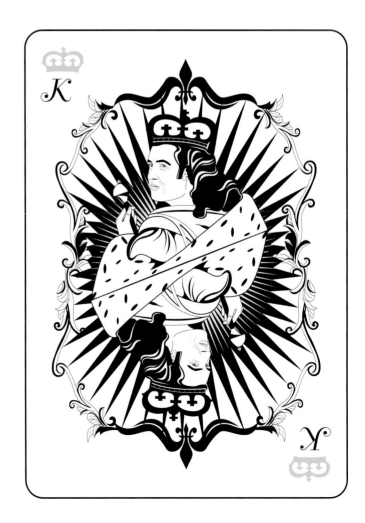

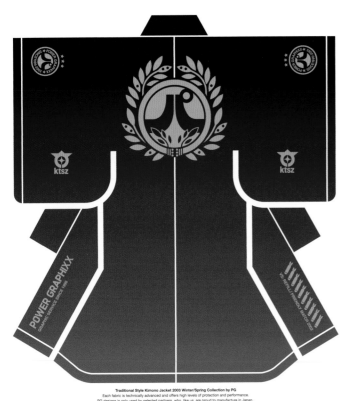

Traditional Style Kimono Jacket 2003 Winter/Spring Collection by PG
Each fabric is technically advanced and offers high levels of protection and performance.
PG designs is only used by selected partners, who, like us, are proud to manufacture in Japan.

sunrise studios

Super extra

Dahl/Andersen/Héral Trio

Carsten Dahl
PIANO, MARIMBA, VIBRAFON

Arild Andersen
BASS

Patrice Héral
TROMMER, PERKUSJON, VOKAL, ELEKTRONIKK

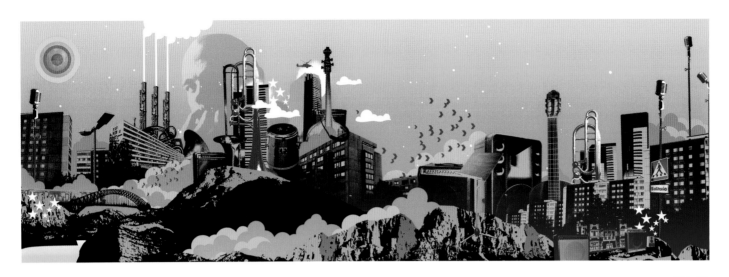

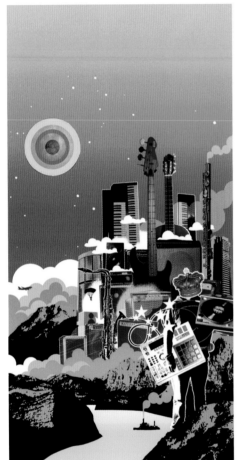

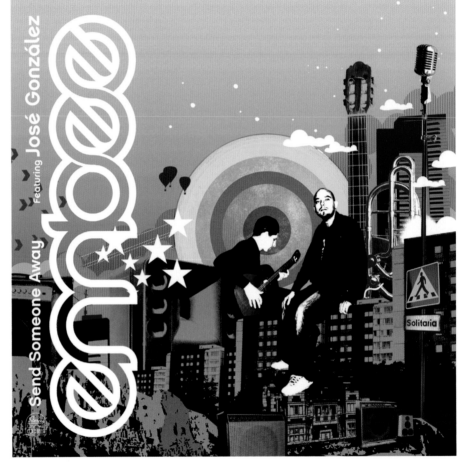

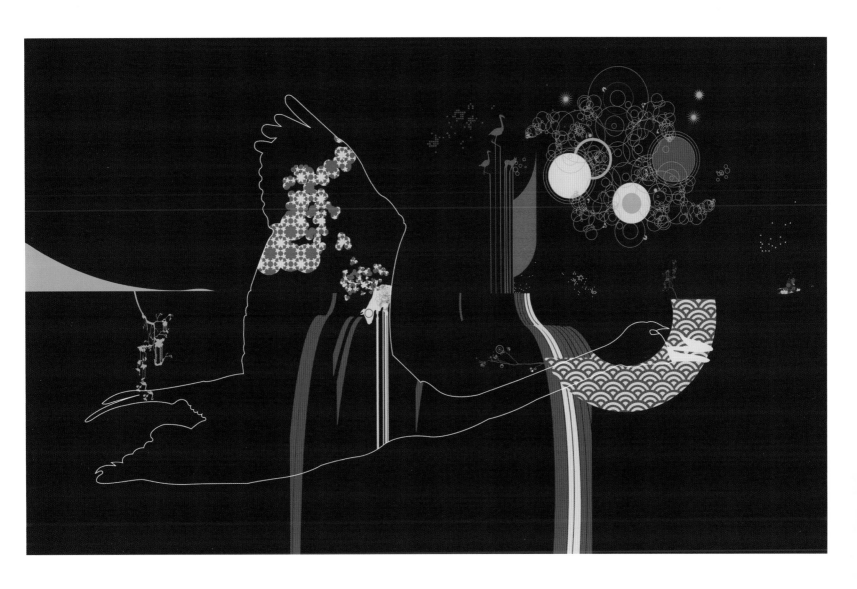

CREATIVE PRIDE

PROUD TO HELP

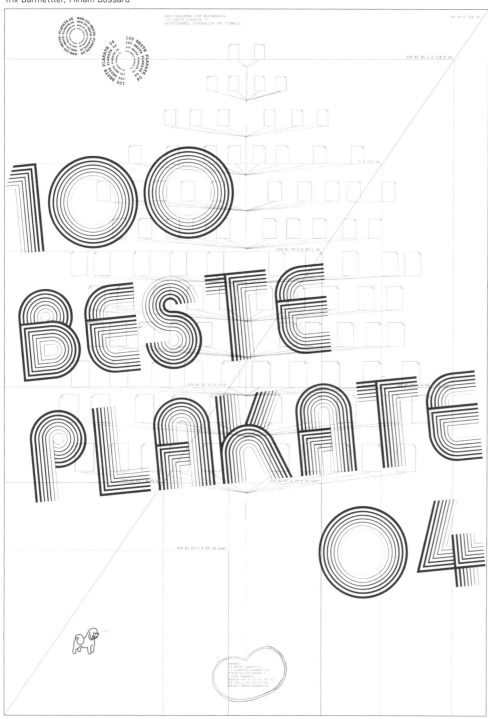

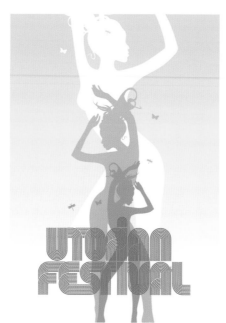

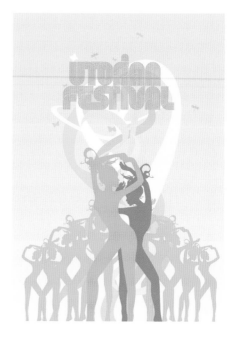

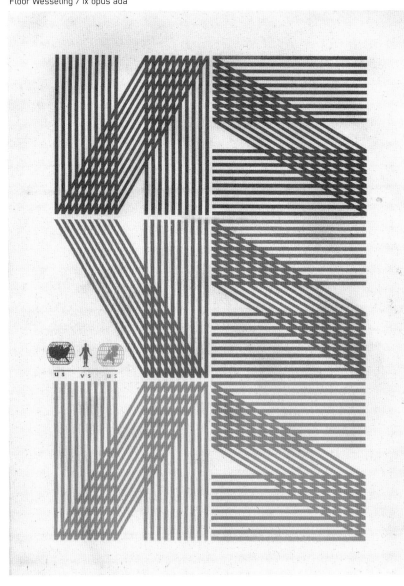

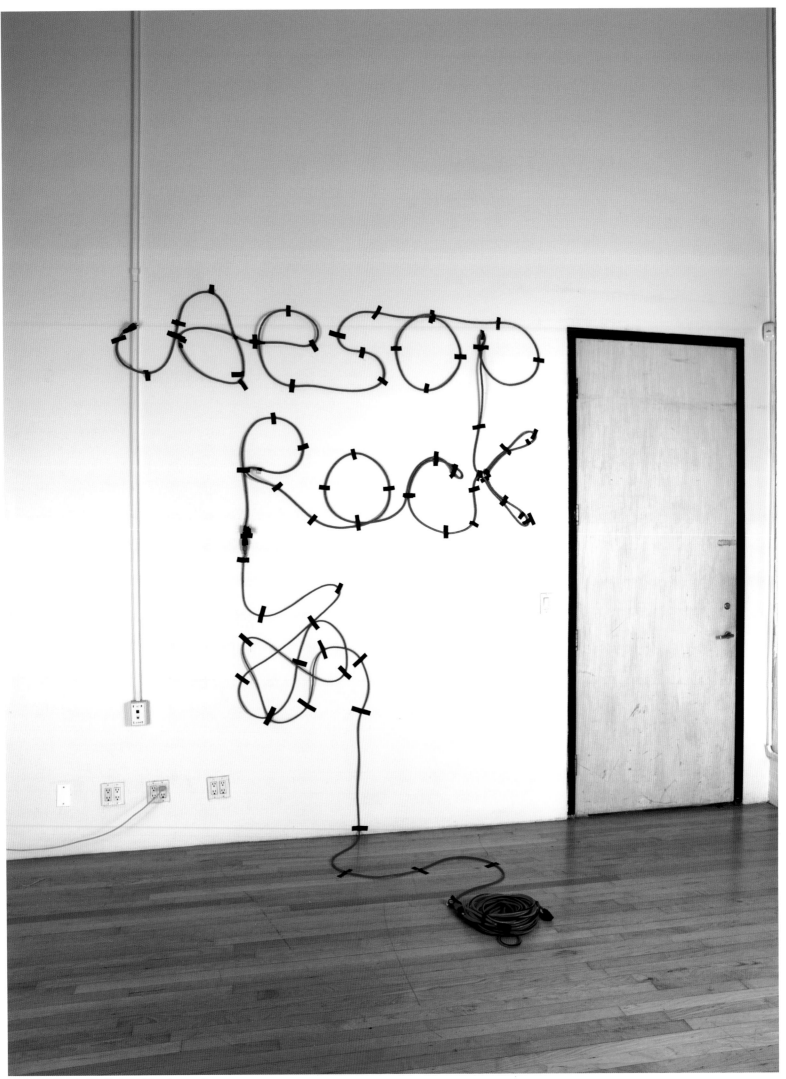

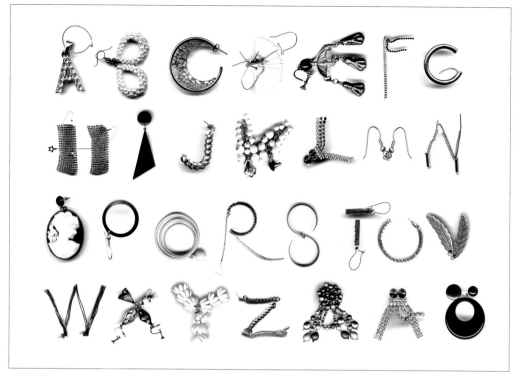

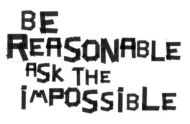

Telling someone something being safe they will not hear it

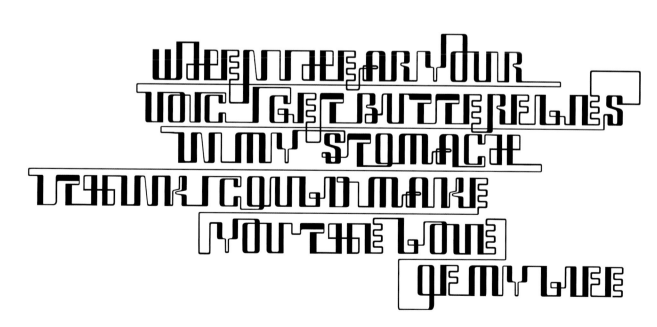

CAN A TYPEFACE SAVE THE WORLD?

? WANT TO MAKE... WORK THAT CHANGES HOW WE THINK THAT SPEAKS FOR THE UNDER REPRESENTED

Kearney Rocholl

from
Ultra
light
to
regular

Ryan Molloy

Antti Hinkula / Syrup Helsinki

Contemporary, metropolitan, laid-back and up-market, Geisha is set to be Nottingham's only place to drink, dine and dance

Reservations
Lounge seating can be reserved and food; waitress service is ava throughout Geisha.
Geisha is also available for privat and corporate functions.

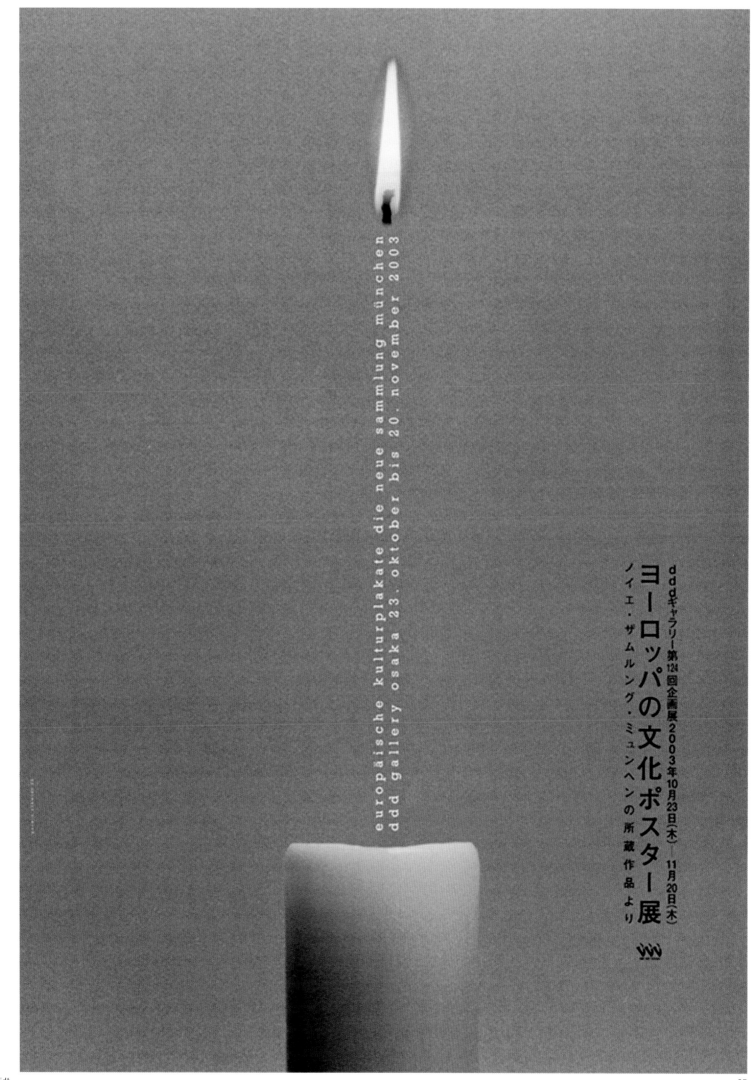

europäische kulturplakate die neue sammlung münchen
ddd gallery osaka 23. oktober bis 20. november 2003

ヨーロッパの文化ポスター展
dddギャラリー第124回企画展 2003年10月23日(木)—11月20日(木)
ノイエ・ザムルング・ミュンヘンの所蔵作品より

Matt Mayes / Signor

Timo Gaessner / 123Buero

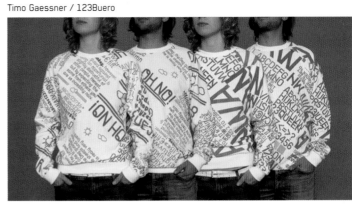

Gordon Young, Andy Altmann / Why not Associates; Photos by Andy McGregor (1) and Rocco Redondo (2+3)

MÉDECINS DU MONDE. URGENCE RAZ-DE-MARÉE ASIE, BP 100 75018 PARIS CROIX-ROUGE FRANÇAISE. "SÉISME ASIE" BP 100, 75008 PARIS. UNICEF "URGENCE SÉISME ASIE DU SUD", BP 600, 75006 PARIS.
HTTP://WWW.MEDECINSDUMONDE.ORG HTTP://WWW.CROIX-ROUGE.FR HTTP://WWW.UNICEF.FR
UNHCR FRANCE. 9, RUE KEPLER 75016 PARIS FONDATION DE FRANCE. SOLIDARITÉ ASIE DU SUD. BP0.22 75008 PARIS HANDICAP INTERNATIONAL. HANDICAP INTERNATIONAL / RAZ-DE-MARÉE, 69361 LYON
HTTP://WWW.UNHCRFRANCE.ORG HTTP://WWW.DONS.FONDATIONDEFRANCE.ORG HTTP://WWW.HANDICAP-INTERNATIONAL.ORG/

VIVANT OMNES VIRGINES

NUCLEOS NON PUTAMINA

VIVAT ACADEMIA

BREVIS ET HUMIDUS

PROMISCUA

ERGO BIBAMUS

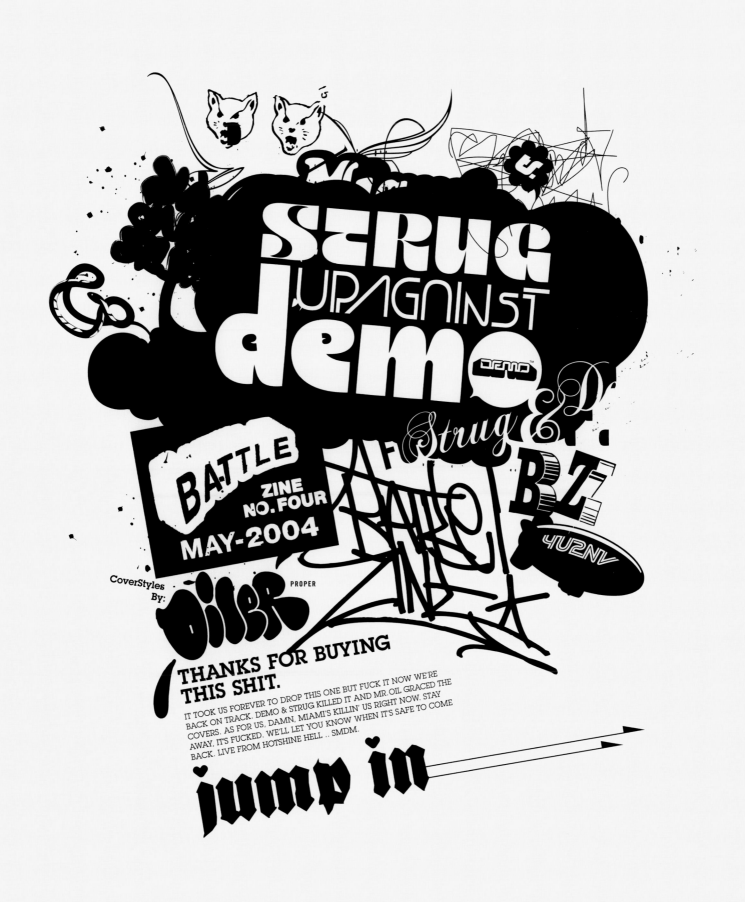

STRUG UPAGAINST demo

Strug & D.

BATTLE
ZINE
NO. FOUR
MAY-2004

CoverStyles By: Oiler PROPER

BZ
4U2NV

THANKS FOR BUYING
THIS SHIT.

IT TOOK US FOREVER TO DROP THIS ONE BUT FUCK IT NOW WE'RE
BACK ON TRACK. DEMO & STRUG KILLED IT AND MR. OIL GRACED THE
COVERS. AS FOR US, DAMN, MIAMI'S KILLIN' US RIGHT NOW. STAY
AWAY, IT'S FUCKED. WE'LL LET YOU KNOW WHEN IT'S SAFE TO COME
BACK. LIVE FROM HOTSHINE HELL .. SMDM.

jump in

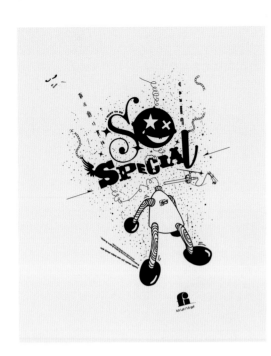

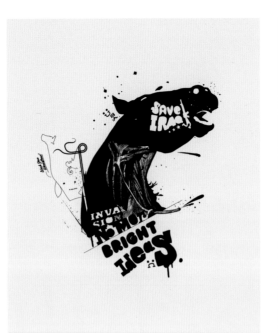

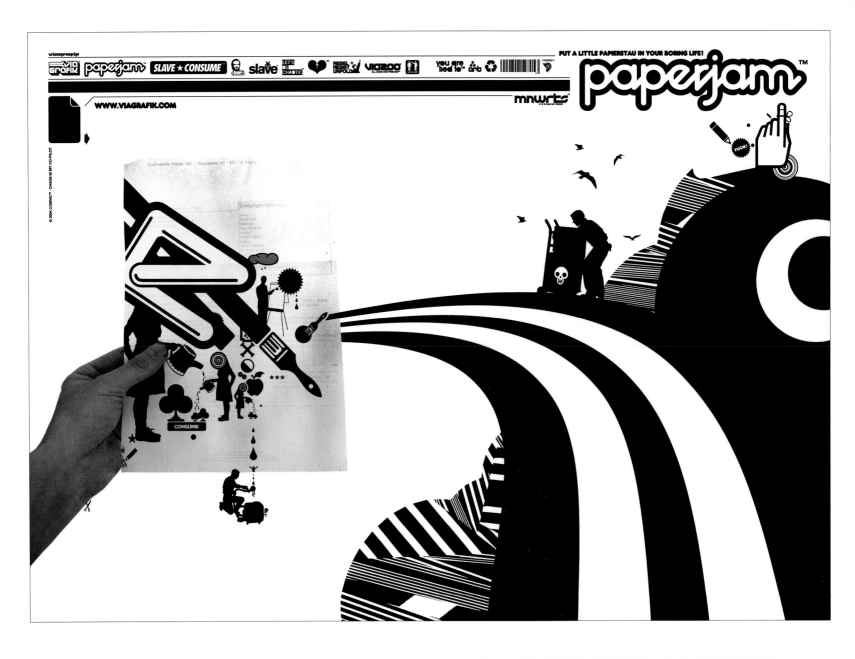

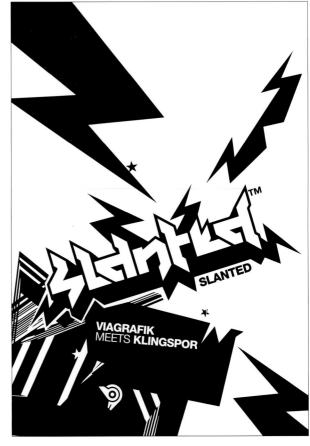

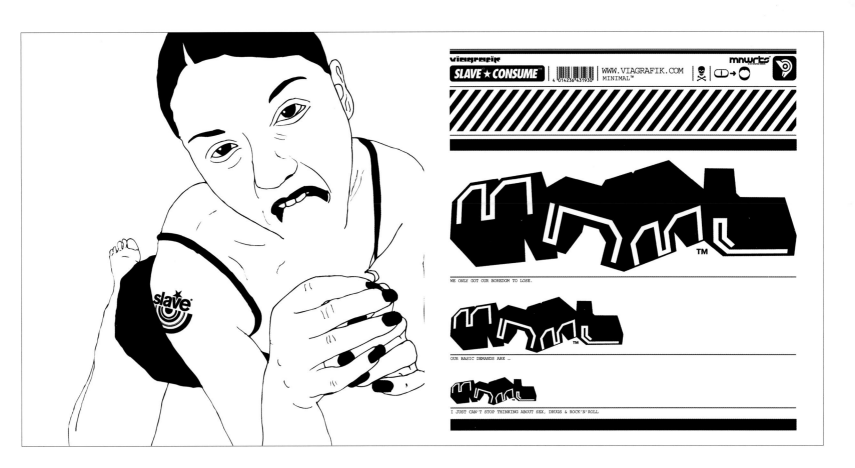

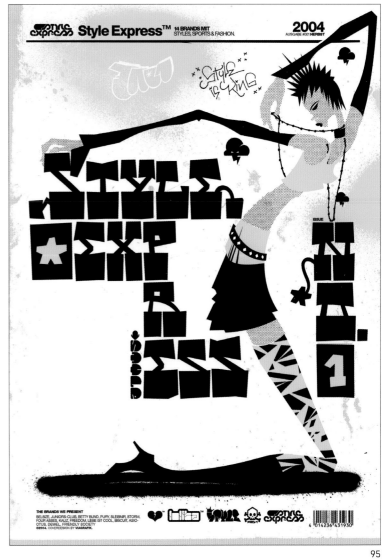

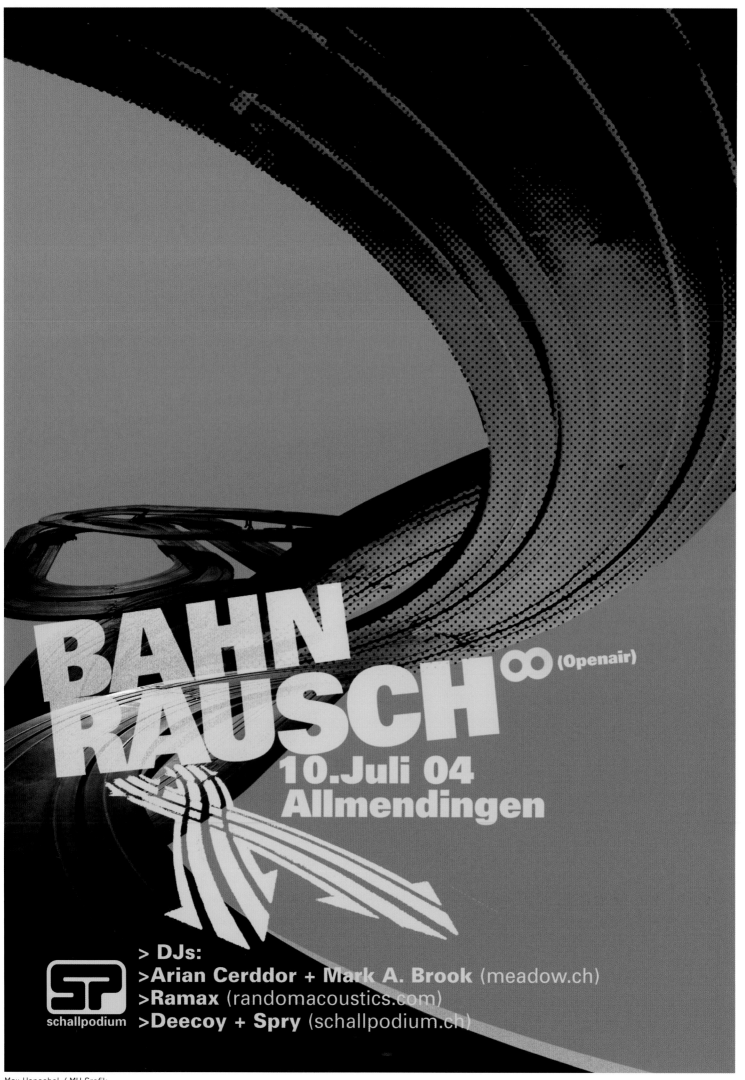

BAHN
RAUSCH ∞ (Openair)
10.Juli 04
Allmendingen

> DJs:
>Arian Cerddor + Mark A. Brook (meadow.ch)
>Ramax (randomacoustics.com)
>Deecoy + Spry (schallpodium.ch)

schallpodium

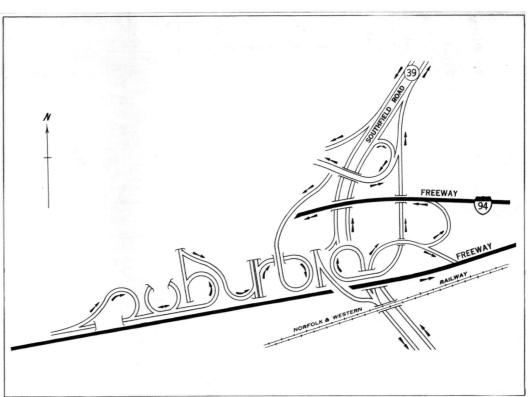

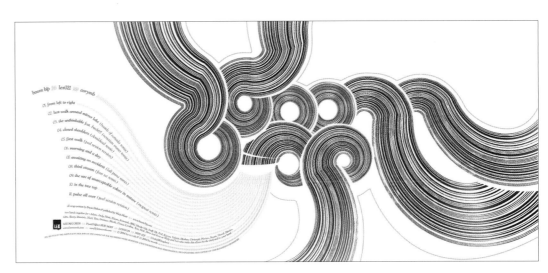

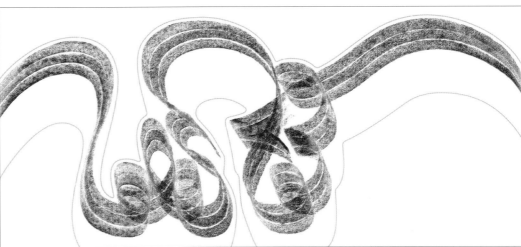

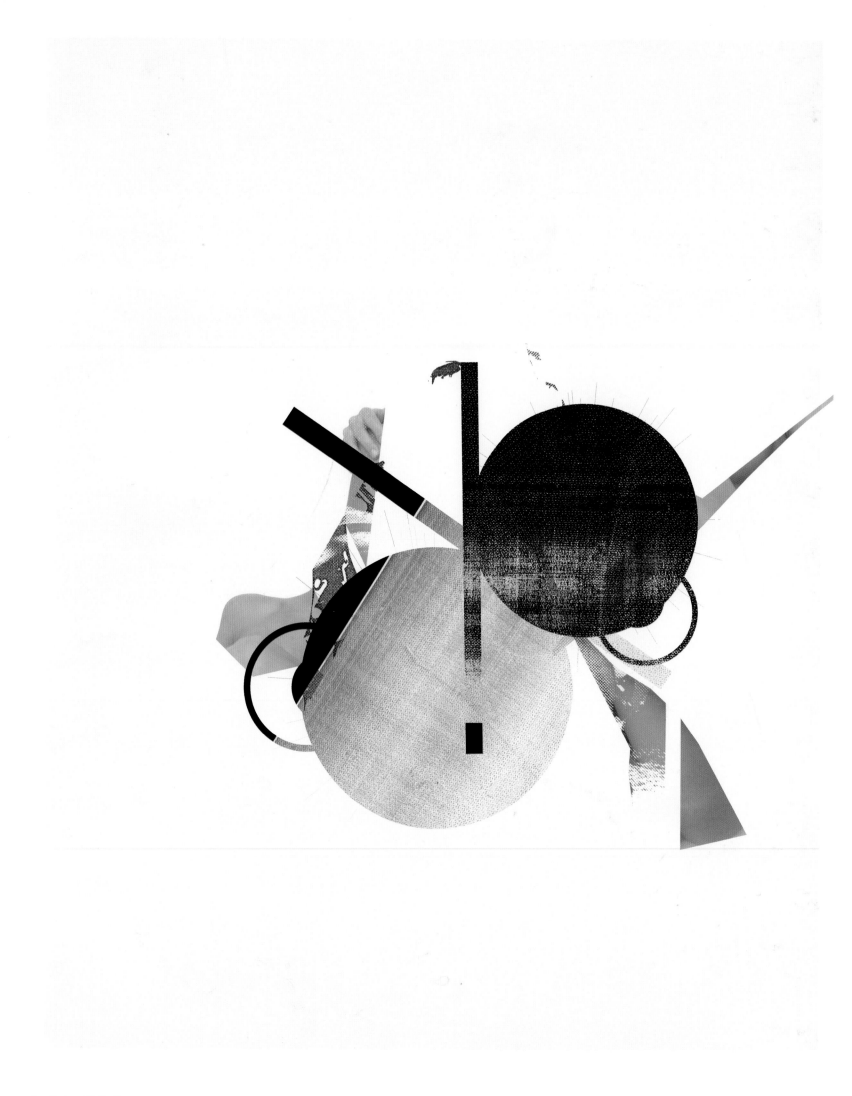

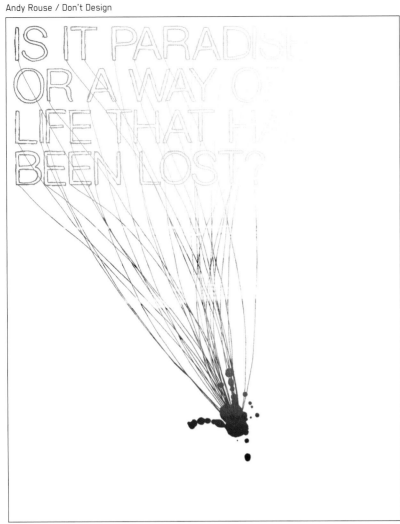

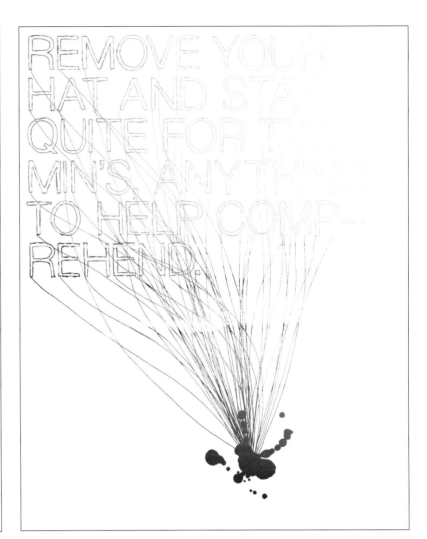

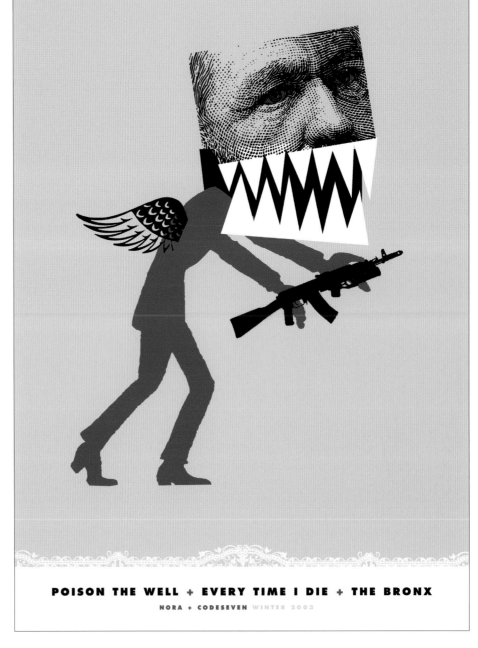

POISON THE WELL + EVERY TIME I DIE + THE BRONX

NORA + CODESEVEN WINTER 2003

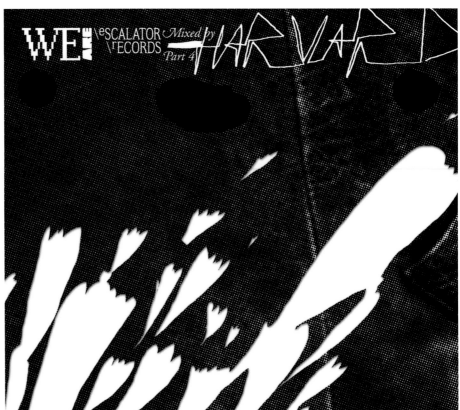

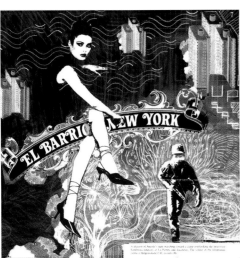

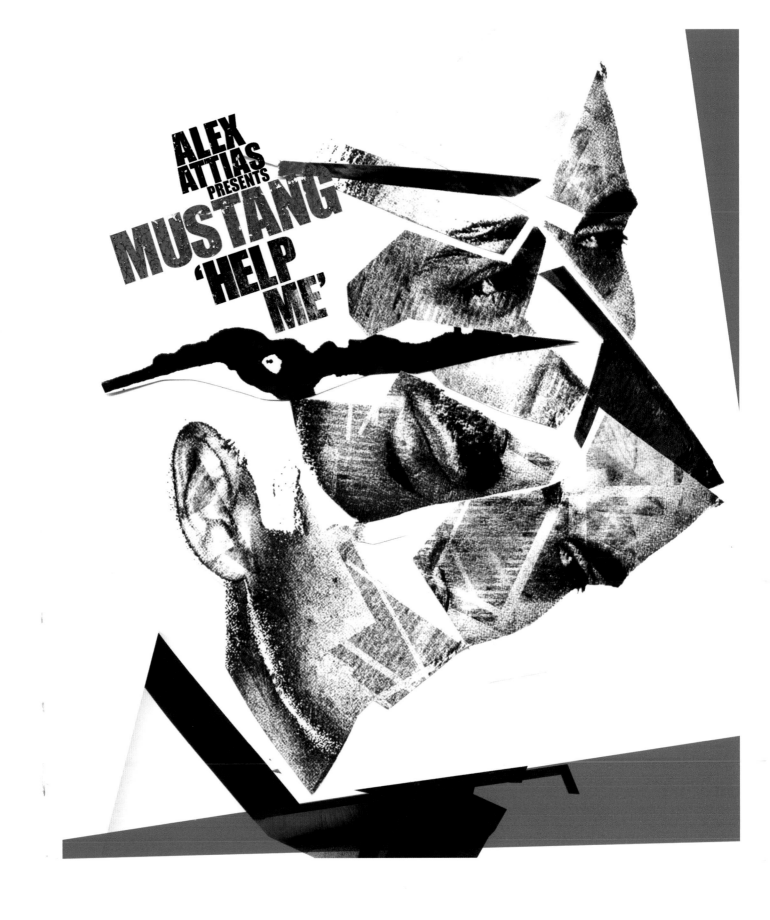

ALEX
ATTIAS
PRESENTS
MUSTANG
'HELP
ME'

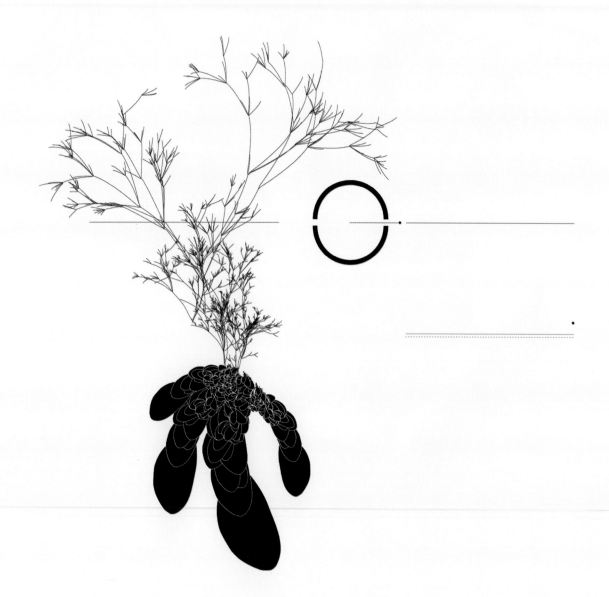

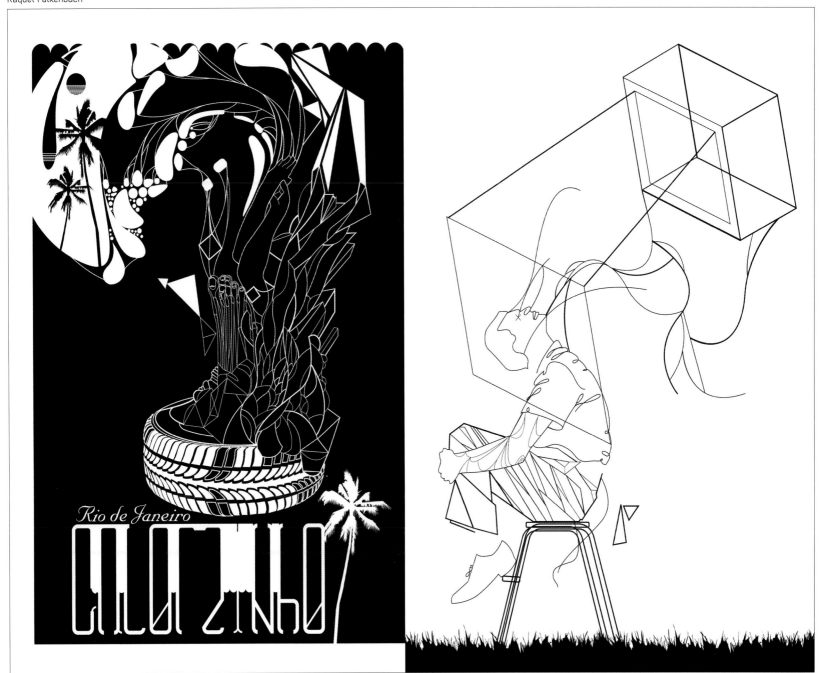

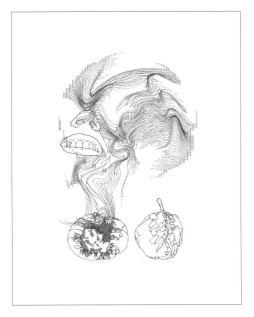

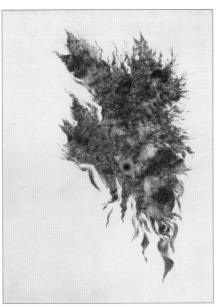

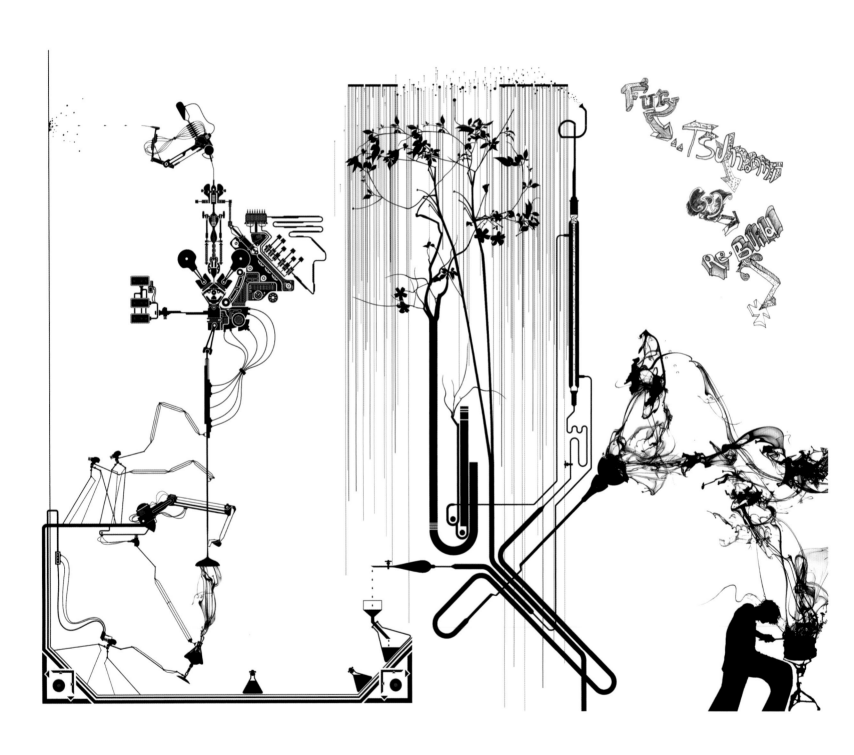

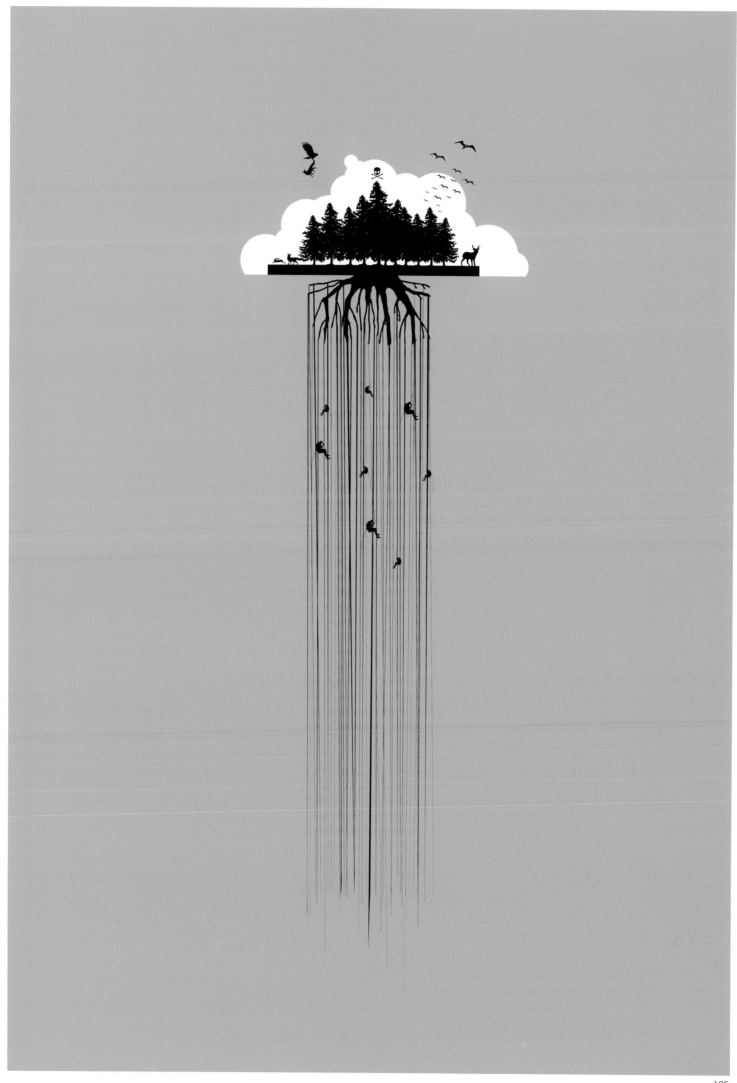

n

junghanß naked

A ONE awakens A TWO I am born B ONE wrong B TWO atmosphere

all tracks written and produced by junghanß. vocals by junghanß. lyrics by s. herzsigir.
except atmosphere written by sen curtis. produced by junghanß

1SIGN 2004 www.100decade.de
artwork www.18oktober.com

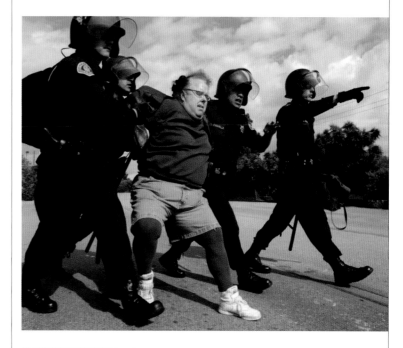

NEO.POP
RELEASE TOUR 2004

CD COMPILED BY NORTHERN LITE OUT 01.06.2004
INCLUDING TRACKS FROM: TURNTABLEROCKER,SUPERPITCHER,
DUB PISTOLS, NORTHERN LITE, SWAYZAK AND MORE

NEO.POP RELEASE TOUR
15.05.04 ERFURT /CENTRUM 19.05.04 BERLIN /CASINO 22.05.04 DRESDEN /FUNKWELT
28.05.04 MAGDEBURG /TIME X-CLUB 04.06.04 REGENSBURG /SUITE 15 05.06.04 MÜNCHEN /BADEANSTALT
12.06.04 ZIEGENRÜCK /TH 18.06.04 SAALFELD /PHASE 2 19.06.04 NIEDERGÖRSDORF /SOUNDTROPOLIS
25.06.04 STUTTGART /CLIMAX 26.06.04 FLUGPLATZ LITTEN - BAUTZEN /ELECTRIC AIRFIELD
02.07.04 JENA /KINSKI 03.07.04 STAFFENHAGEN /TANKHAUS 09.07.04 LEIPZIG /VELVET

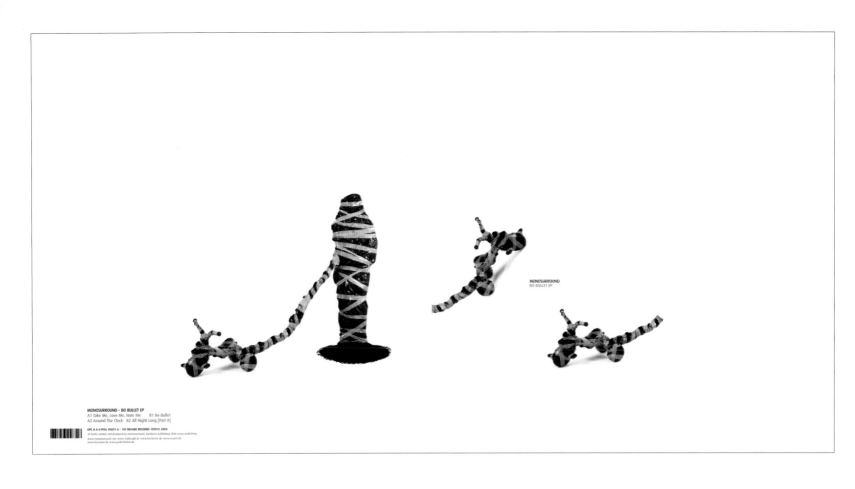

MONOSURROUND – BO BULLET EP
A1 Take Me, Love Me, Hate Me B1 Bo Bullet
A2 Around The Clock B2 All Night Long [Part II]

UPC A 4 4 YFSA 45831 6 – 151 DECADE RECORDS 1020145 2003
all tracks written and produced by monosurround, hardcore publishing, BHs music publishing
www.monosurround.net www.1ddecade.de www.hardcore.de www.neuton.de
www.houseam.de www.punkt-khdm.de

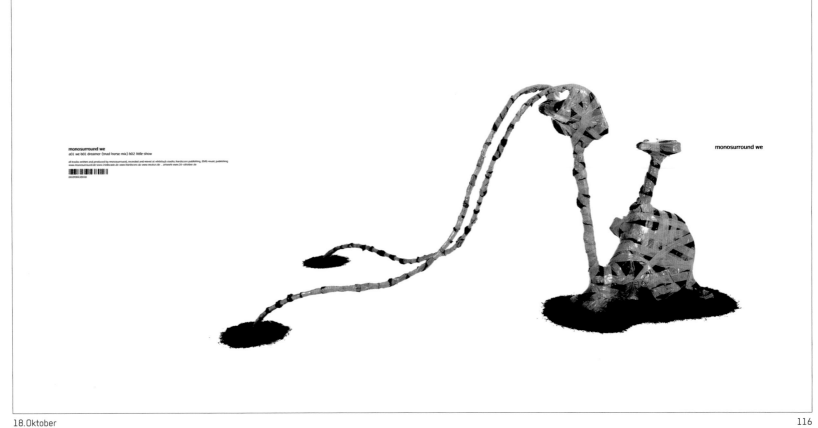

monosurround we
a01 we b01 dreamer (mad horse mix) b02 little show

all tracks written and produced by monosurround, recorded and mixed at whitelayb studio, hardcore publishing, EMG music publishing
www.monosurround.de www.1ddecade.de www.hardcore.de www.neuton.de ... artwork www.18-oktober.de
6839965386506

FENG SHUI FOR SALE

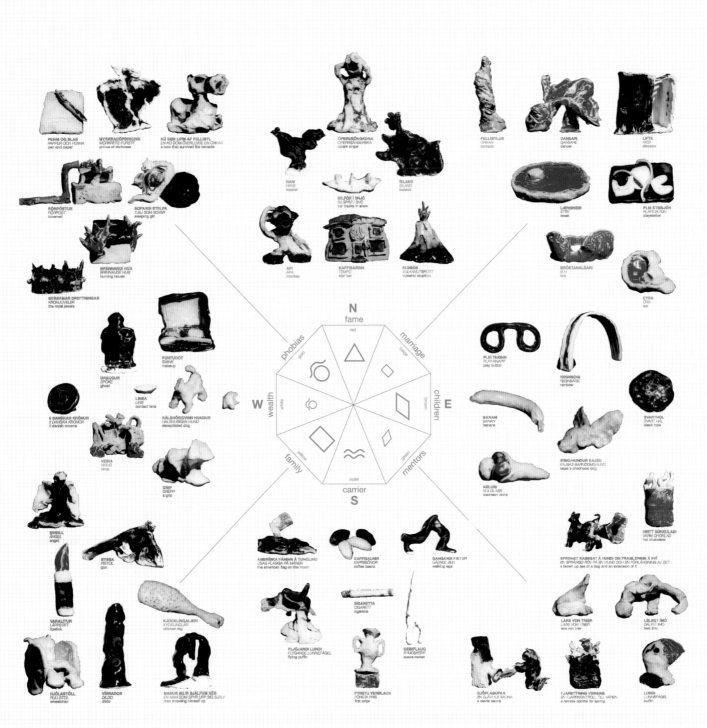

Feng-Shui / Fast-Food. Malmö, Sviþjóð, Nóvember 1999

I nóvember 1999 hittist í Malmö hópur listamanna* frá Íslandi og Svíþjóð í þeim tilgangi að þá hugsanir sínar í leir. Áhakstur þeirar vinnu urðu nokkur hundruð styttur sem gerðar voru með daglegt líf, drauma og leir listamannanna að leiðarljósi. Styttumar tengdu listamennirnir við Feng Shui austræna heimspeki sem nýlega var orðin að vestrænni tískubólu og nefndu verkefnið, Feng Shui - Fast Food.

Í jóladsinni 1999, seldu listamennirnir tælenskan núðlur og grænt te sí hjóhlrsi í miðborg Malmö, með hverri máltíð fylgð brefpoki með einni styttu í. Pókamir voru fjökkaðir eftir áreðkunum Þörum og réð bæðingardagur viðskiptavinanna því hvaða poki varð fyrir valinu. Í pokanum voru bæði upplýsingar um það hvar viðskiptavinurinn skyldi staðsetja styttuna inni á heimili sínu sem og persónufsing á honum samkvæmt lúkun listamannanna á Feng Shui heimspekinni. Þið var rekið ós þennan dag og seldust meira en 150 máltíðir. Á þessu plakati má sjá tihö bot af þeim styttum sem gefnar voru þennan dag.

* Christian Andersson, Ingibjörg Magnadóttr, Kajsa Dahlberg, Karlotta Blöndal, Niklas Johansson, Unnar Örn Auðarson og Ylva Westerlund.

Feng-Shui / Fast-Food. Malmö, Sverige. November 1999

I november 1999 möttes en grupp konstnärer* från Sverige och Island i Malmö för att realisera projektet Feng Shui Fast Food. Projektets förste idé bestod i att vi tillsammans tillverkade lerfigurer av varierande utseende och storlek. Skulpturernas motiv var tagna ur vårt dagliga liv, våra drömmar, tankar och fobier. Vi valde att relatera dem till en österländska filosofi, Feng Shui, som nyligen hade blivit en västerländisk trend.

Projektet presenterades i en husvagn som mitt i Malmös julvandring tog plats vid Triangeins köpcentrum. Från husvagnen serverade vi thailändska wookade nudlar och grönt te. Tillsammans med varje portion följde en papperspåse innehållandes en av våra lerskulpturer. Kundema fick olika påsar beroende på kön, ålder och födelsedag. Tillsammans med varje skulptur följde en kortfattad information om Feng Shui-läran och råd kring skulpturens placering i hemmet. Med skulpturen följde även en beskrivning om kundens personlighet enligt vår tolkning av Feng Shui. Feng Shui och Fast Food visade sig vara en populär kombination och vi sålde över 150 portioner nudlar under dagen.

På postern kan du se ett urval av de keramikfigurer vi gav bort under dagen.

*Christian Andersson, Unnar Örn Auðarson, Karlotta Blöndal, Kajsa Dahlberg, Ingibjörg Magnadóttr, Niklas Johansson och Ylva Westerlund.

Feng-Shui / Fast-Food. Malmö, Sweden, November 1999

In November a group of artists* from Sweden and Iceland came together a few times in the city of Malmö to make ceramic figures. We made a few hundred of them, with all kinds of motifs from our daily lives, dreams and phobias. We then related them to an Eastern philosophy called Feng Shui that had recently become on western trend.

The work consisted of a caravan that we parked in the centre of Malmö and in the midst of Christmas shoppers we sold Thai noodles and green tea from the caravan. We gave away with it each portion a paper bag with one of the little ceramic sculptures in it. People would receive one of four different paper bags, depending on the season they were born in. It included instructions concerning where to place the small statue within the client's apartment. It also had a description of their personality according to our own meaning of the Feng Shui philosophy. This day was hectic and we sold over 160 meals.

On this poster you can see some of the ceramic figures that were given away that day.

*The group consisted of Christian Andersson, Unnar Örn Auðarson, Karlotta Blöndal, Kajsa Dahlberg, Ingibjörg Magnadóttr, Niklas Johansson and Ylva Westerlund.

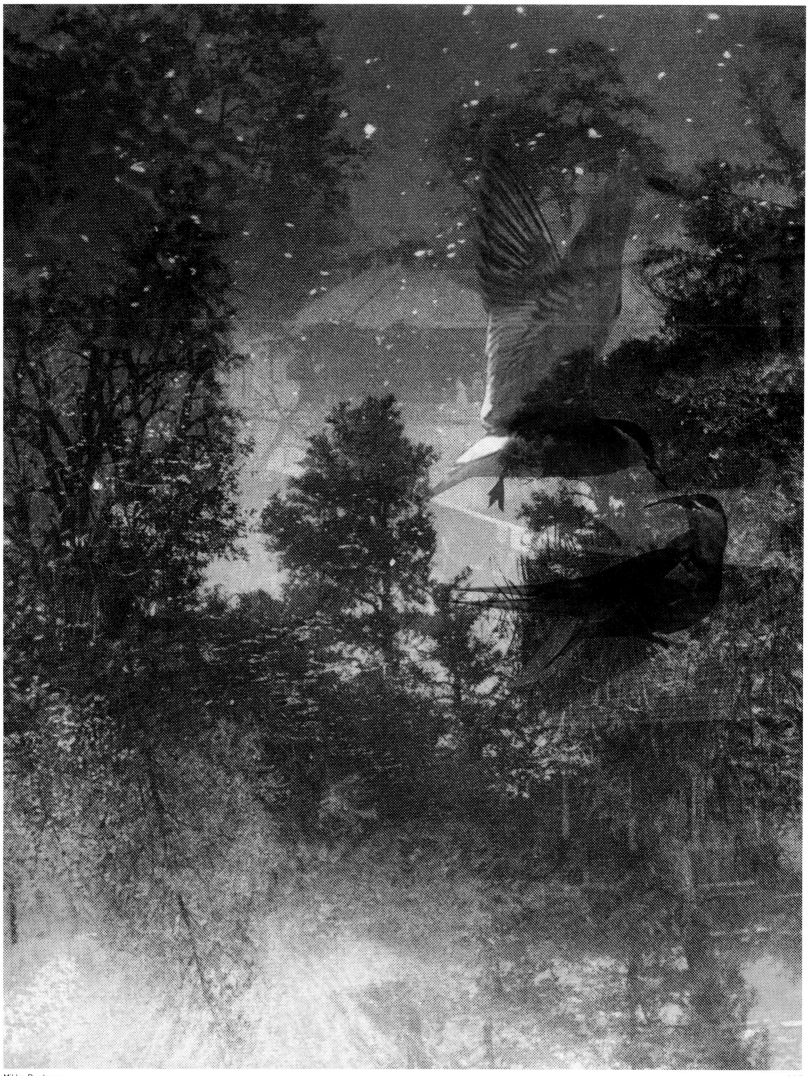

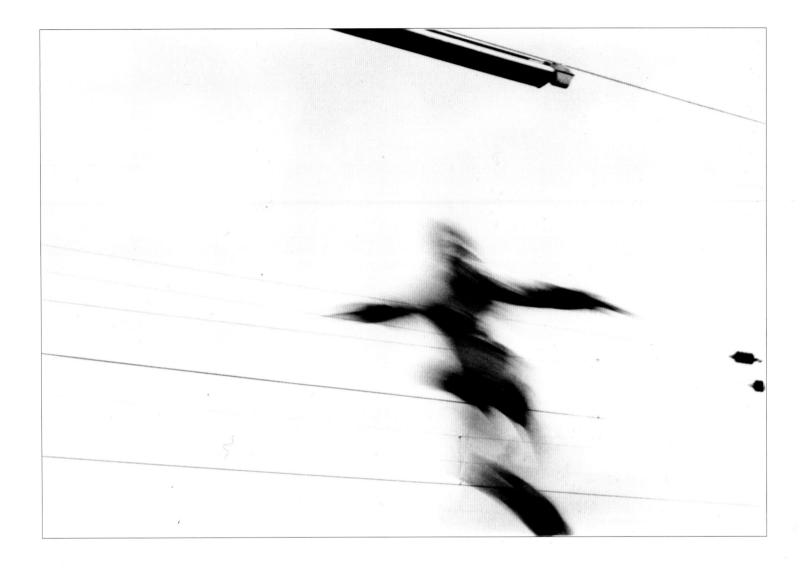

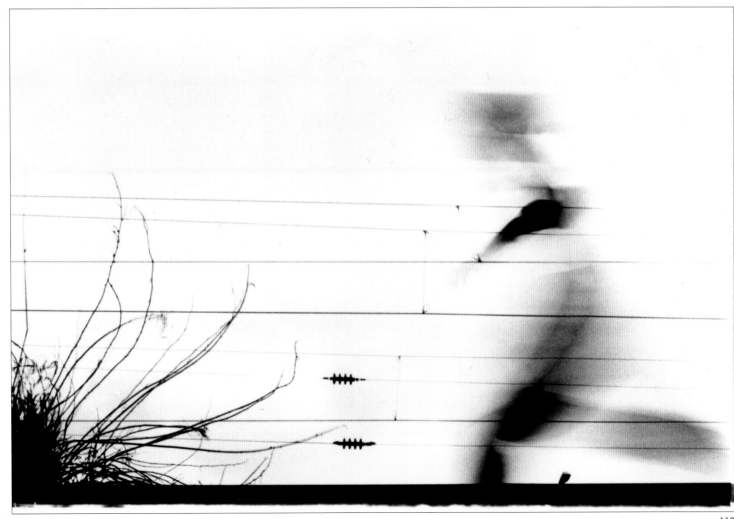

Friederike Preuschen

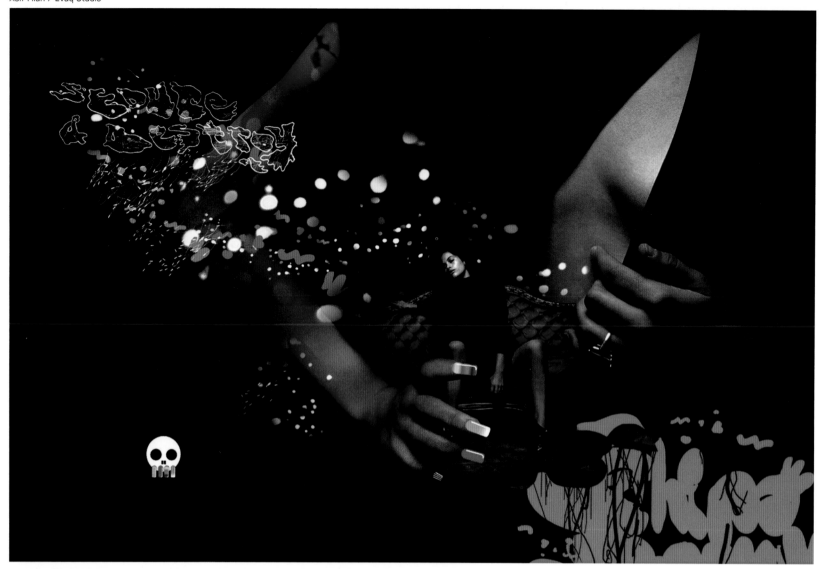

FEATURING MOONSTARR REMIX

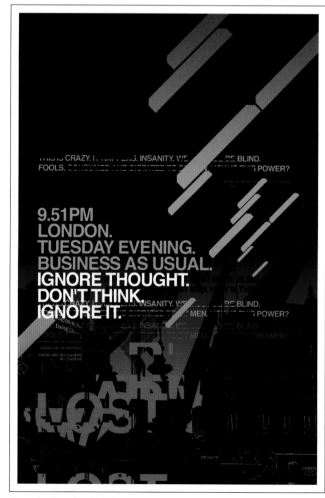

9.51PM
LONDON.
TUESDAY EVENING.
BUSINESS AS USUAL.
IGNORE THOUGHT.
DON'T THINK.
IGNORE IT.

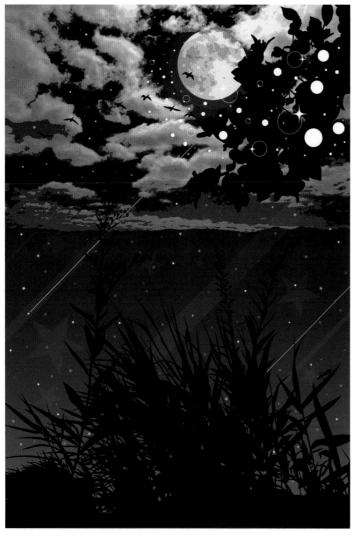
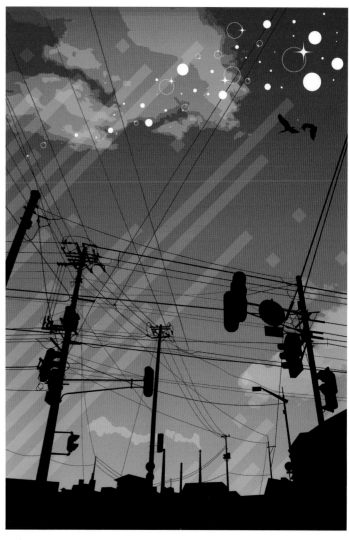
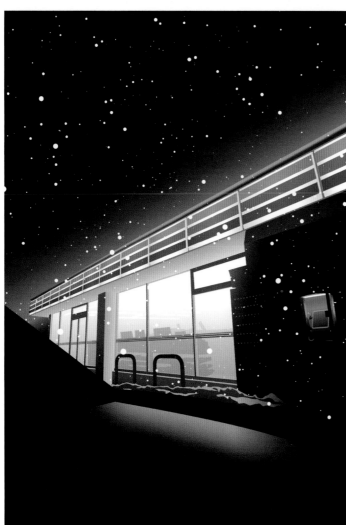

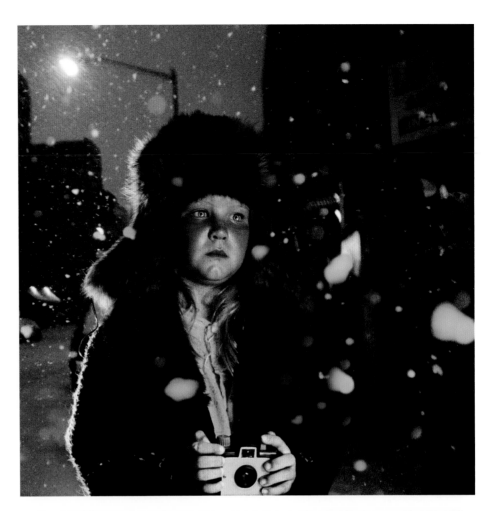

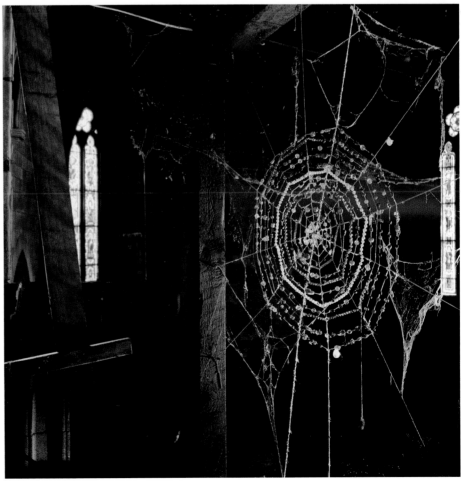

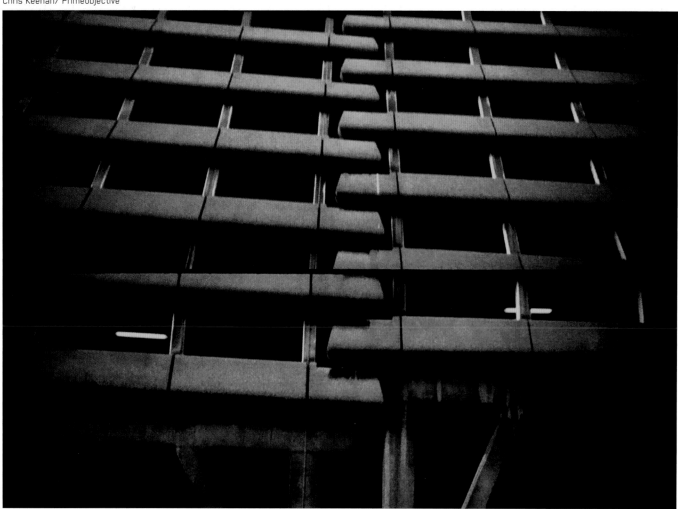

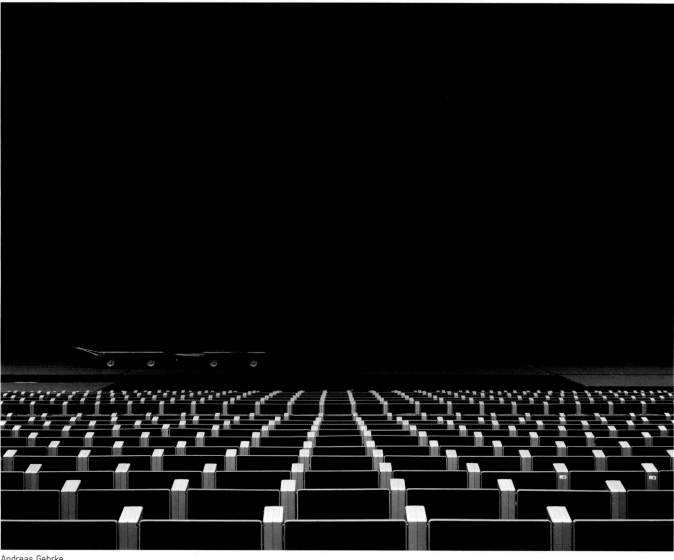

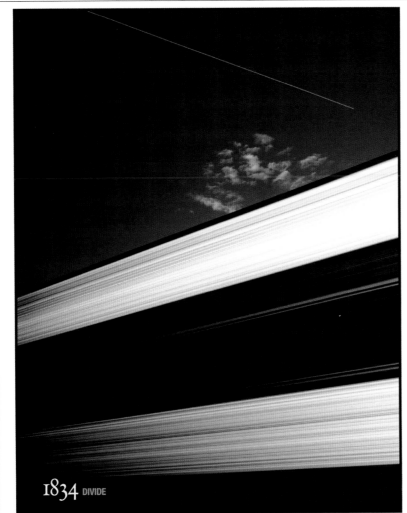

002

blackout
design by pep karsten (nice, france)

communication
info@nineaem.com

exploration
http://www.nineaem.com
http://photo.nineaem.com
http://www.alkaa.com

NINEAEM
www.nineaem.com

1834 DIVIDE

2001 OCT 24

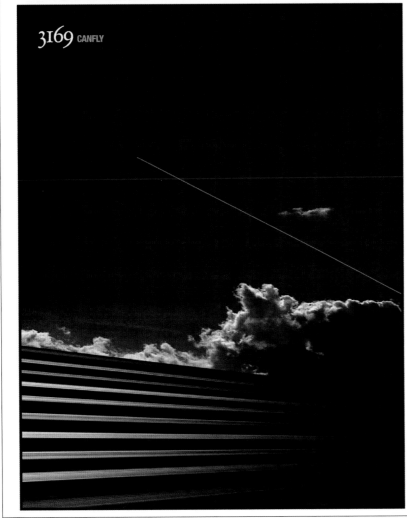

3169 CANFLY

002

blackout
design by pep karsten (nice, france)

communication
info@nineaem.com

exploration
http://www.nineaem.com
http://photo.nineaem.com
http://www.alkaa.com

NINEAEM
www.nineaem.com

2001 OCT 24

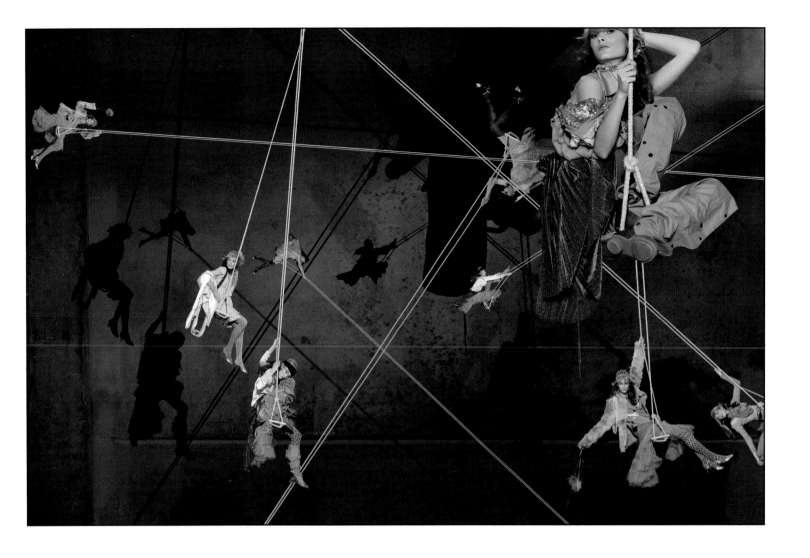

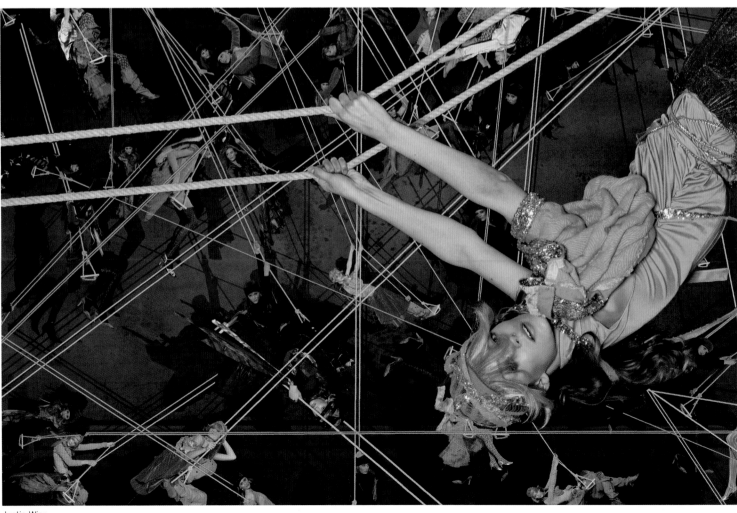

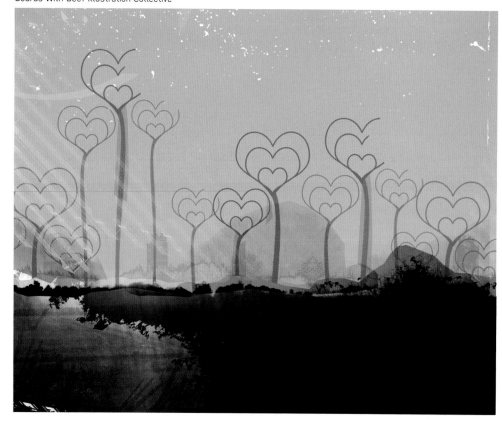

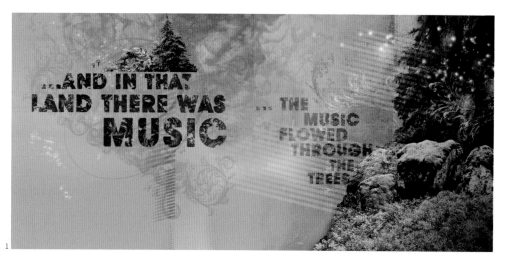

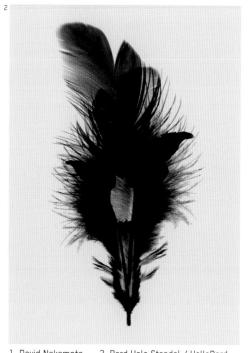

Mario Sader

Salon cafe galleria "Rooms"

MOODSTOCK

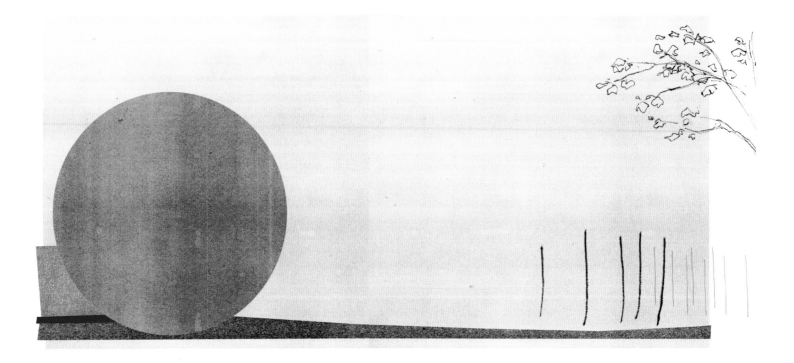

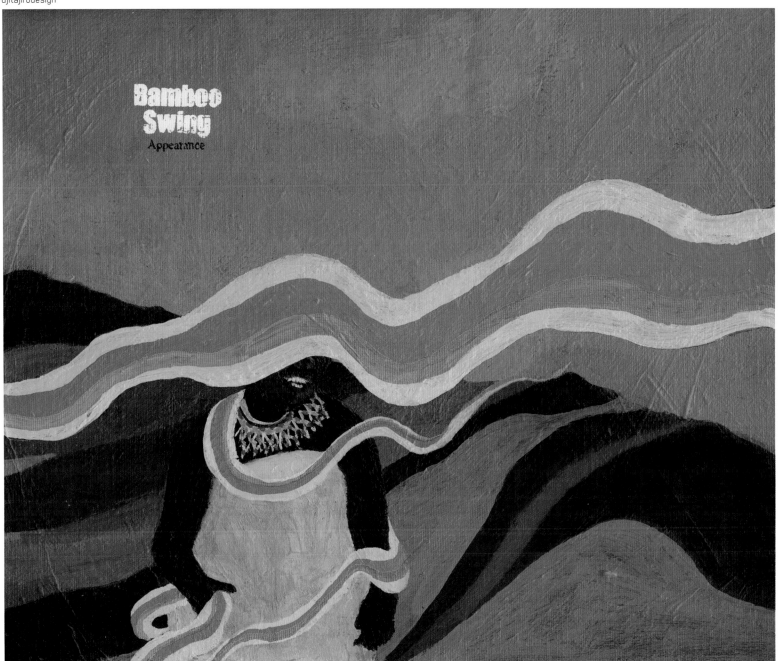

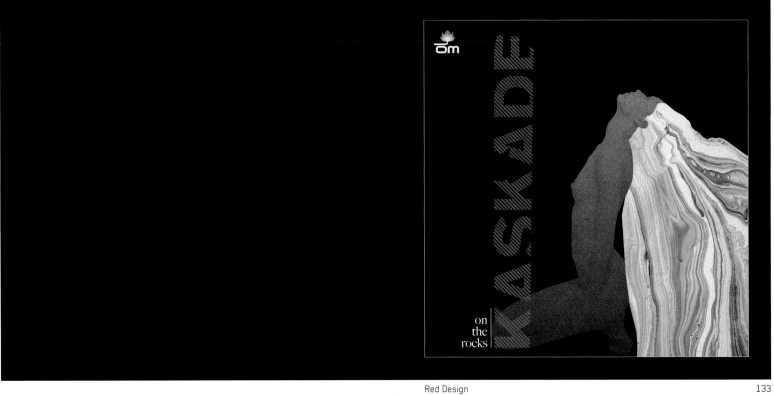

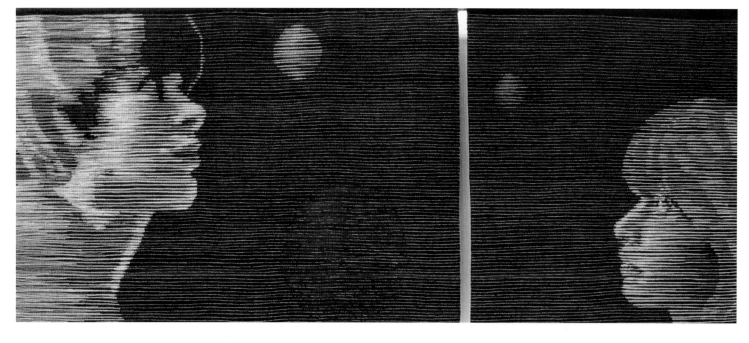

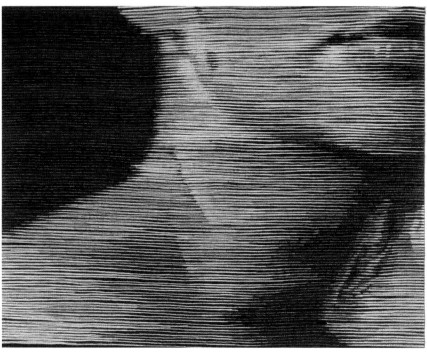

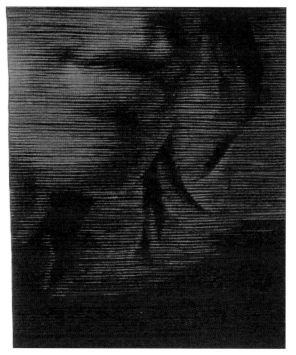

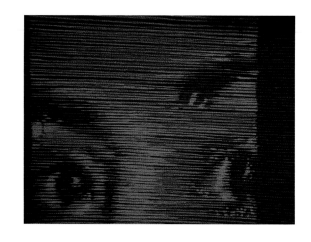

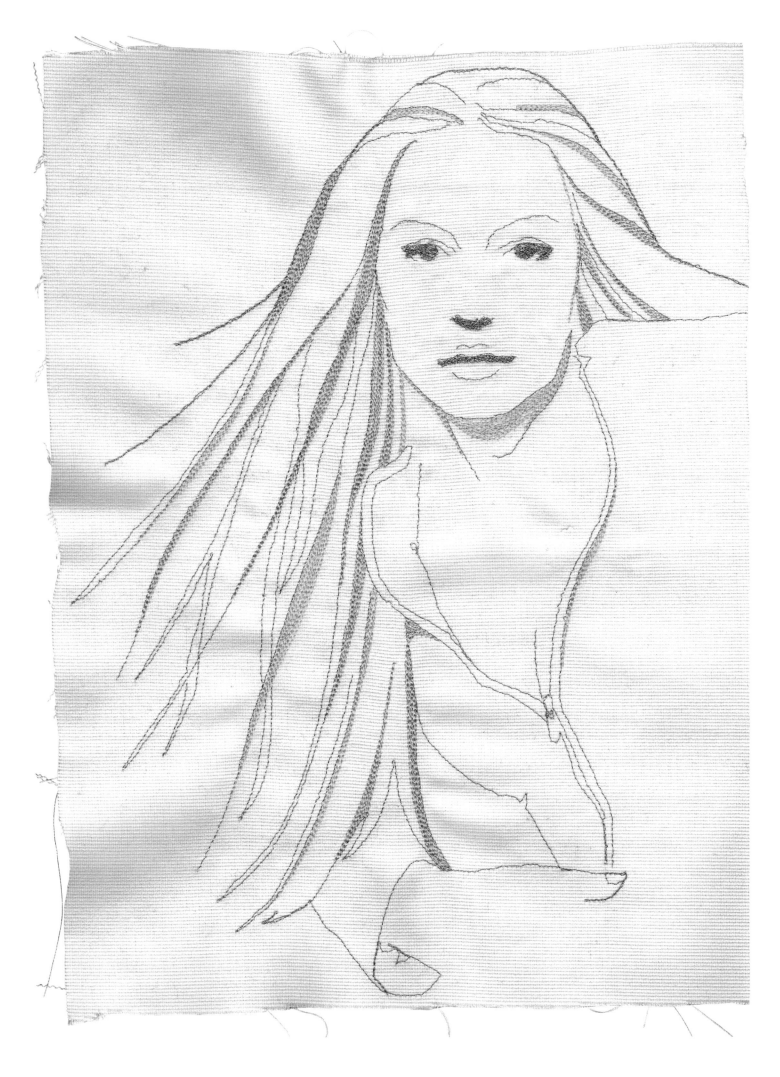

CARVED·FROM·HOLY·WOOD

THE GOOD WOOD GANG

— by —

Friends with You

Unluck your Luck Today

Divination Amulet

From the Black Forest comes a new type of lucky amulet.
A wooden charm thats history dates back to the ancient children Gods, and the toys that delighted them.
They can bring magic and mystery into your life. If you treat them with respect they might grant all your wishes, they work
different for every person, and they all have a specialty power. Black Foot a.k.a. Captain Bingo opens and closes all doors.
Sweet Tooth brings you success and surprises. Lucky Doovoo can answer all your problems, love, health, distress. Squid Racer,
a triple team of power, all united to help you achieve your goals. And the rare Mr. TTT Burger will satisfy all your indulgences
and help you to a delicious existence while showing you the key to immortality.

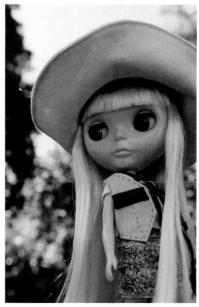

Brian Quinlan / Bufalo Club

Anni Fittkau / Crashcarcity

Jake Steel

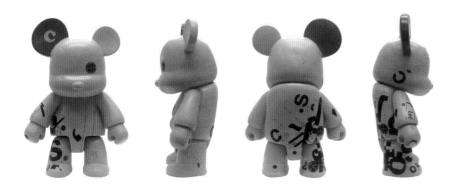

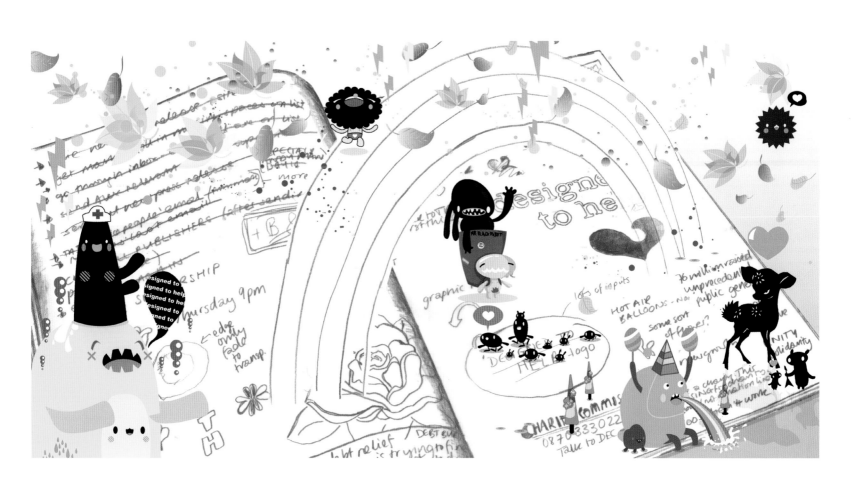

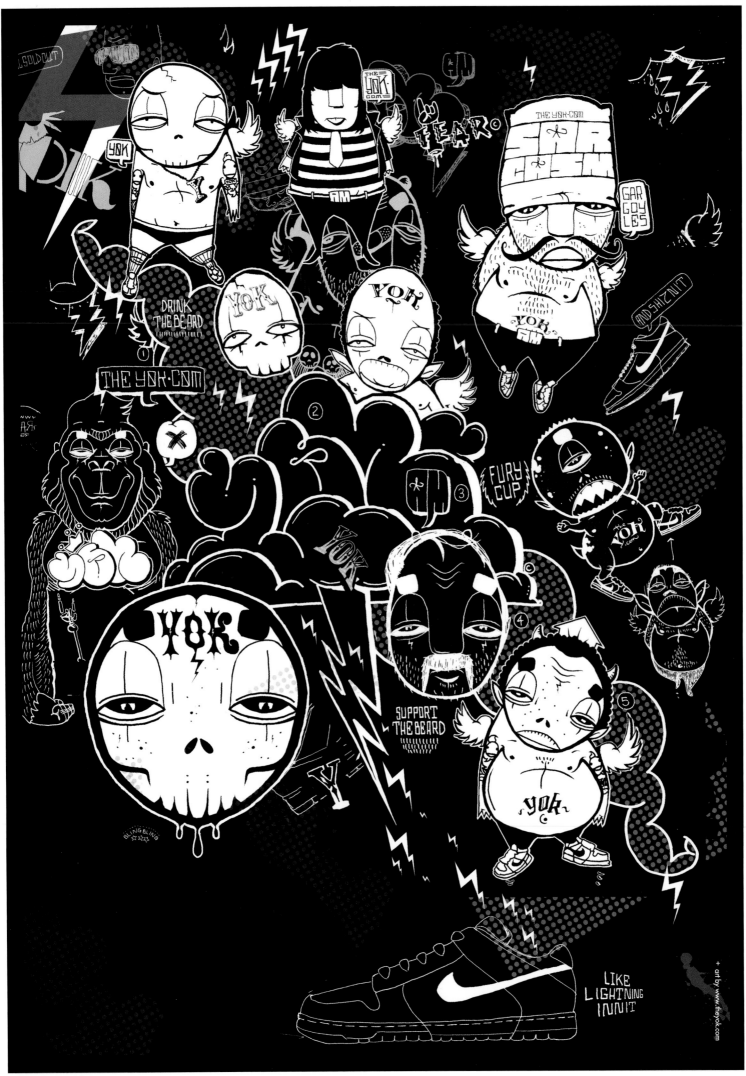

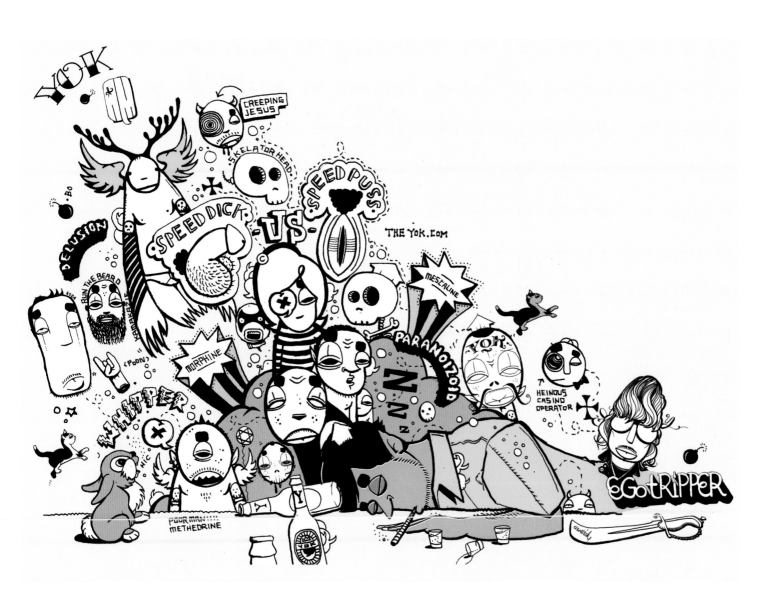

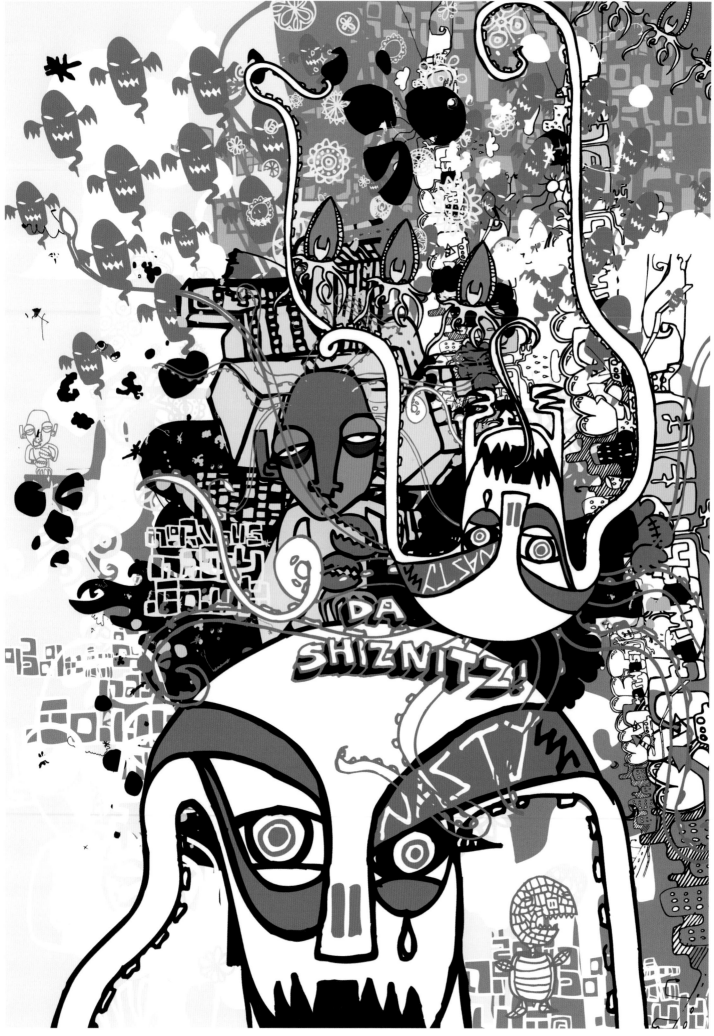

no. ◯/120

www.a-sidestudio.co.uk

Ross Imms / A-Side Studio

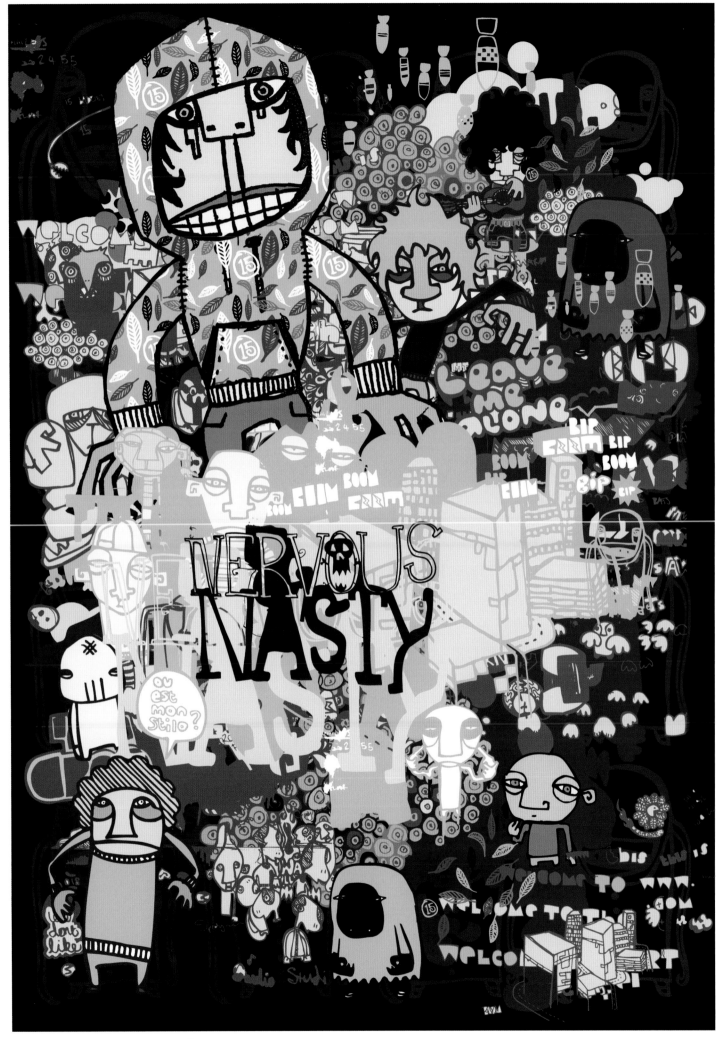

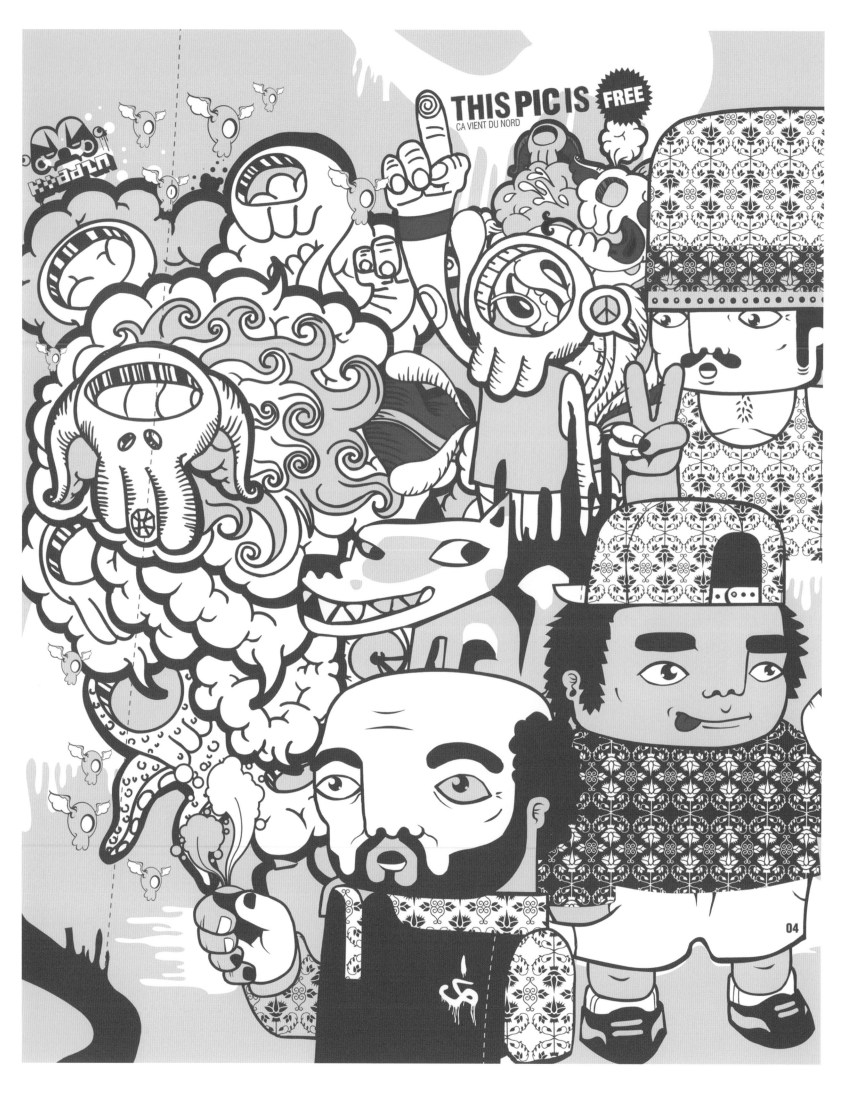

THIS PIC IS FREE
CA VIENT DU NORD

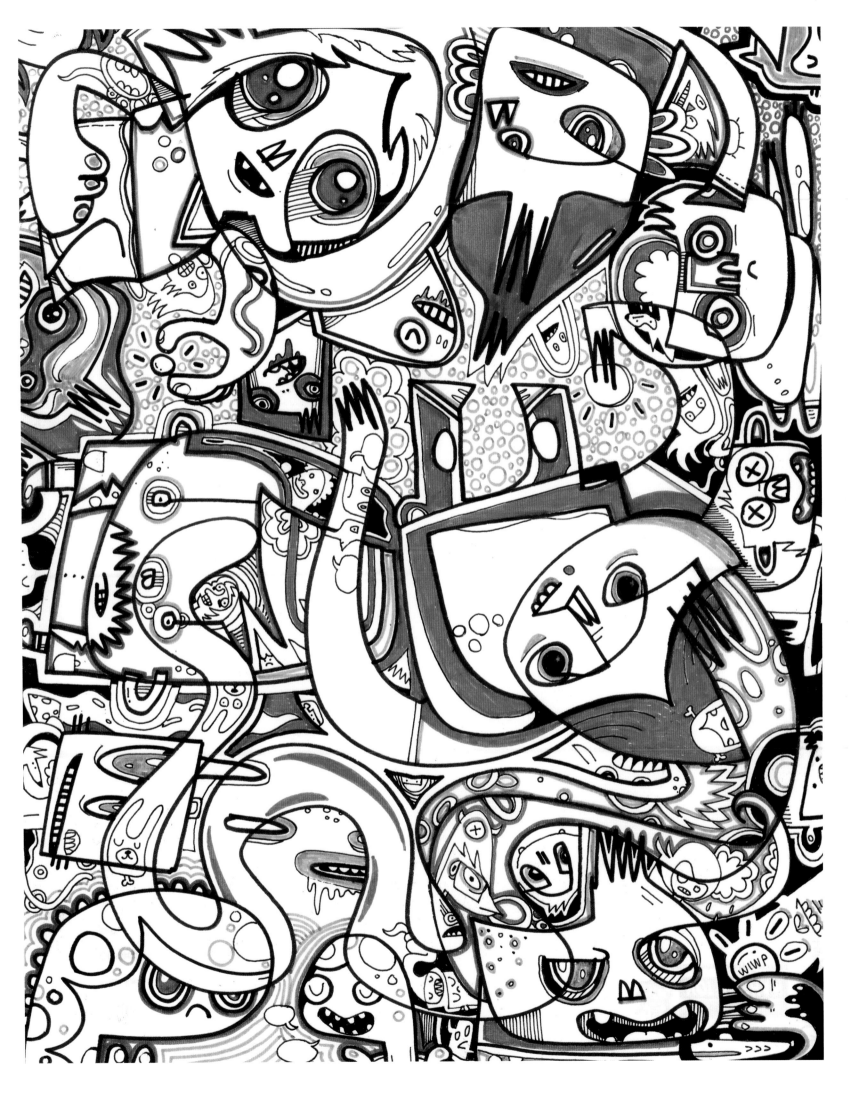

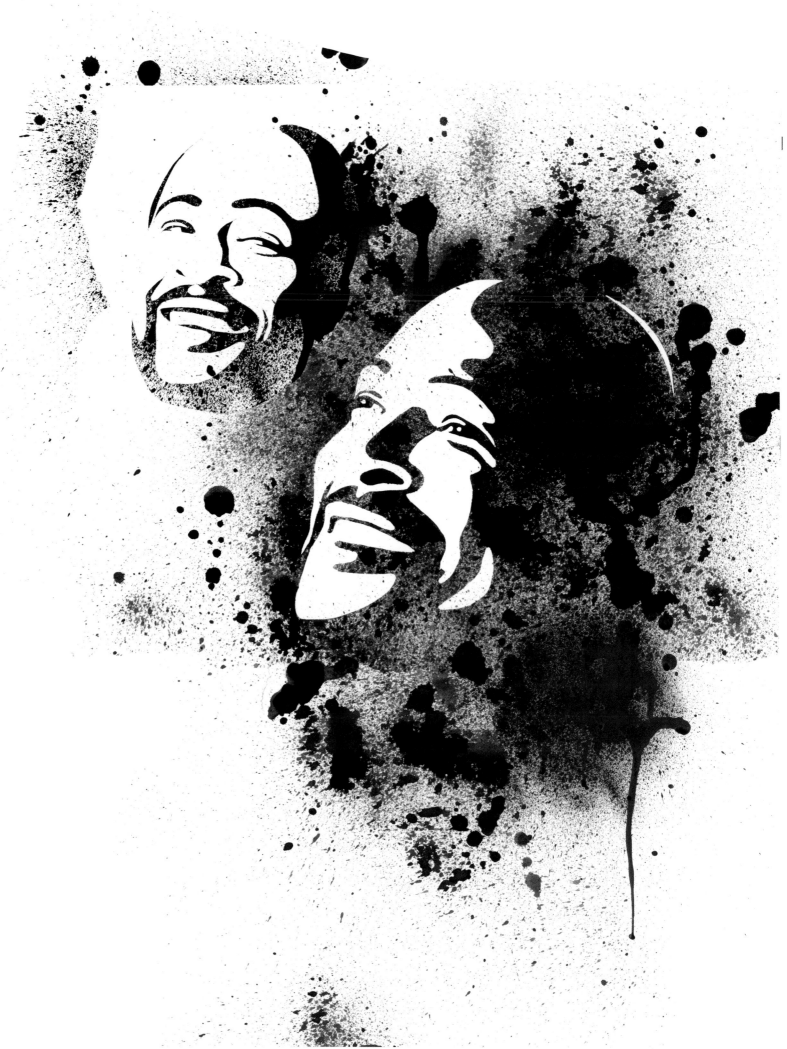

Reto Ehrbar / Raffinerie

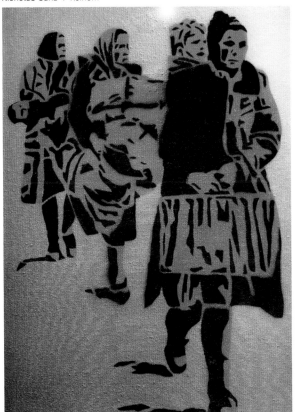

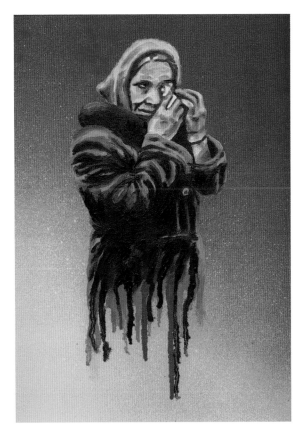

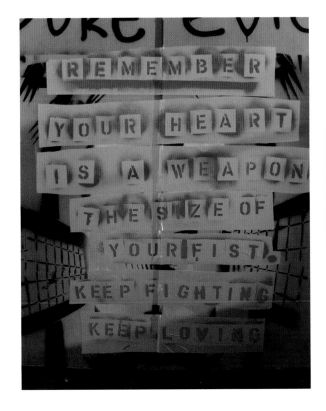

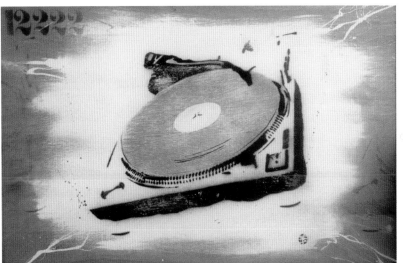

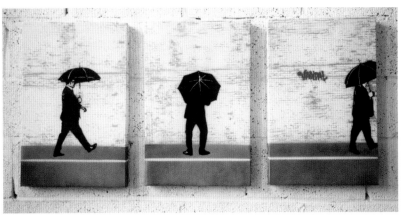

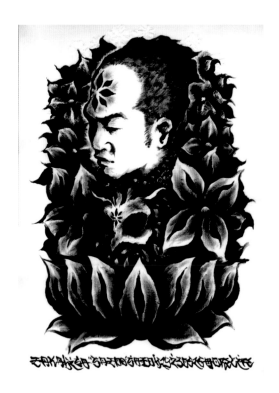

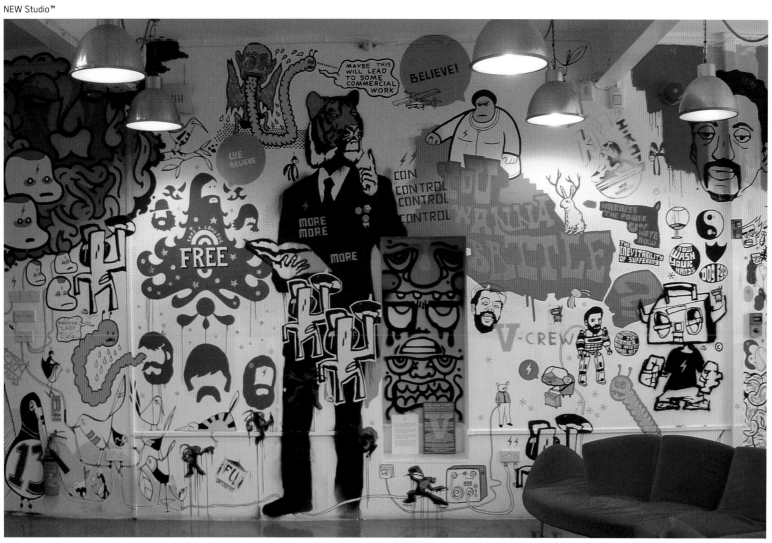

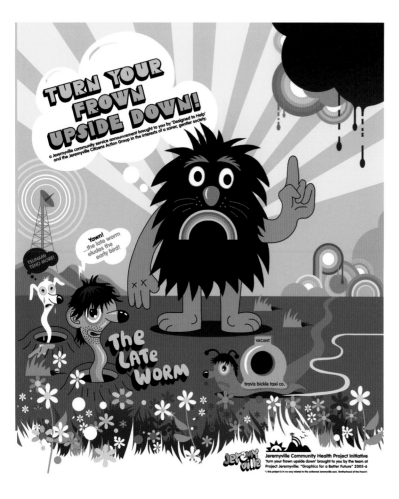

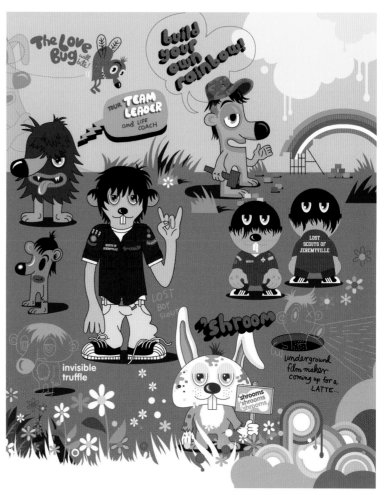

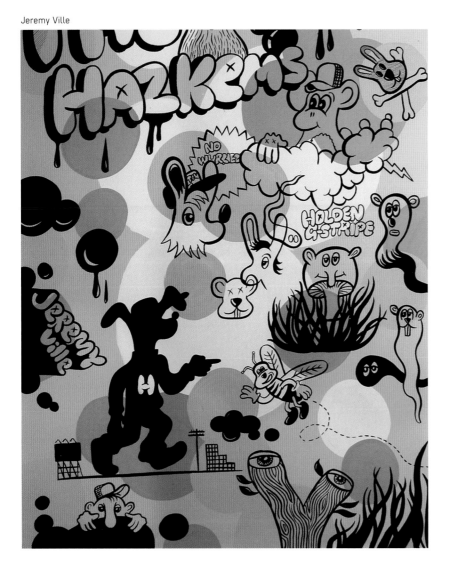

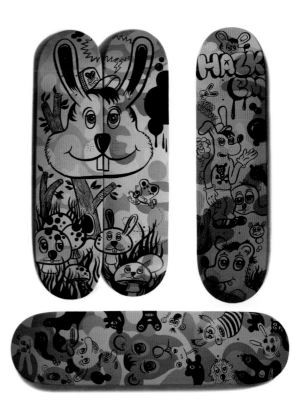

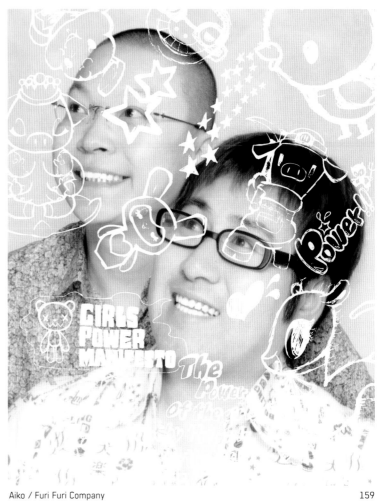

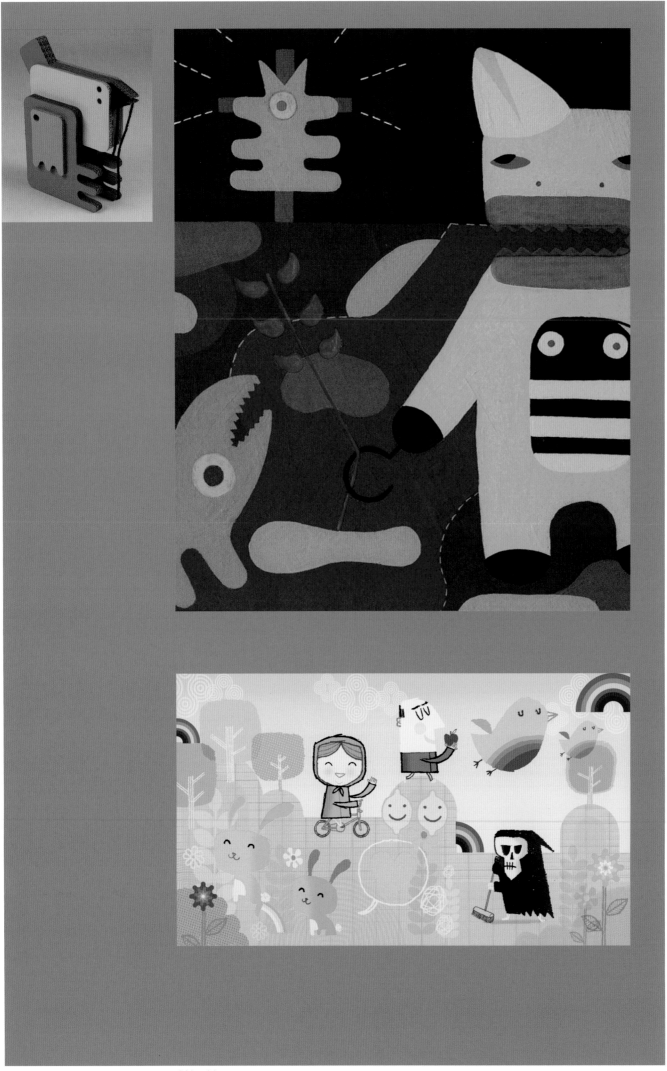

SOCIAL ALGEBRA

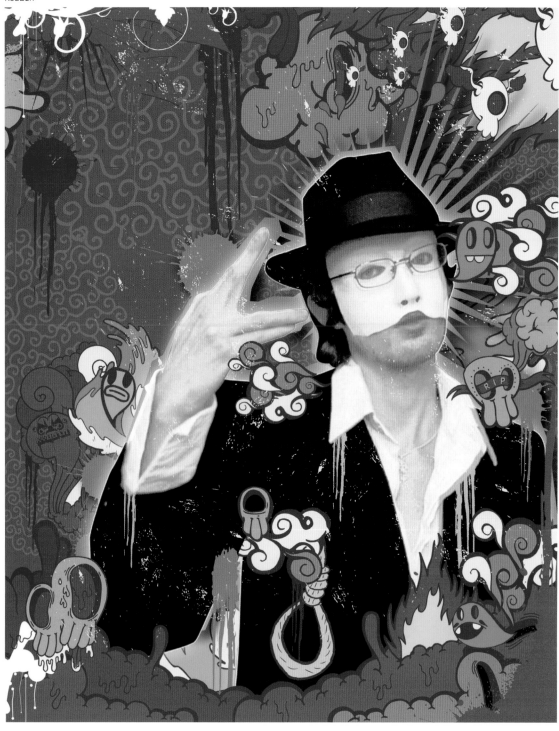

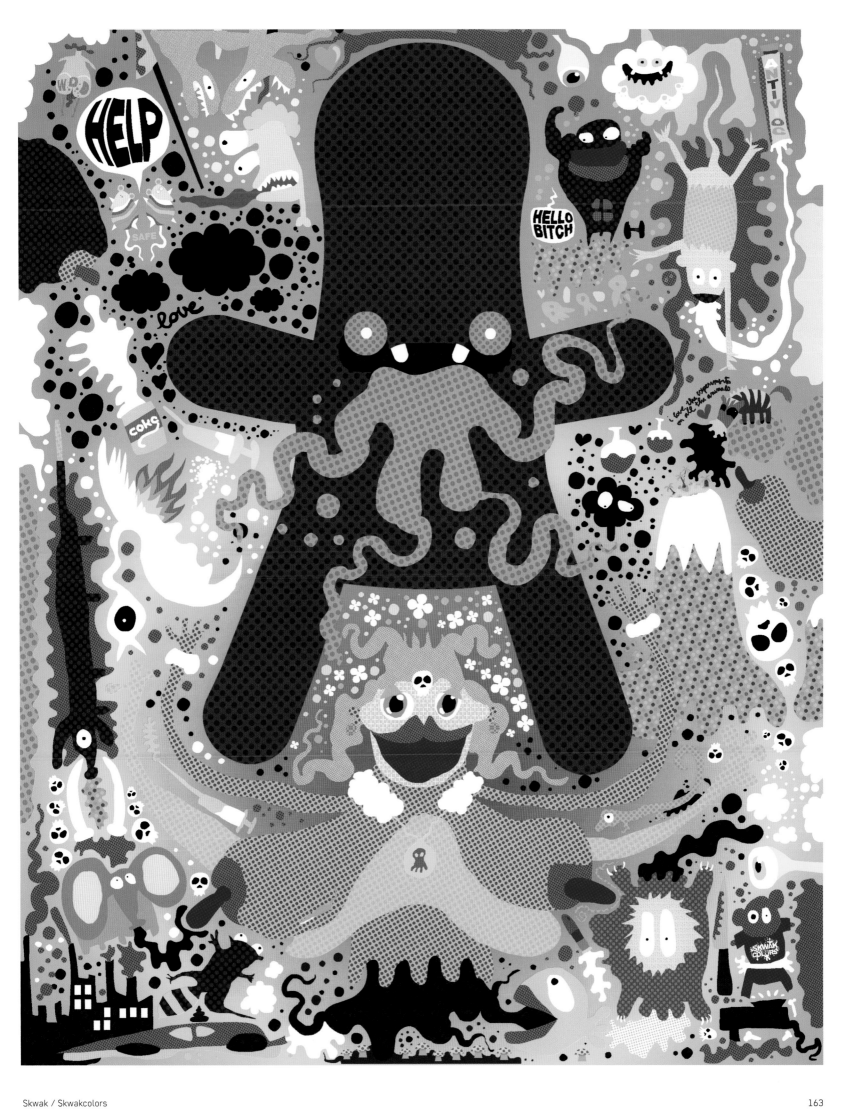

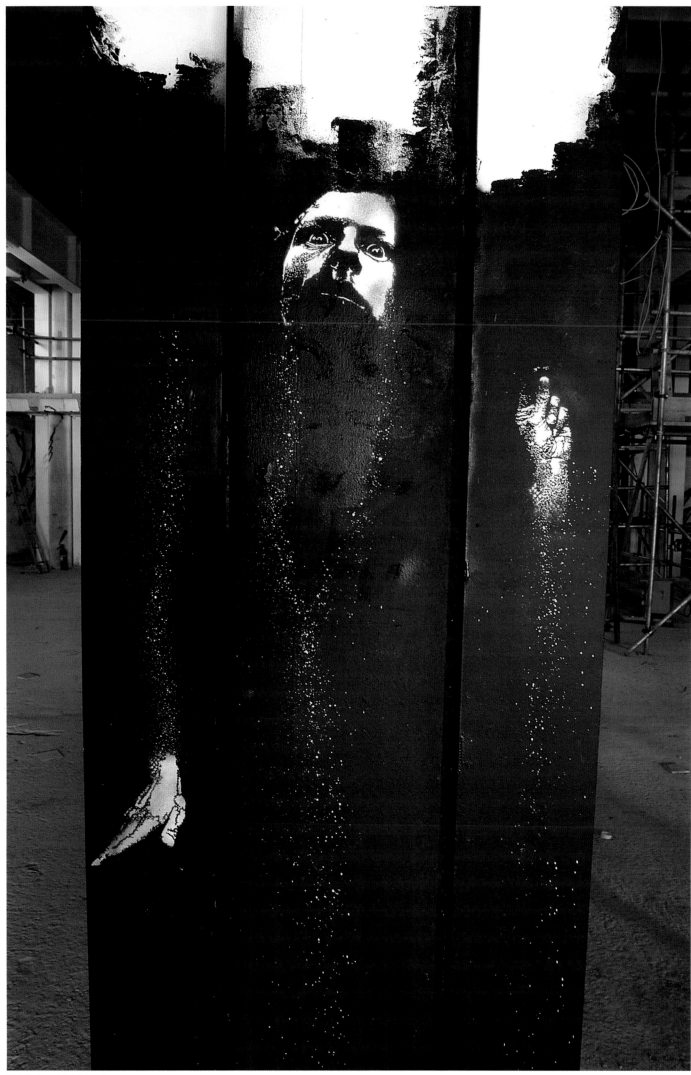

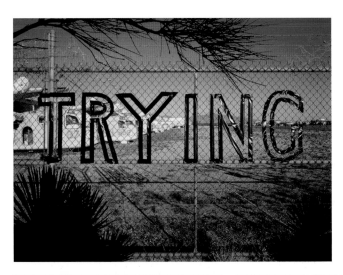
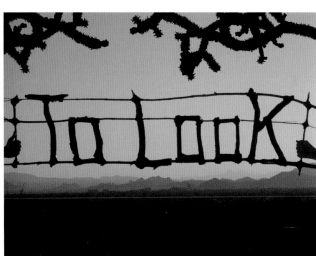

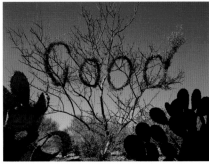
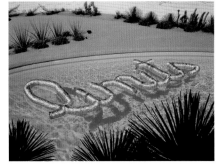
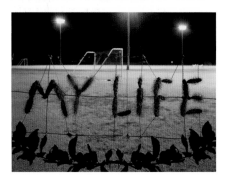

And night . . . fell.

It was a beautiful day in the town of Obalia and the folks were losing their minds.

The sun had burned for three years solid. And in this town, if it was daylight you had to go to work. There used to be a party every night on every street. But night had gone and life had turned to dust.

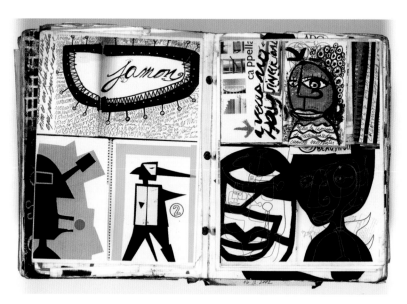

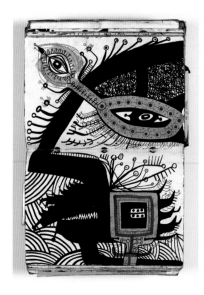

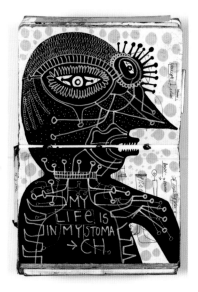

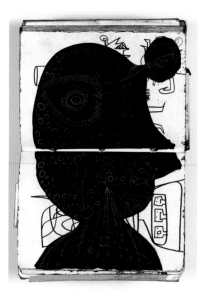

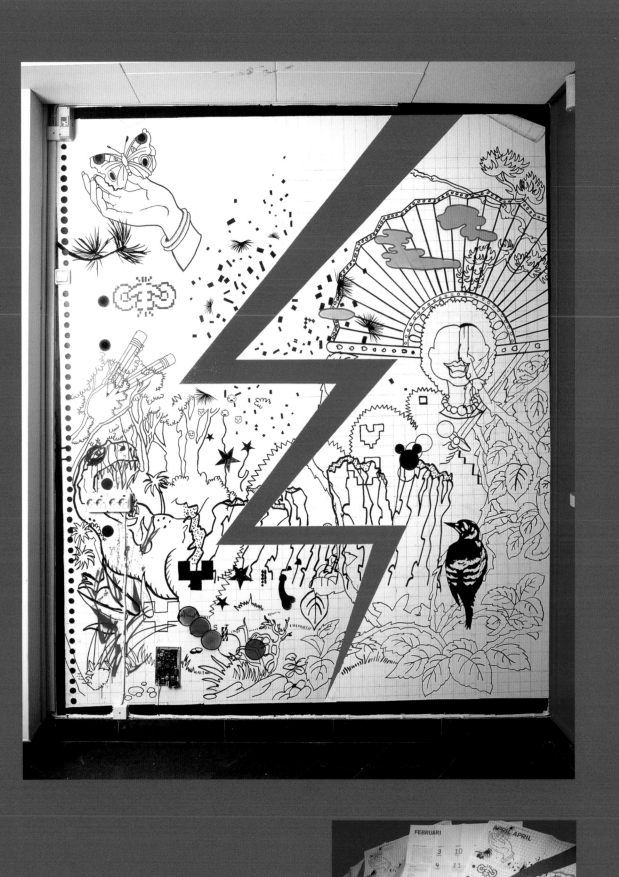

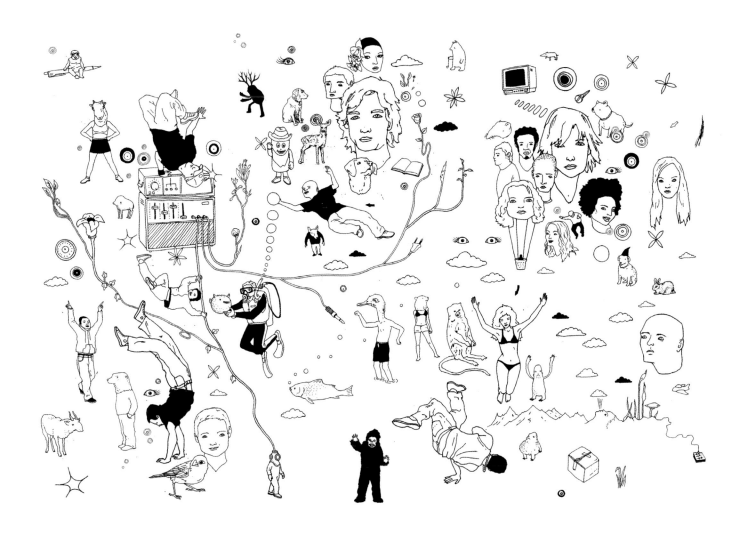

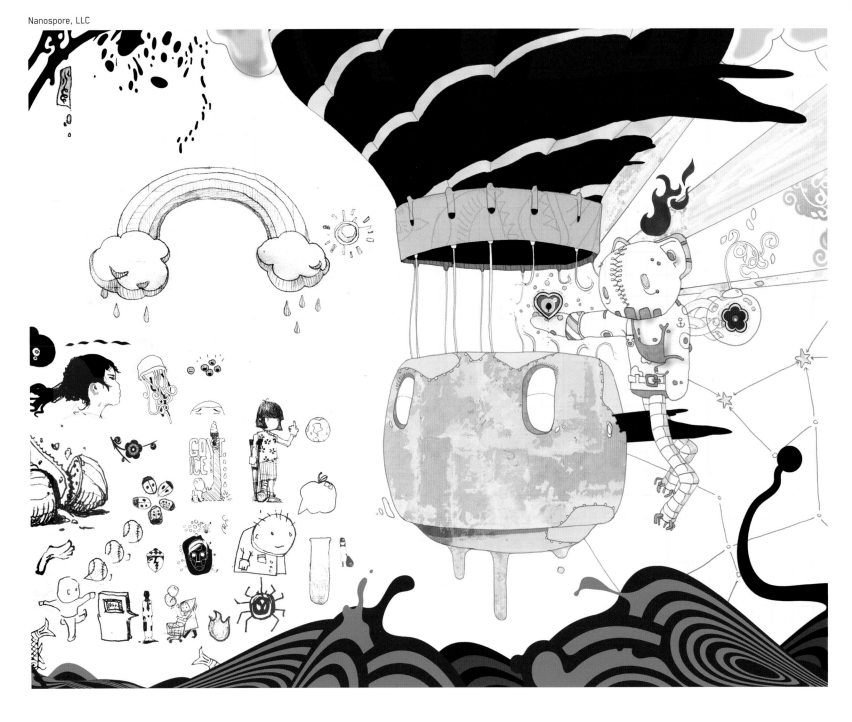

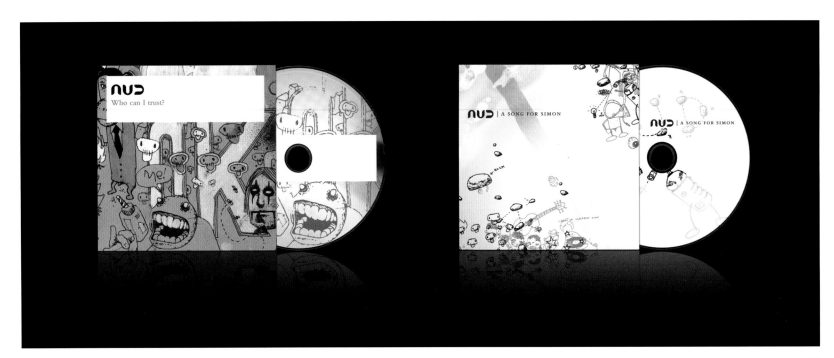

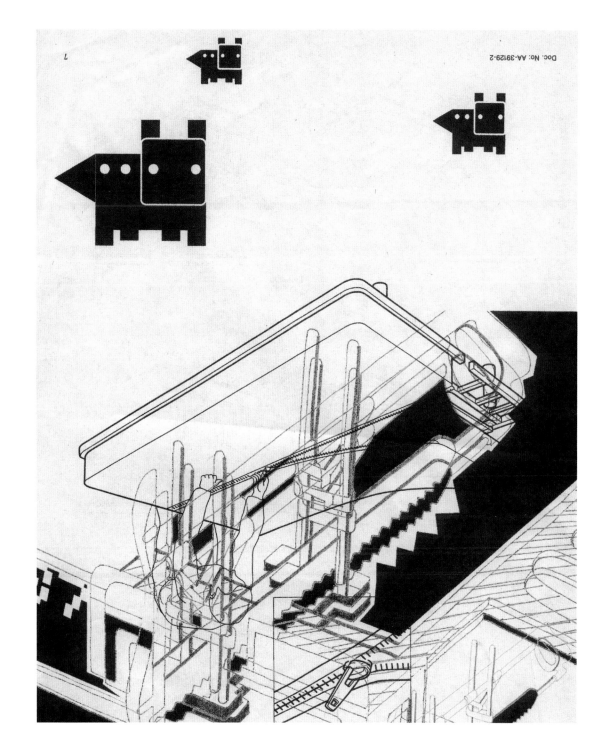

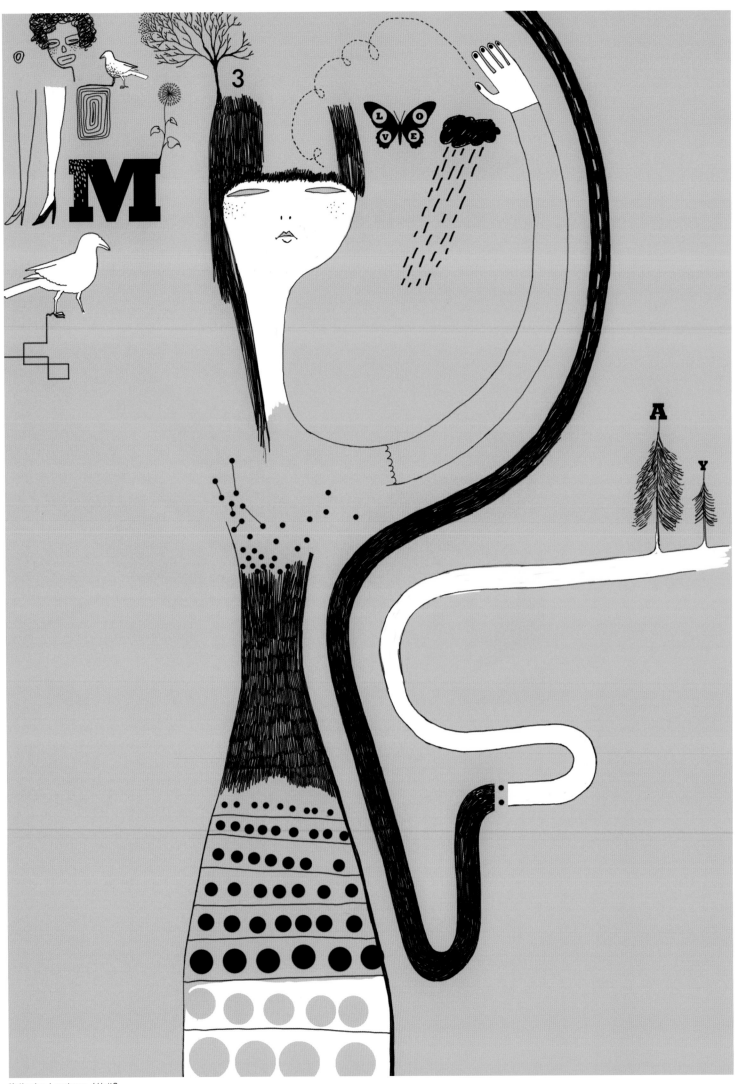

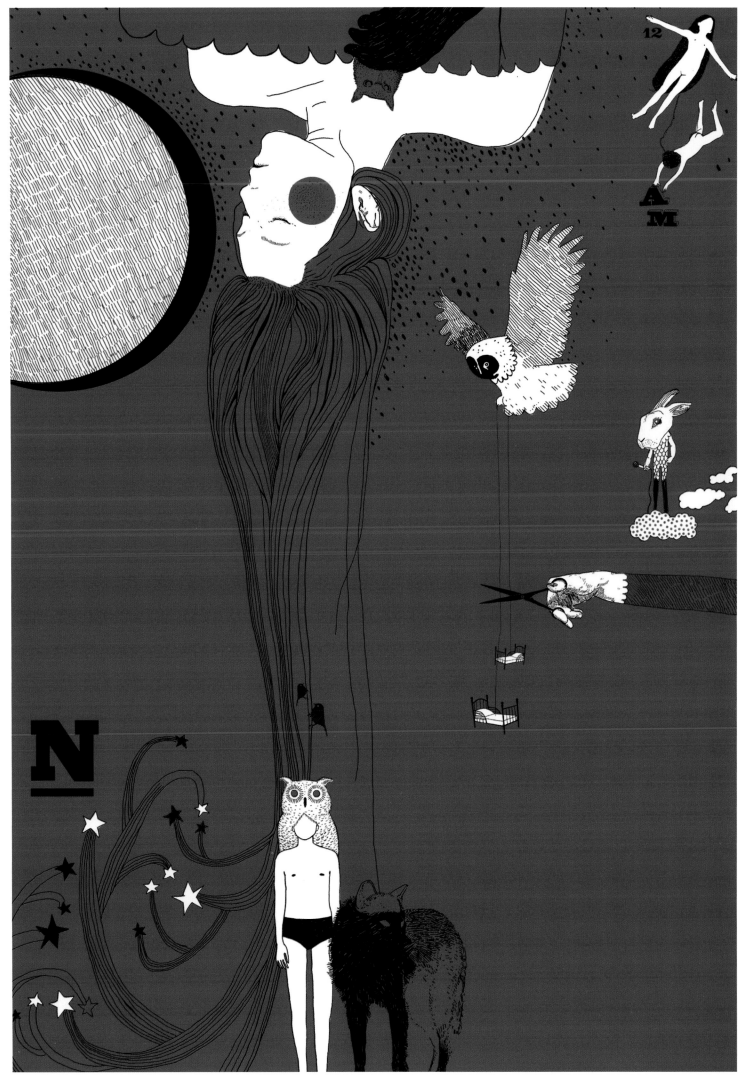

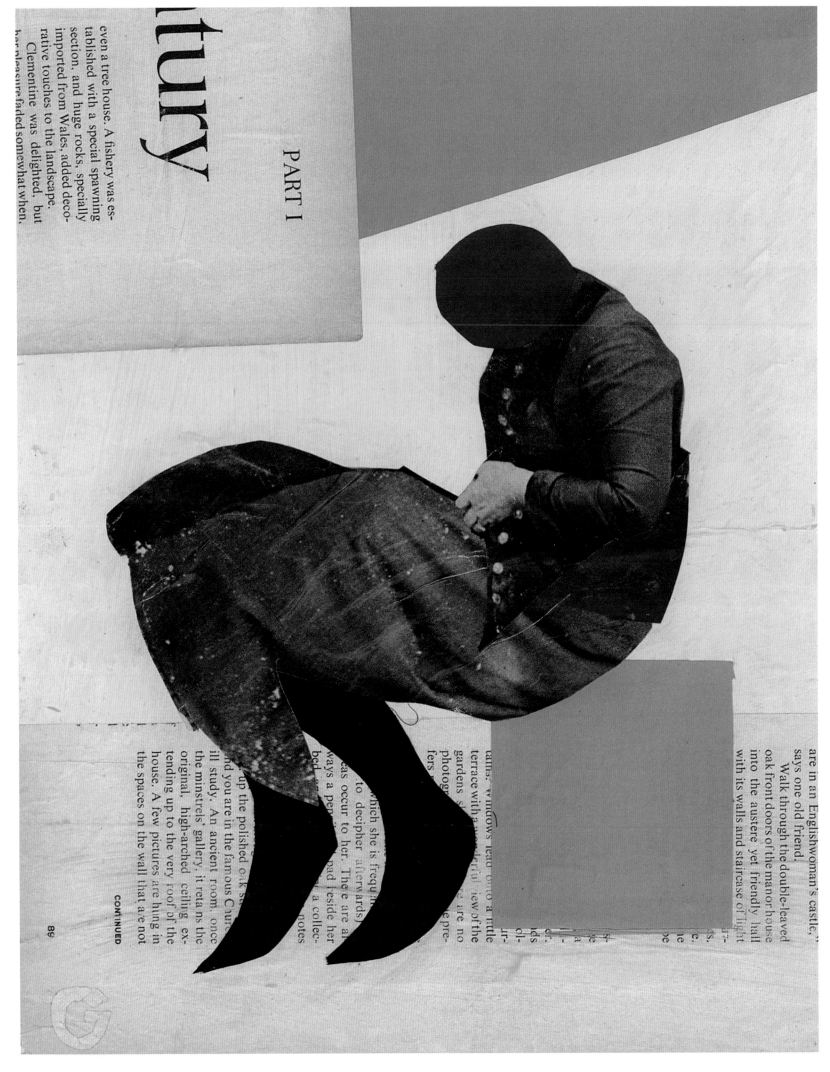

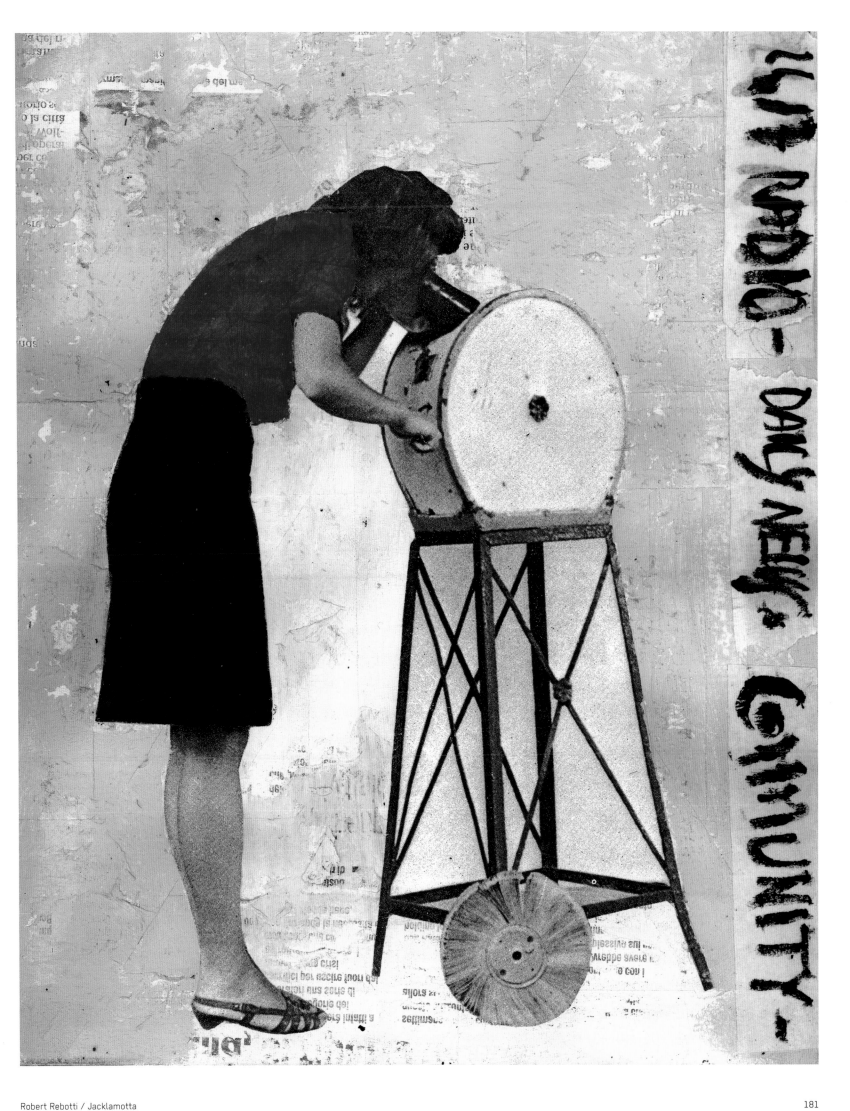

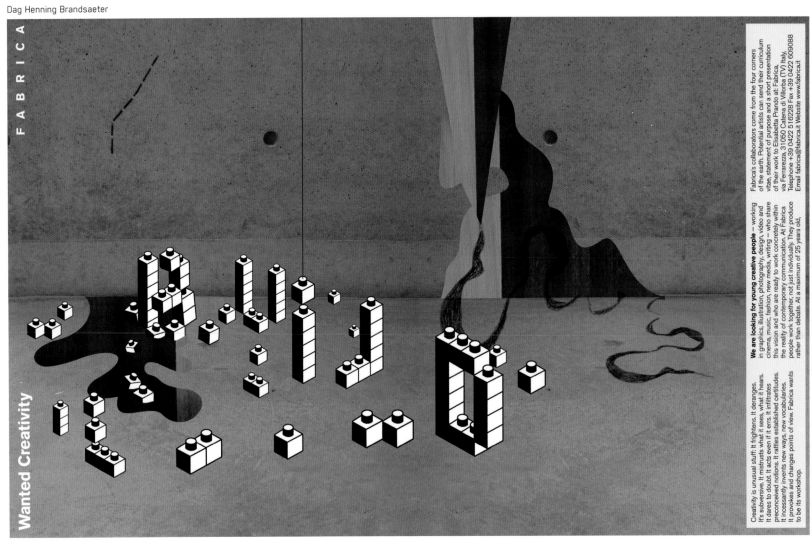

F A B R I C A

Wanted Creativity

Creativity is unusual stuff. It frightens. It deranges. It's subversive. It mistrusts what it sees, what it hears. It dares to doubt. It acts even if it errs. It infiltrates preconceived notions. It rattles established certitudes. It incessantly invents new ways, new vocabularies. It provokes and changes points of view. Fabrica wants to be its workshop.

We are looking for young creative people — working in graphics, illustration, photography, design, video and cinema, music, fashion, new media, writing — who share this vision and who are ready to work concretely within the reality of contemporary communication. At Fabrica people work together, not just individually. They produce rather than debate. At a maximum of 25 years old,

Fabrica's collaborators come from the four corners of the earth. Potential artists can send their curriculum vitae, statement of purpose and a short presentation of their work to Elisabetta Prando at: Fabrica, via Ferrarezza, 31050 Catena di Villorba (TV) Italy, Telephone +39 0422 516228 Fax +39 0422 609088 Email fabrica@fabrica.it Website www.fabrica.it

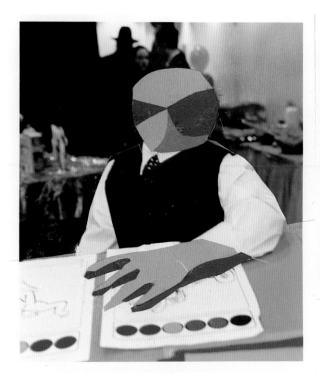
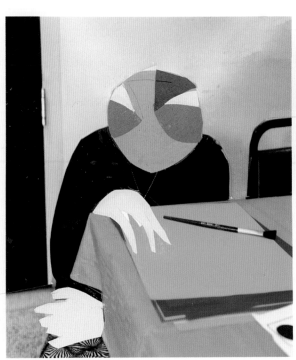

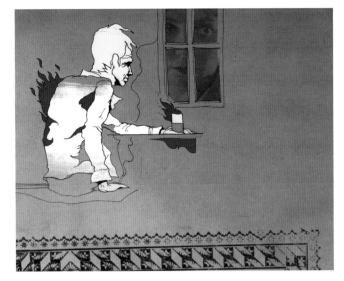

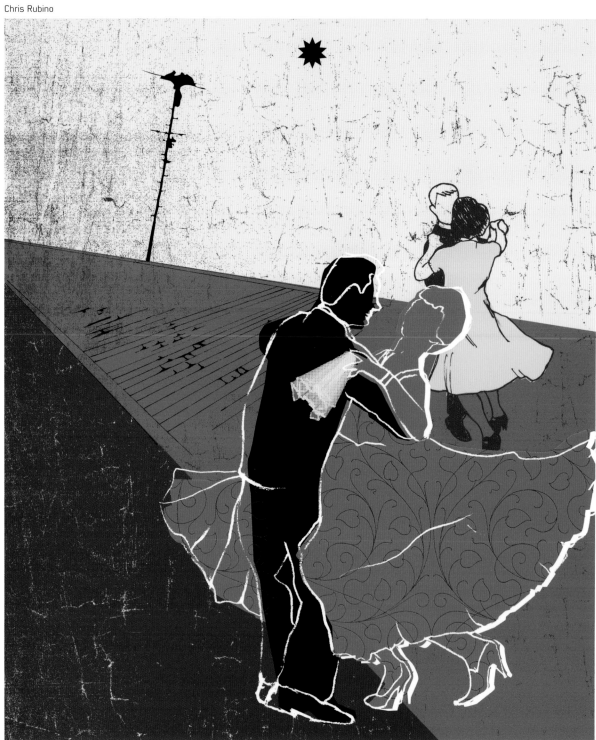

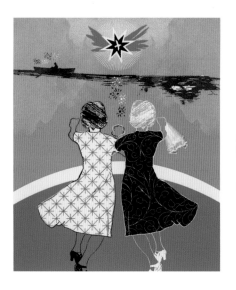

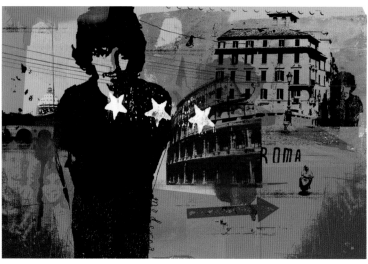

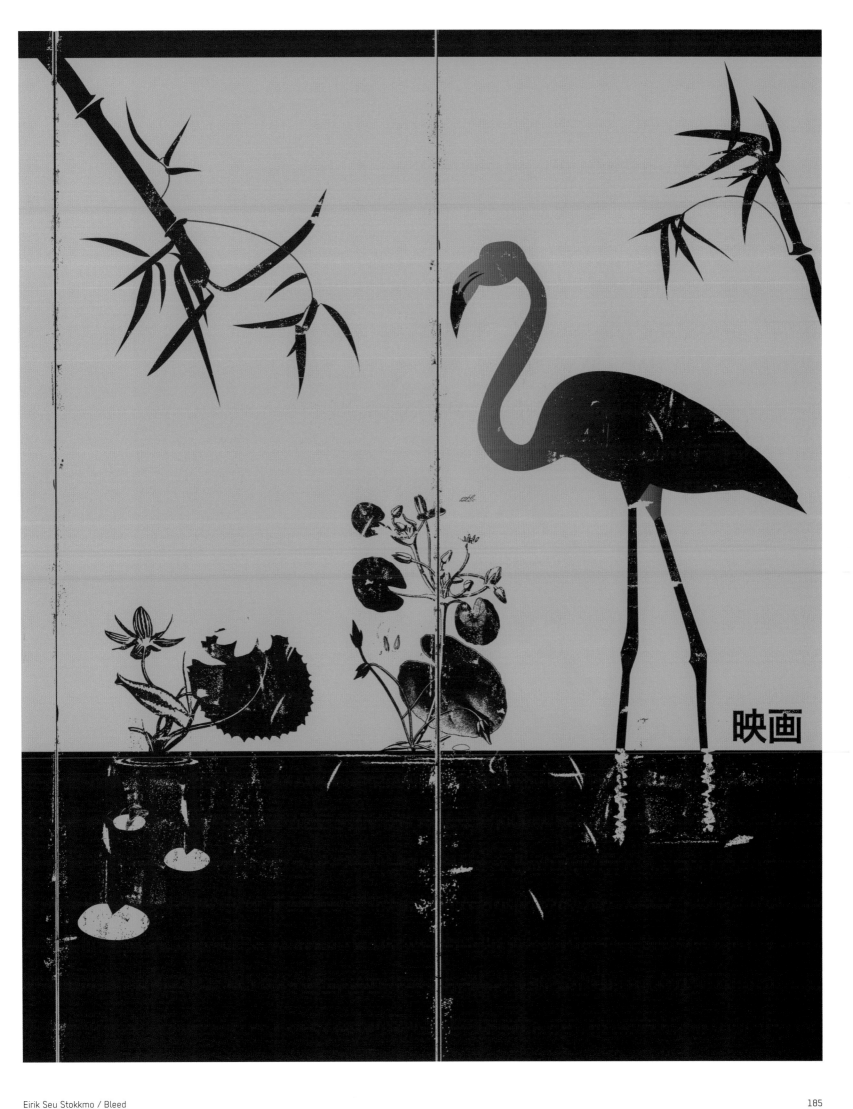

映画

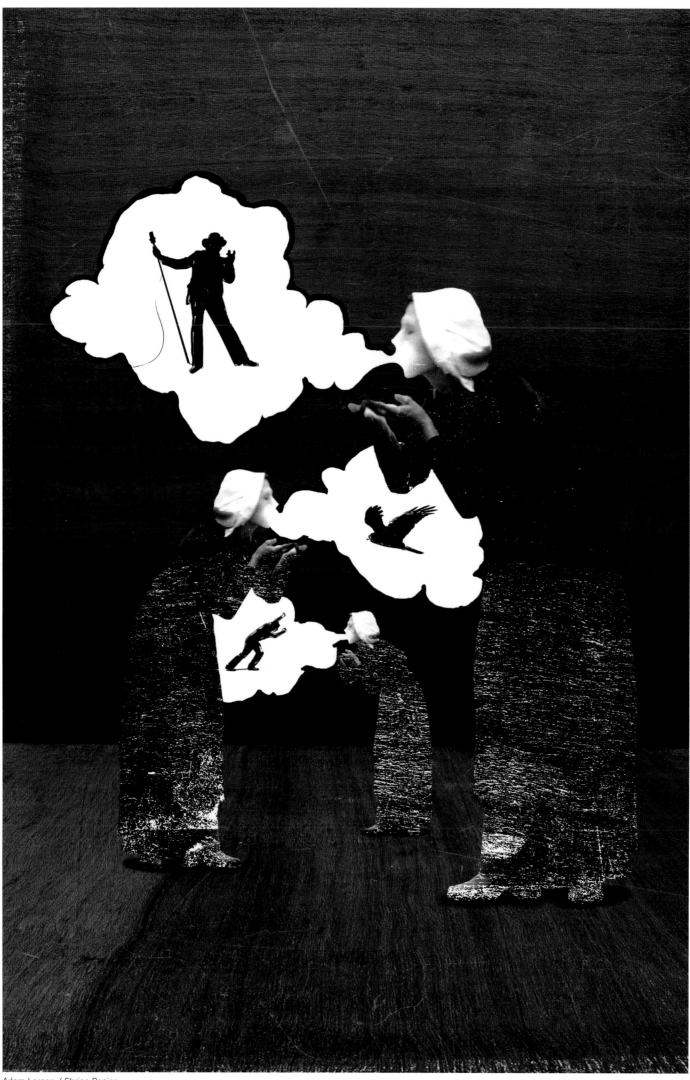

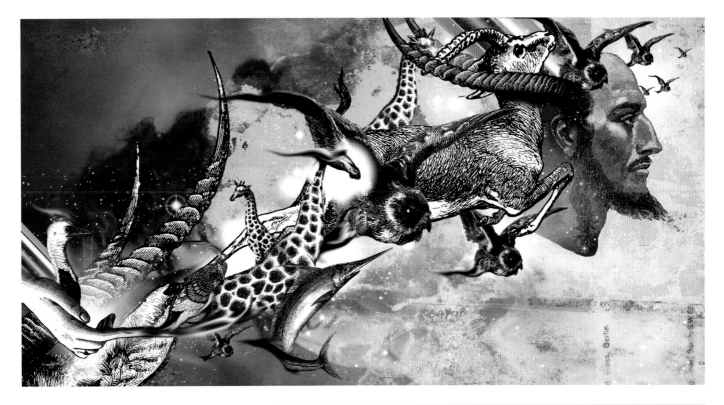

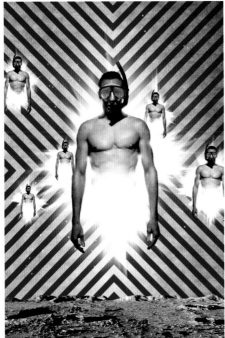

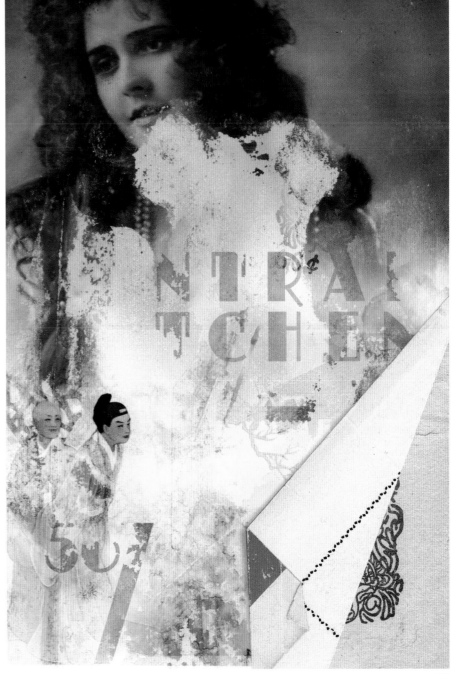

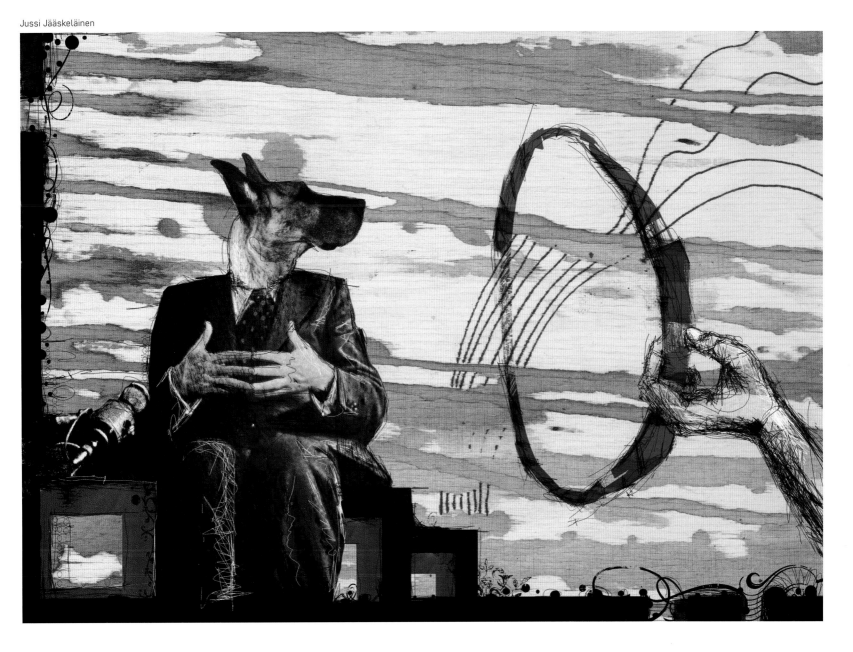

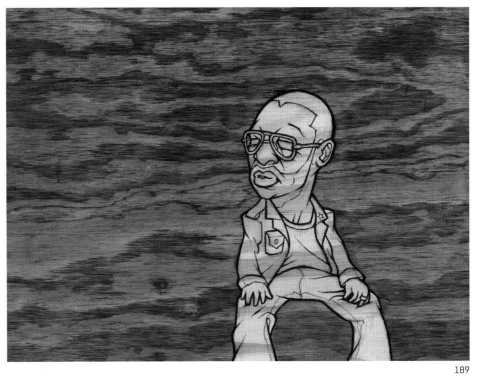

J. Byrnes / Adapt Studio

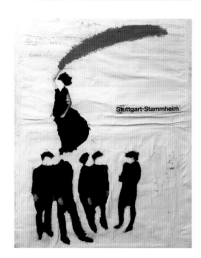

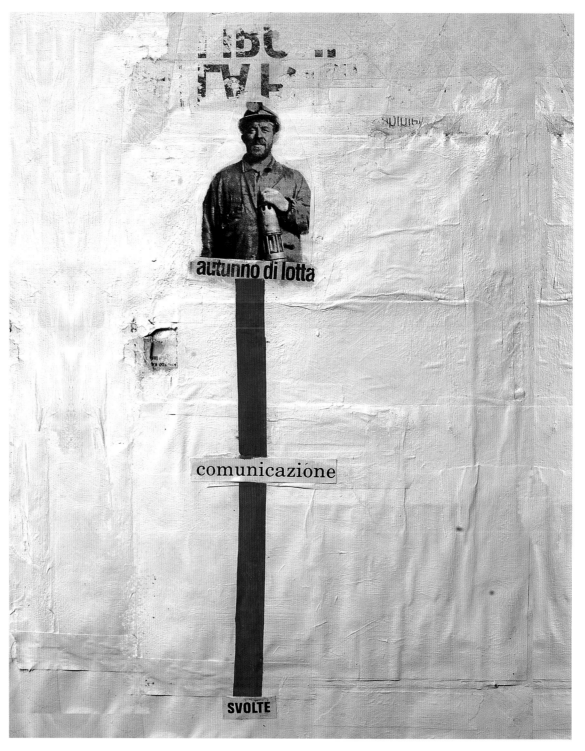

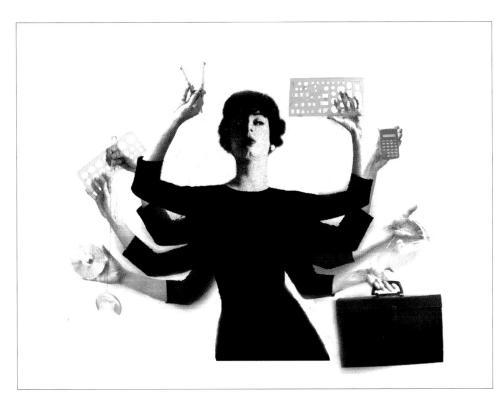

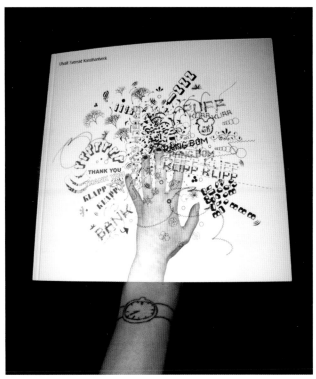

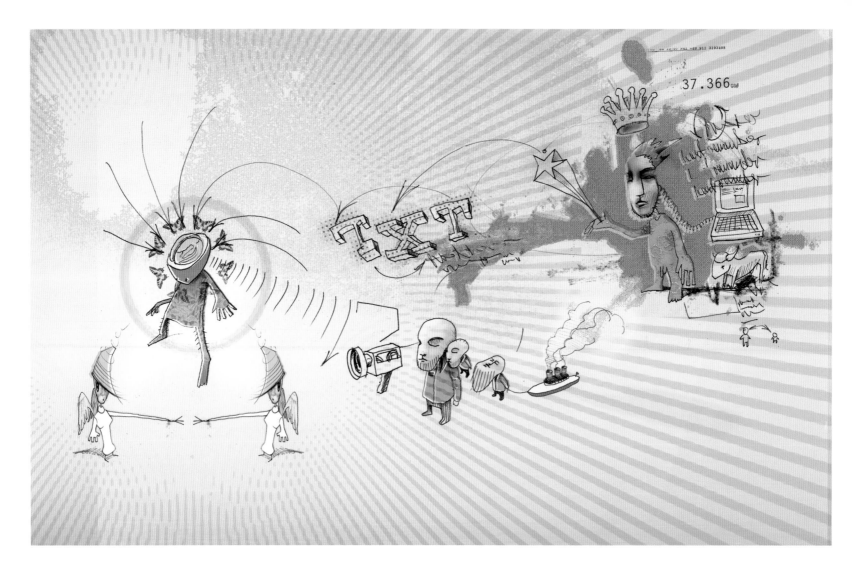

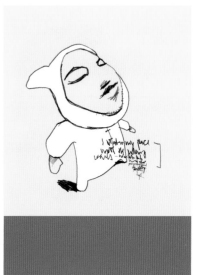

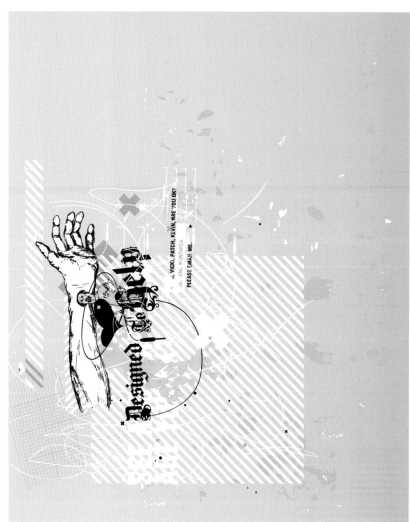

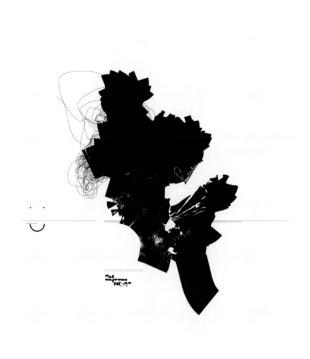

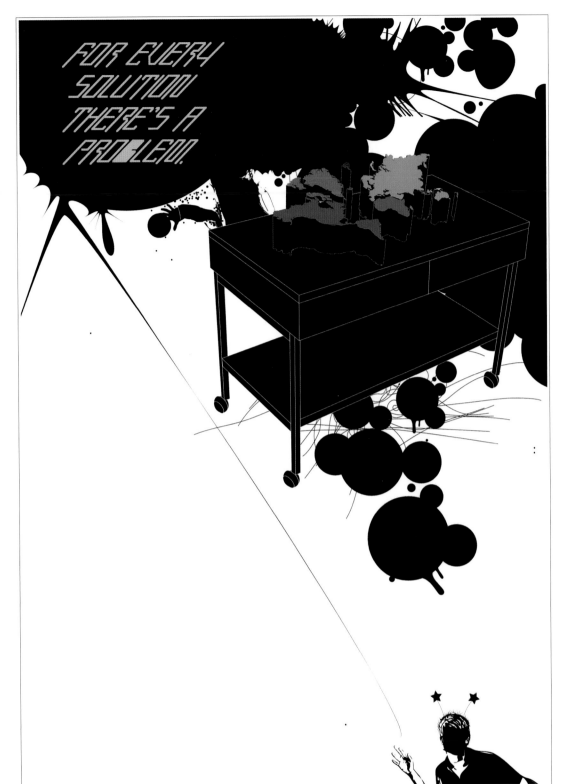

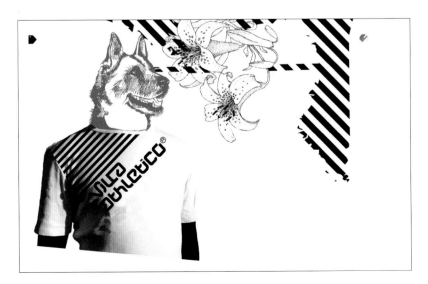
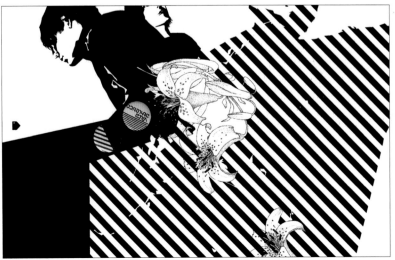

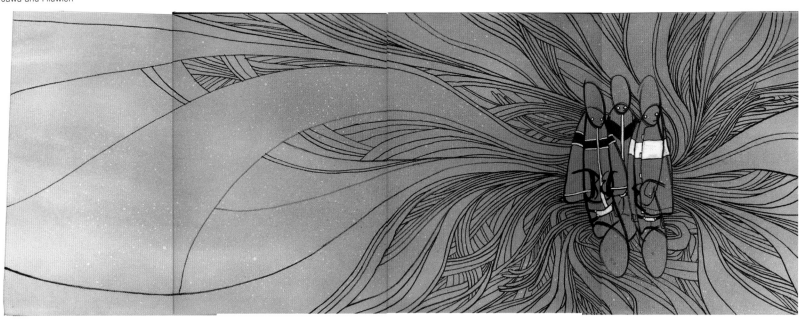

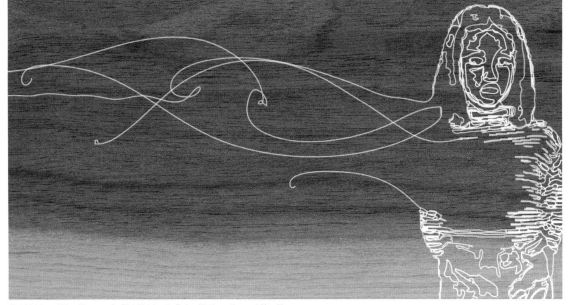

THE ROYAL

SUMMER 2004 / ISSUE 3

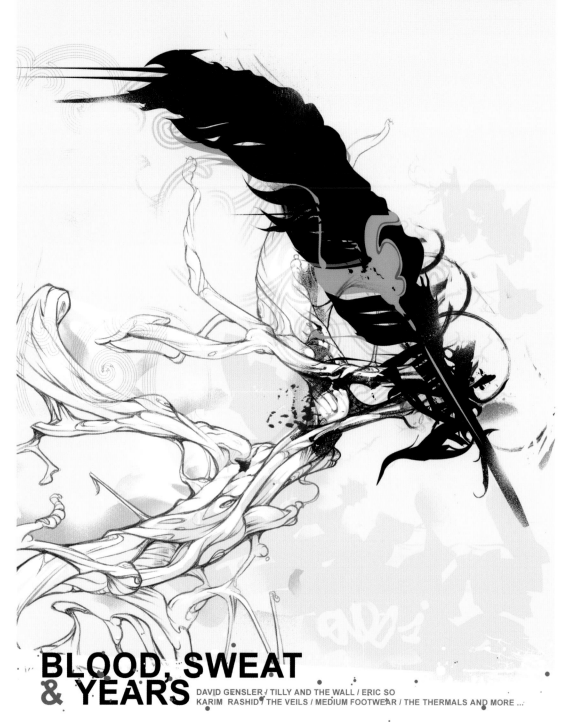

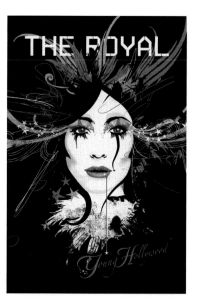

BLOOD, SWEAT
& YEARS

DAVID GENSLER / TILLY AND THE WALL / ERIC SO
KARIM RASHID / THE VEILS / MEDIUM FOOTWEAR / THE THERMALS AND MORE ...

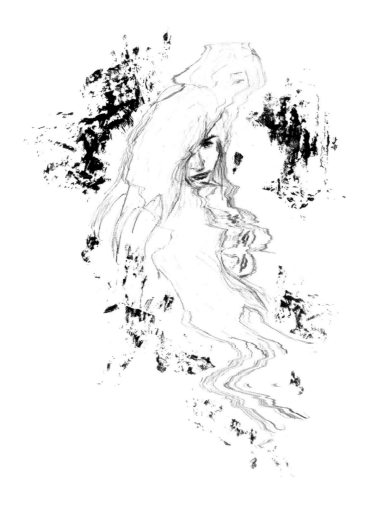

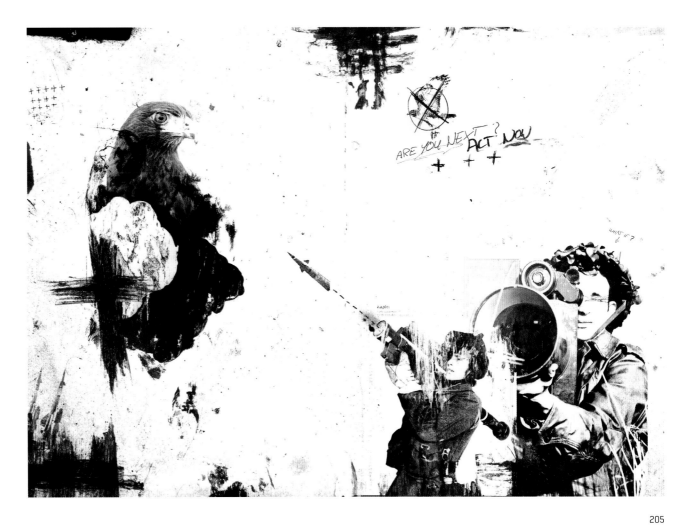

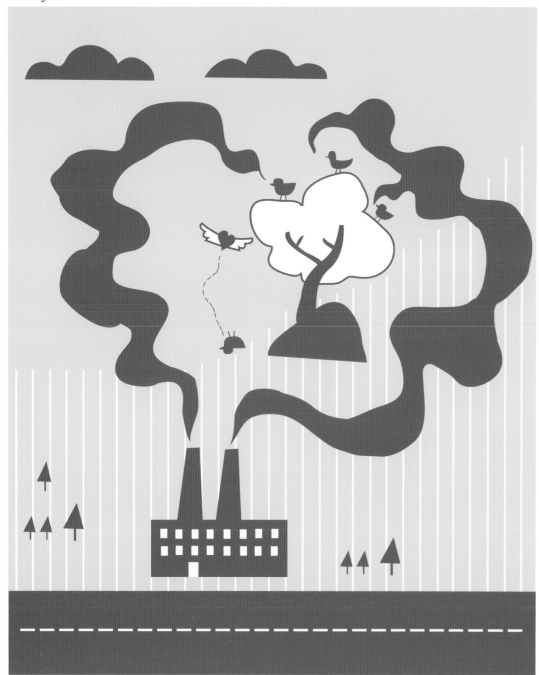

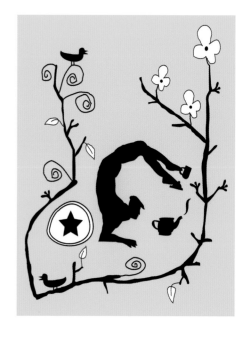

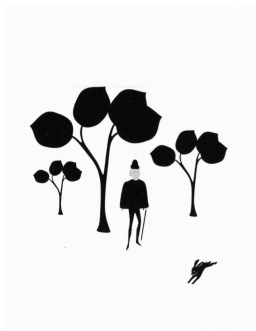

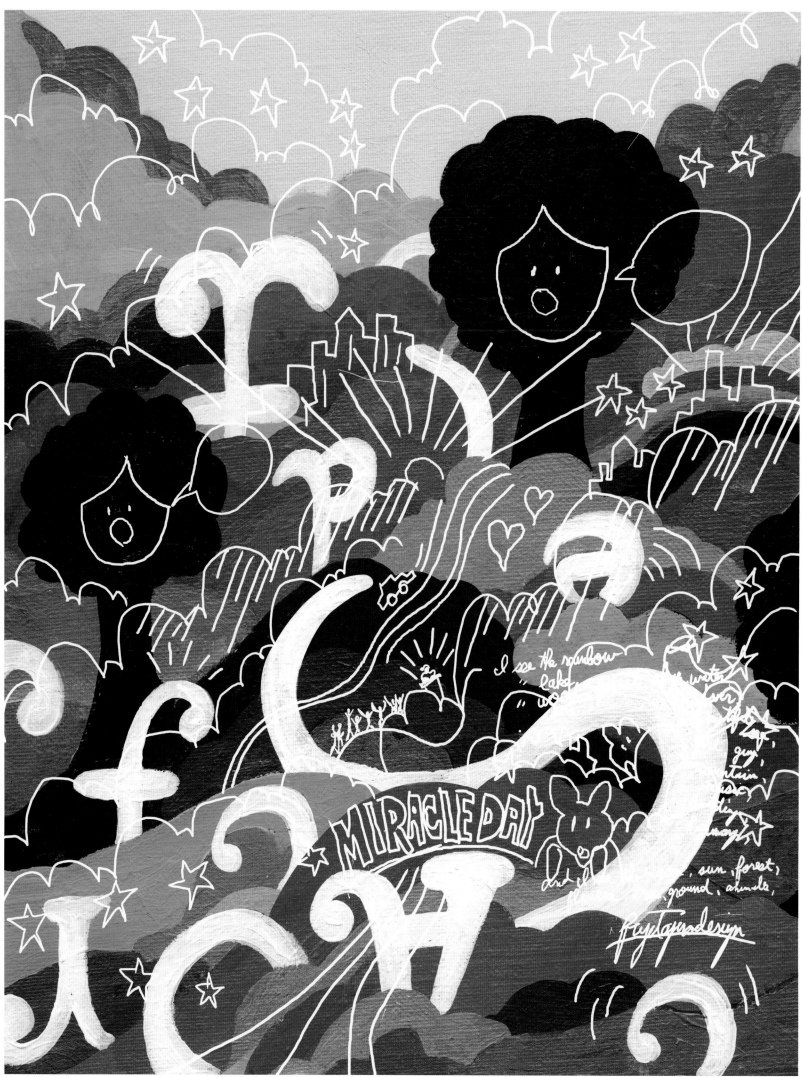

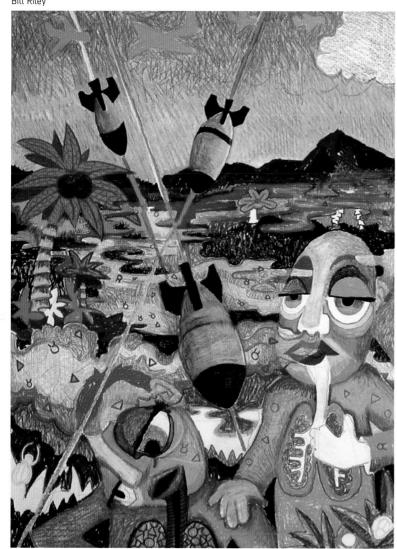

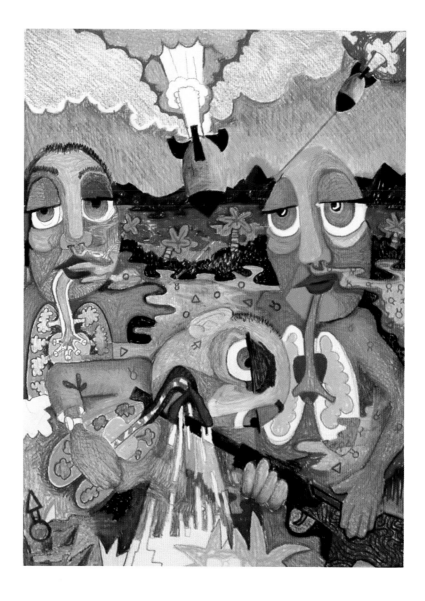

Christian Walden

Chrissie Macdonald / Peepshow studio

Chisato Shinya

心と体の調和を

منت خدای راعزوجل که طاعتش موجب

專為同胞服務
精通廣東話

hat.

scarf

shoes.

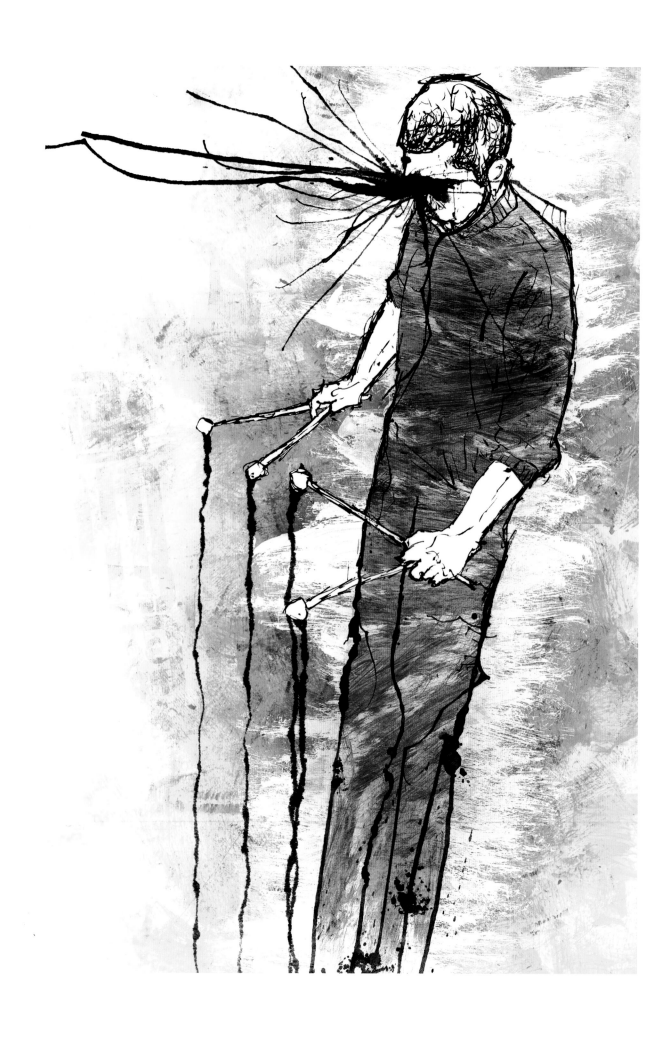

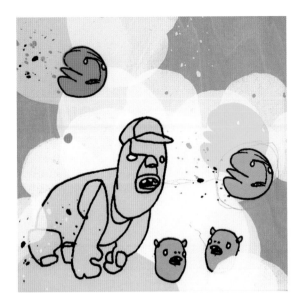

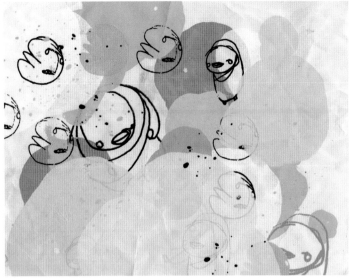

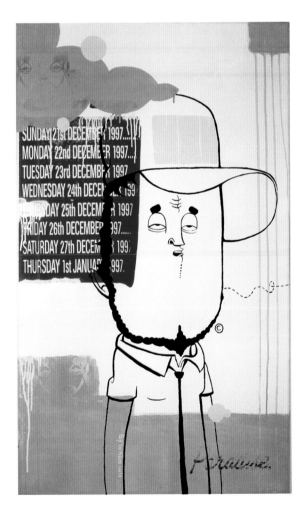

Anaïs Nin Ut av redet

Anaïs Nin Venusdeltaet

Mark Tappin / Blue Source

Pete Fowler

Satoshi Matsuzawa

Chocolate
Chocolate brown has sweet and mellow soul.
It makes me melt down.

Salbo,ma
60's lounge and 70's action pictures
http://www.salboma.com

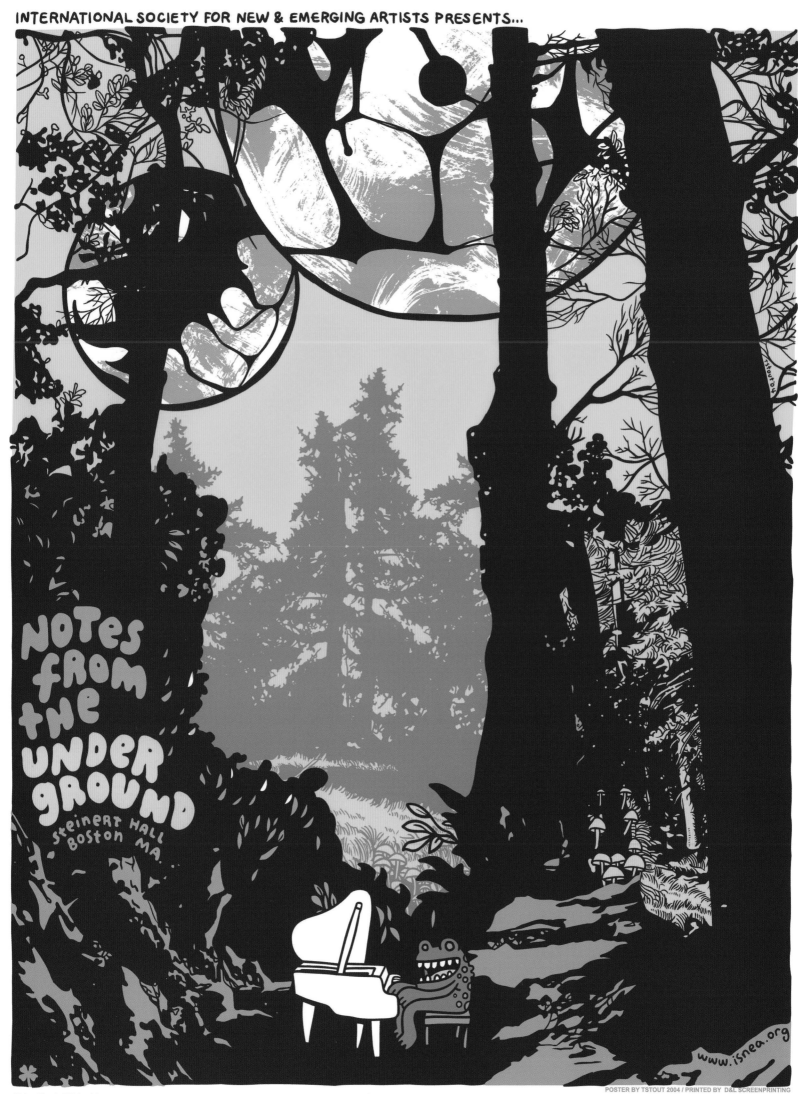

POSTER BY TSTOUT 2004 / PRINTED BY D&L SCREENPRINTING

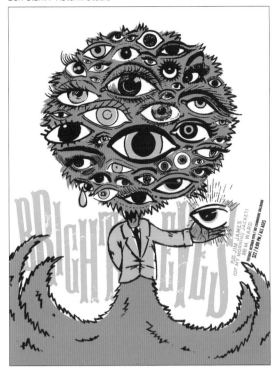

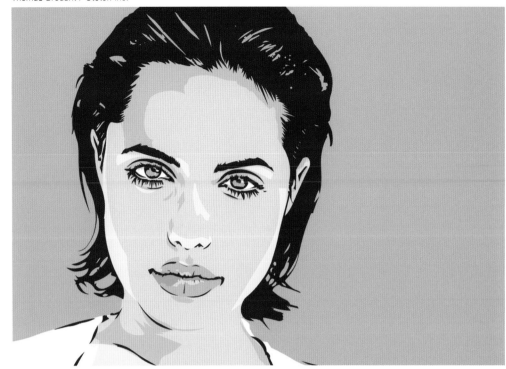

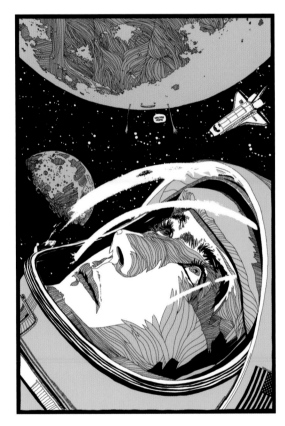

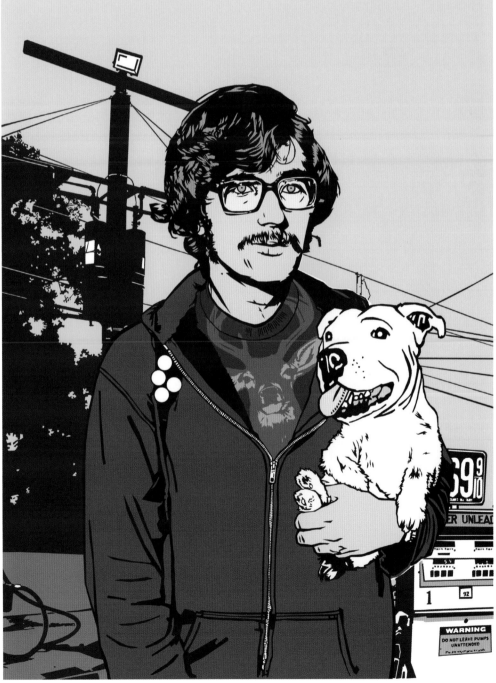

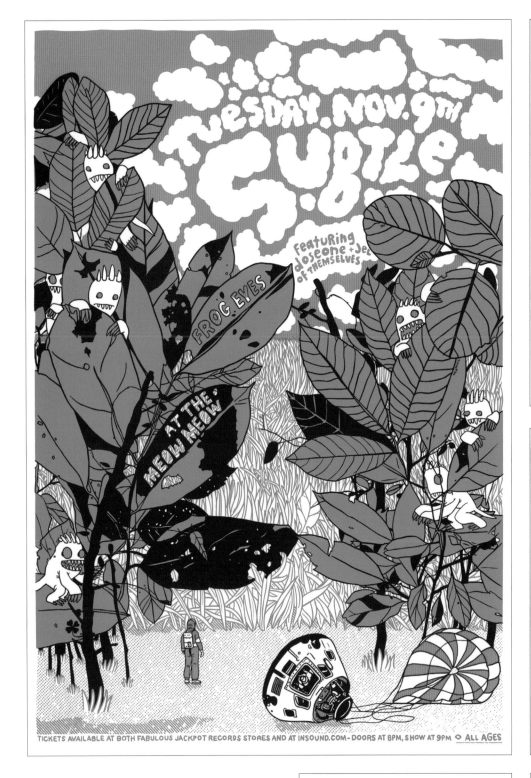

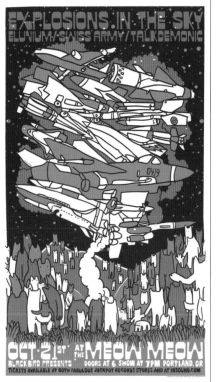

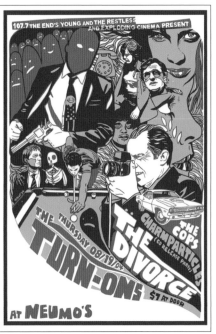

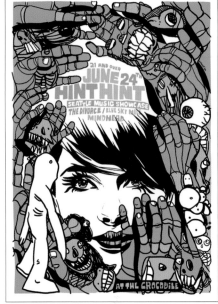

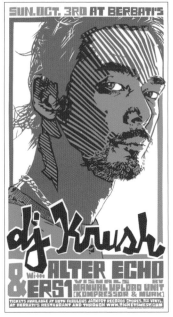

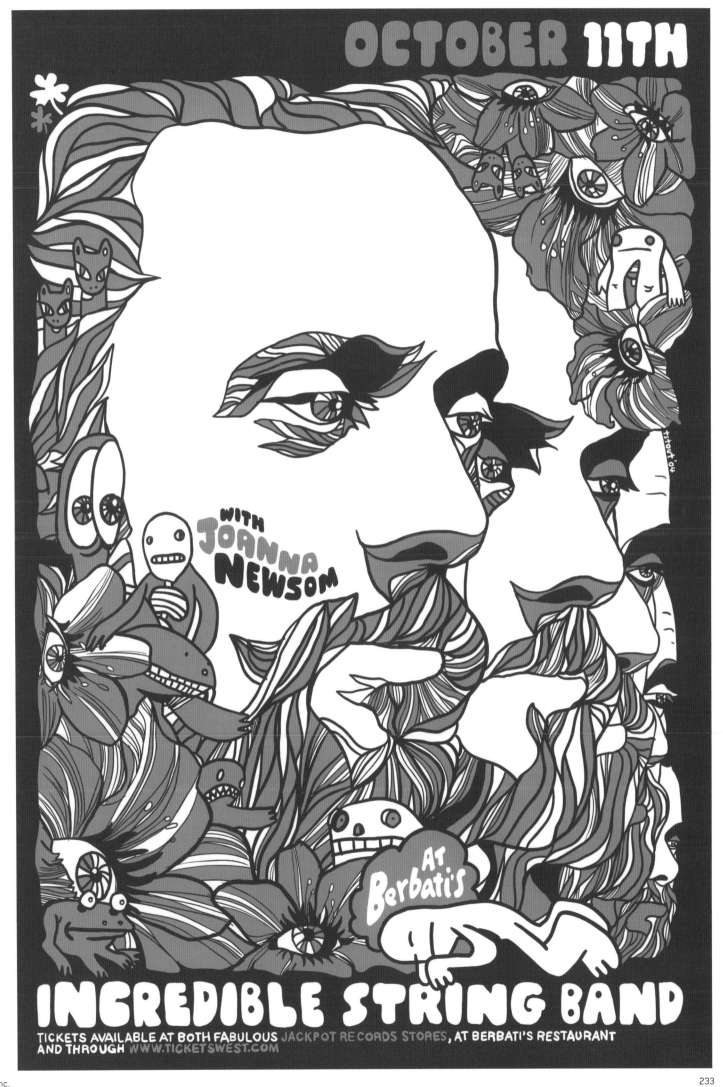

OCTOBER 11TH

WITH JOANNA NEWSOM

AT Berbati's

INCREDIBLE STRING BAND

TICKETS AVAILABLE AT BOTH FABULOUS JACKPOT RECORDS STORES, AT BERBATI'S RESTAURANT AND THROUGH WWW.TICKETSWEST.COM

Tyler Stout / Tstout inc.

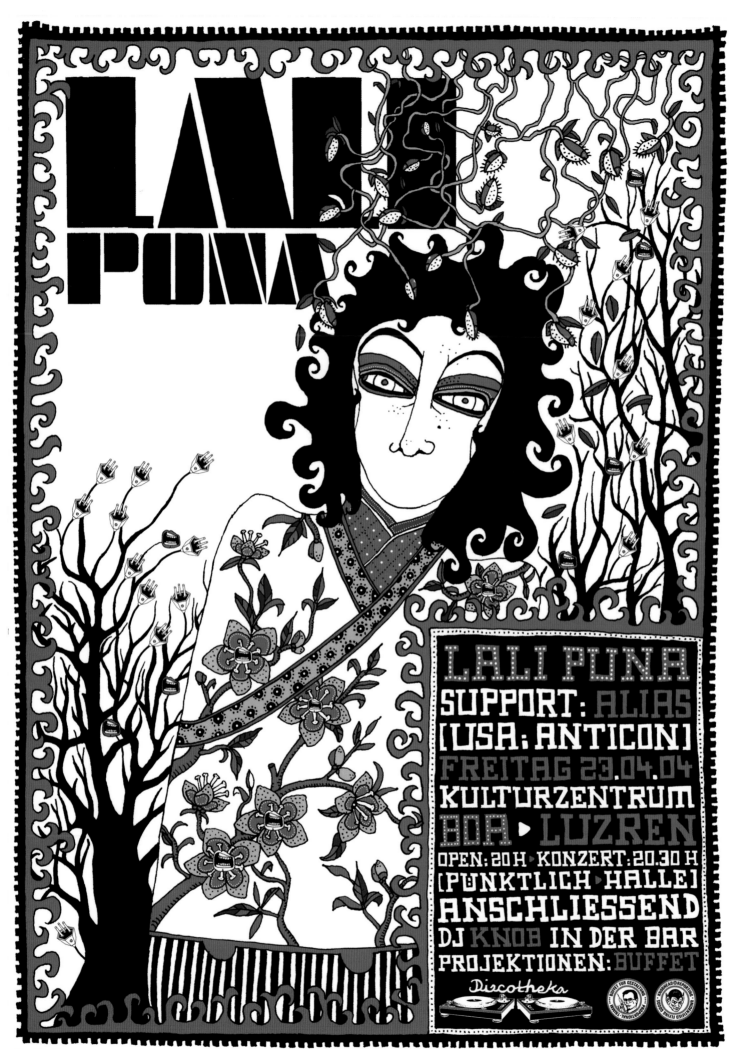

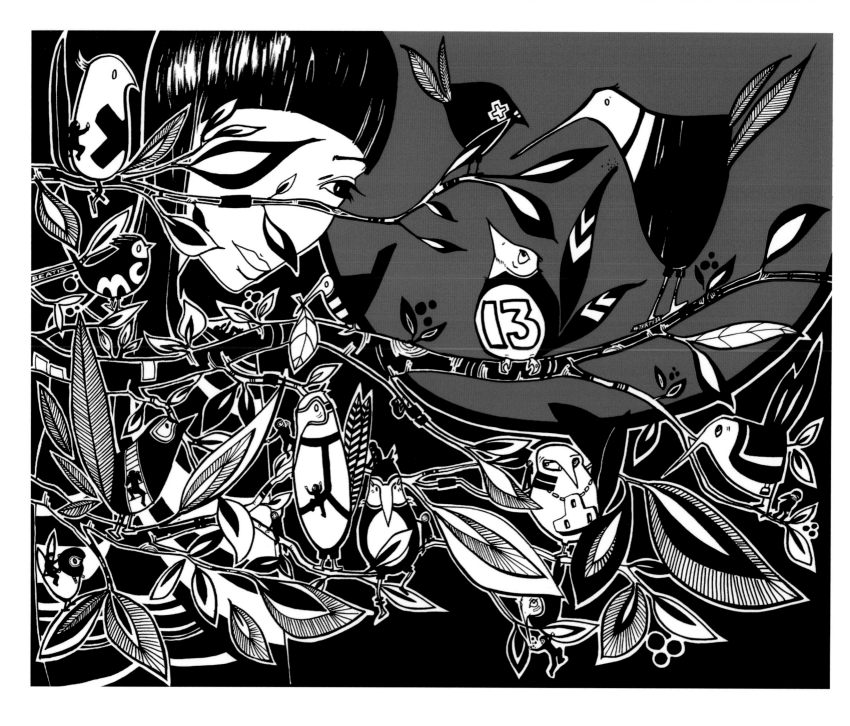

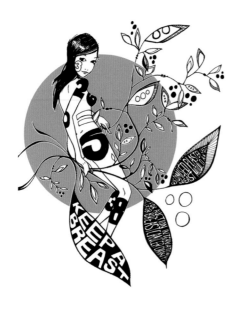

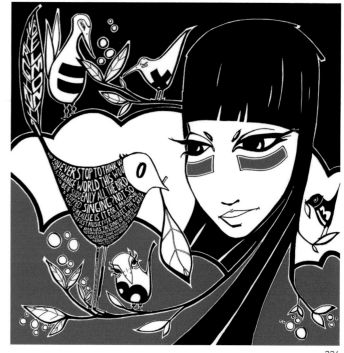

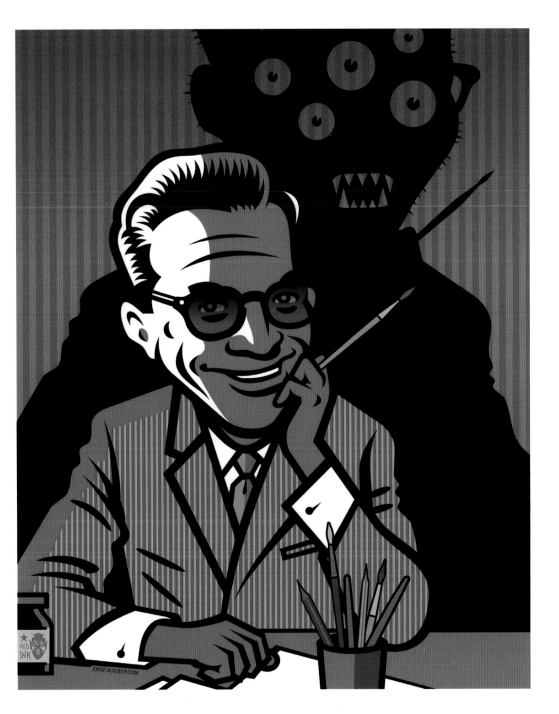

Jorge Alderete

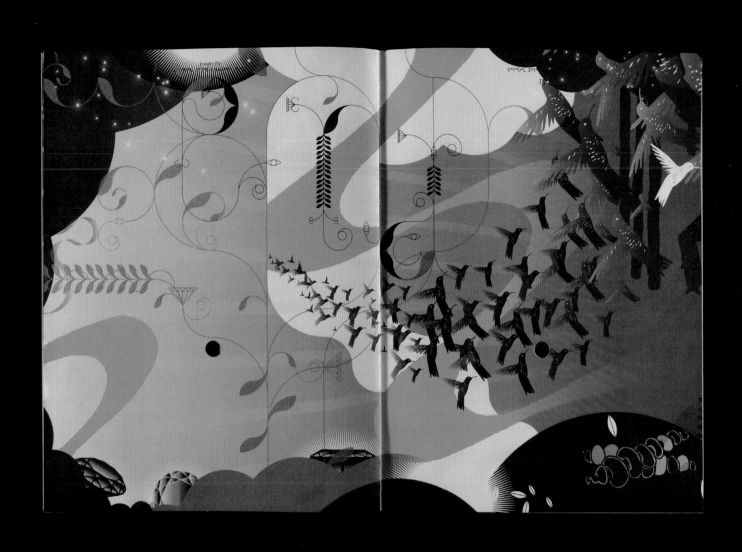

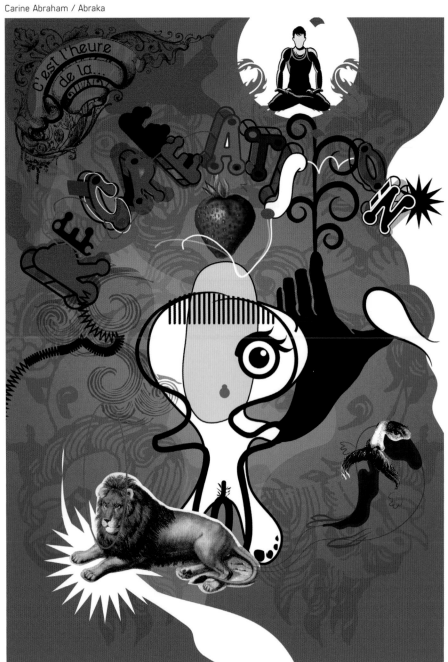

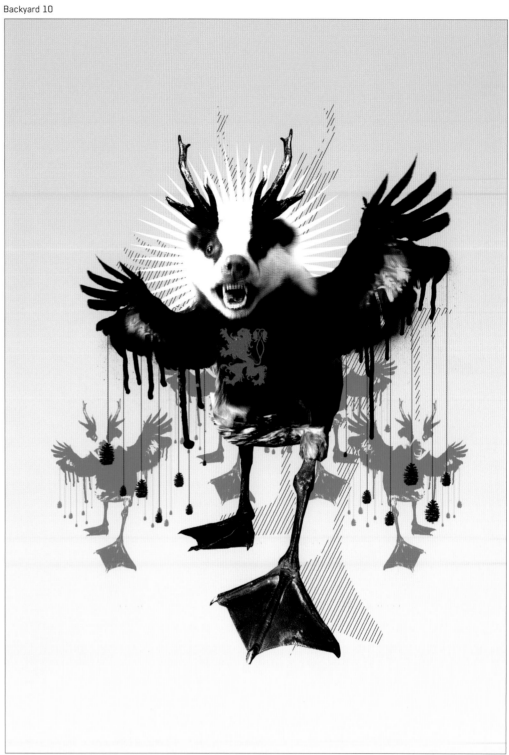

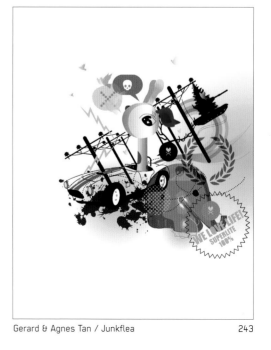

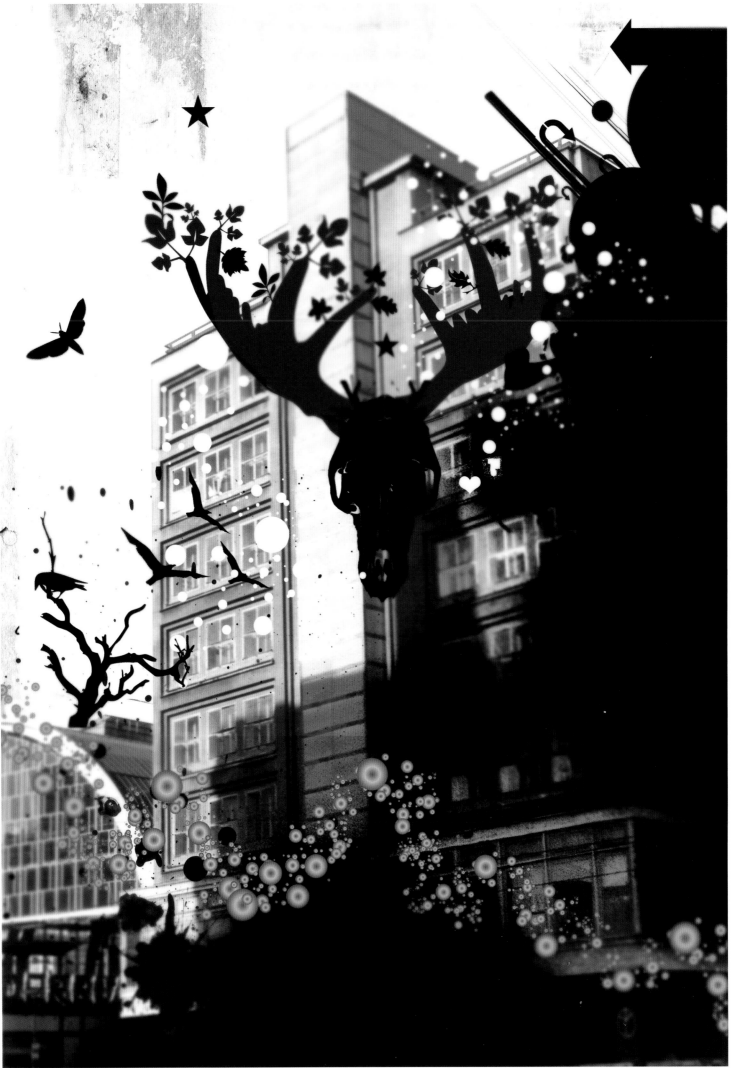

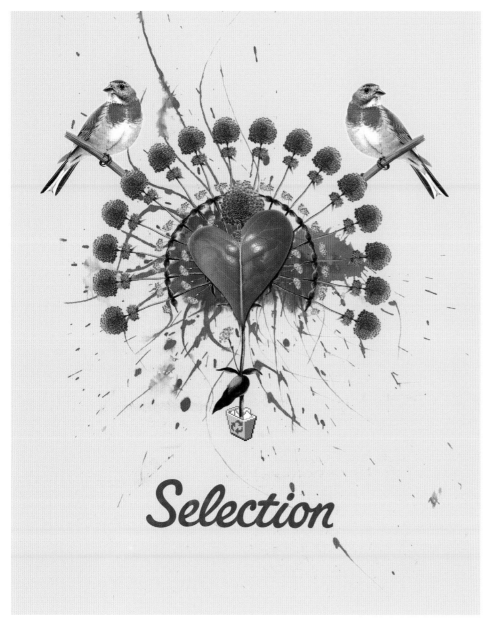

Teis Albers / Graphik

Lisa Schibel / Vasava

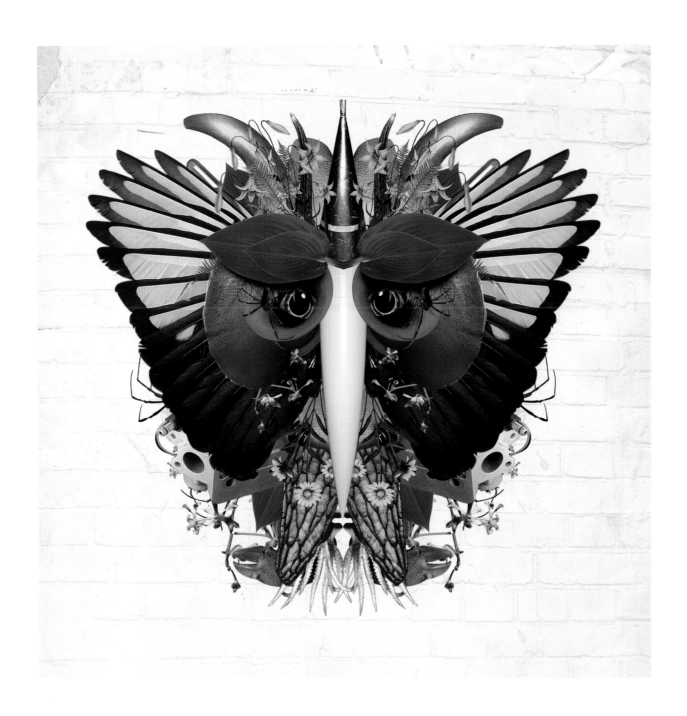

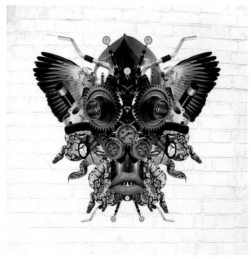

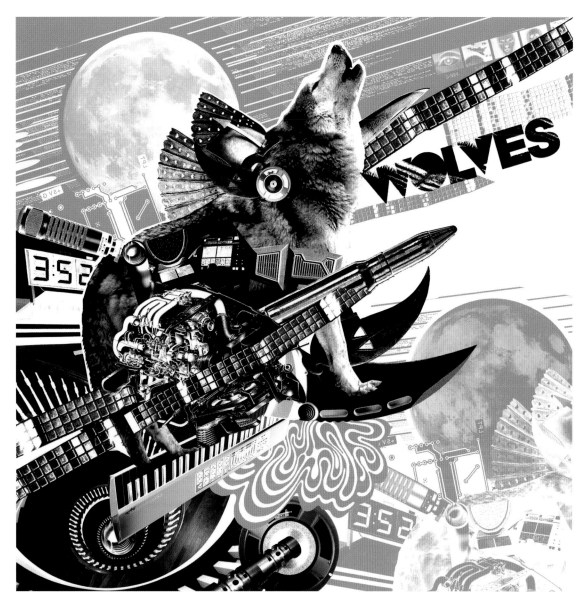

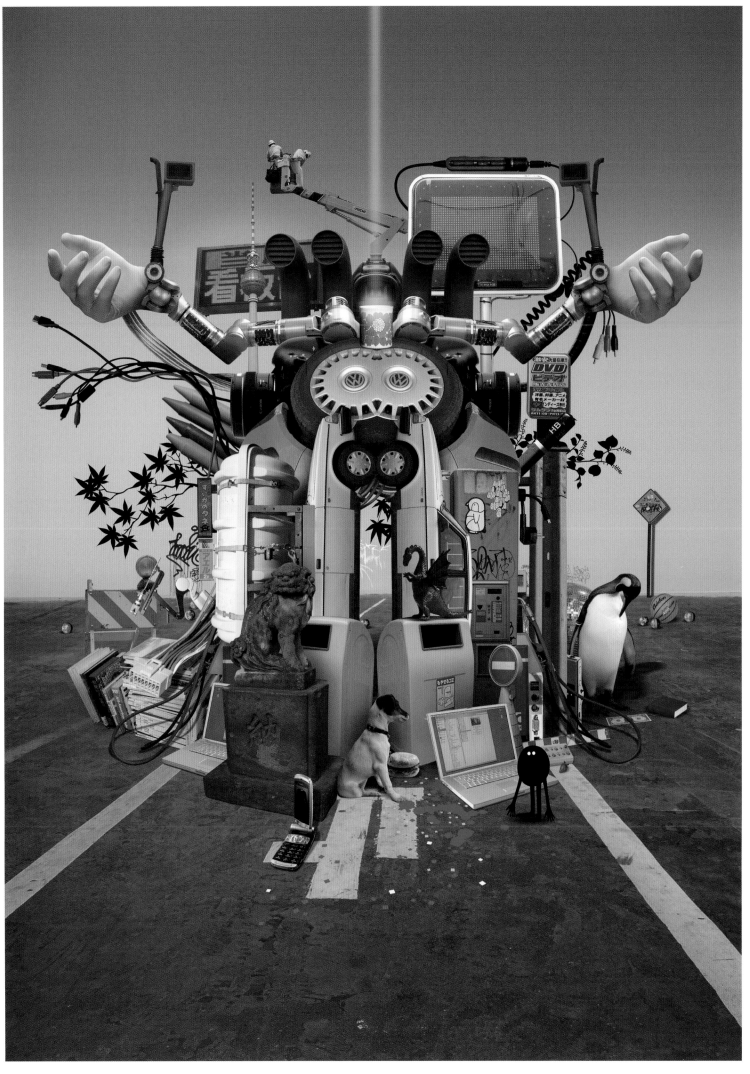

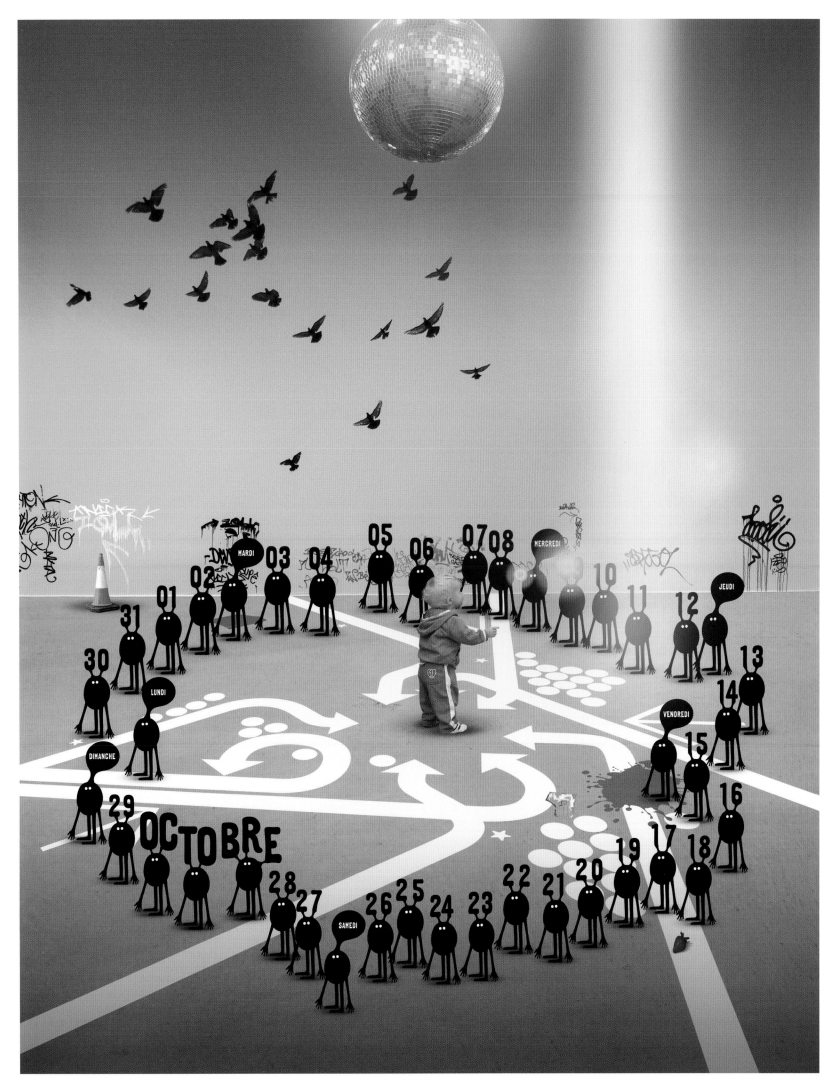

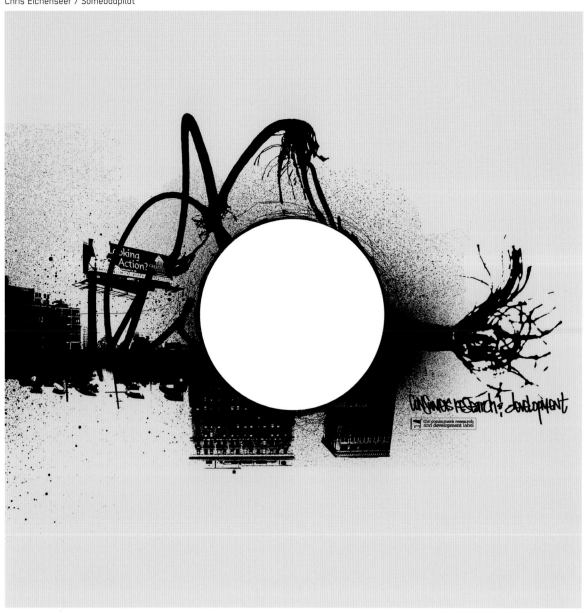

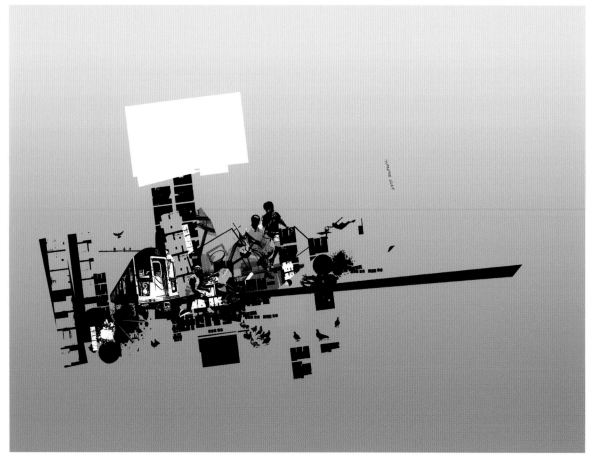

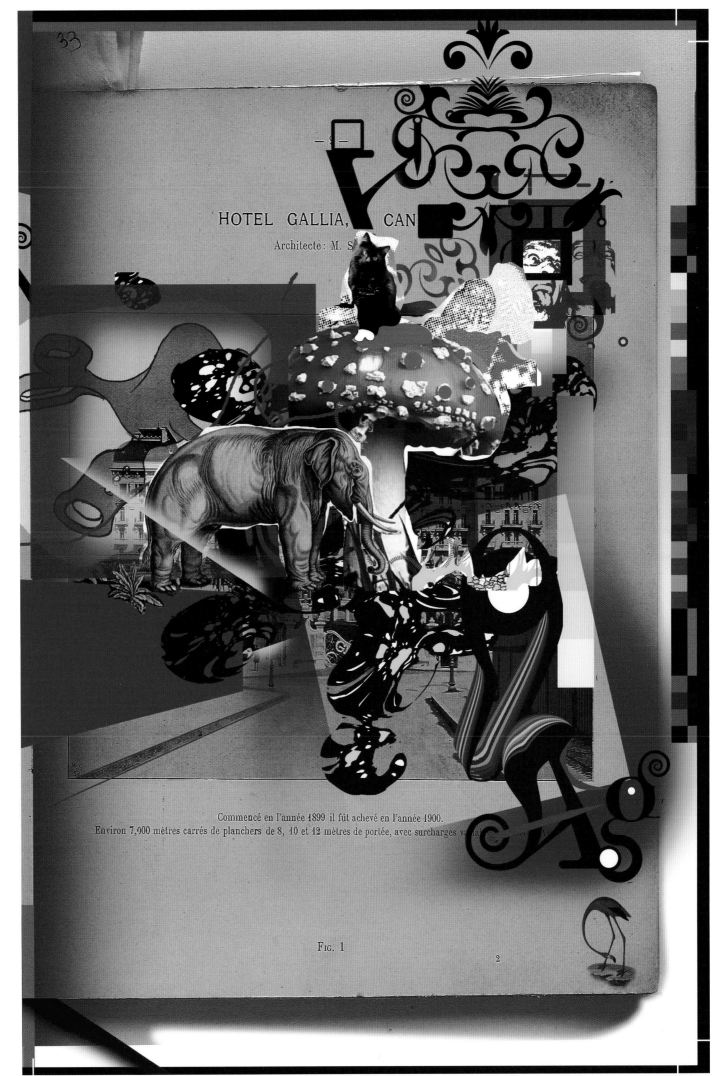

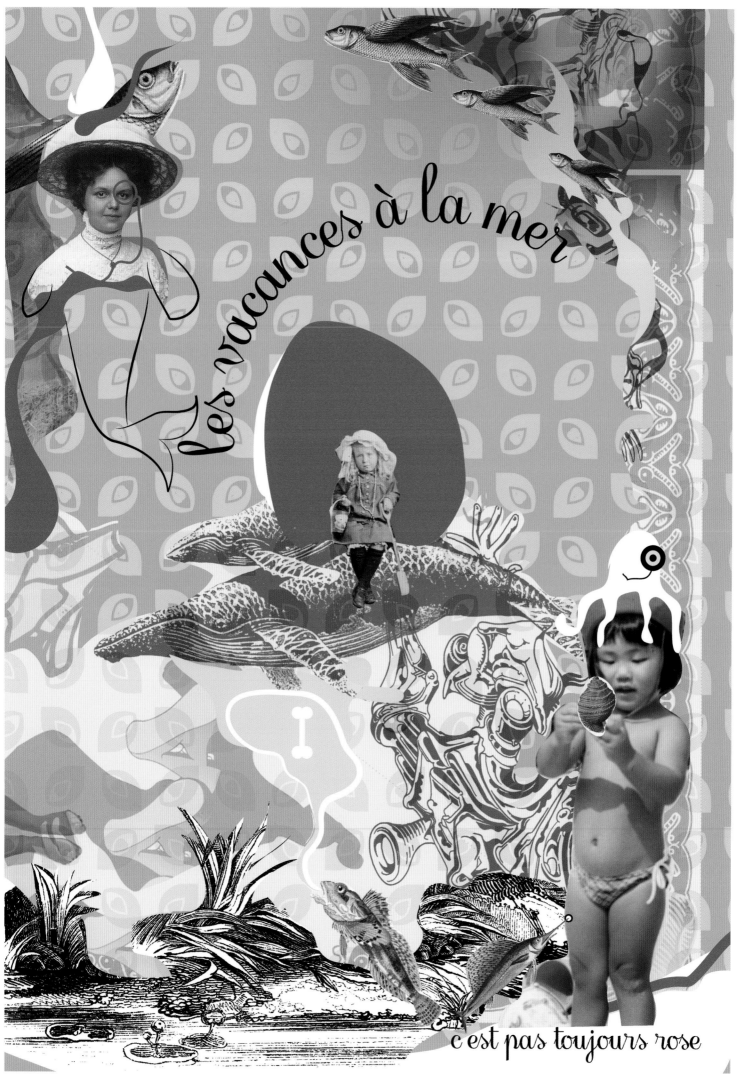

Les vacances à la mer

c'est pas toujours rose

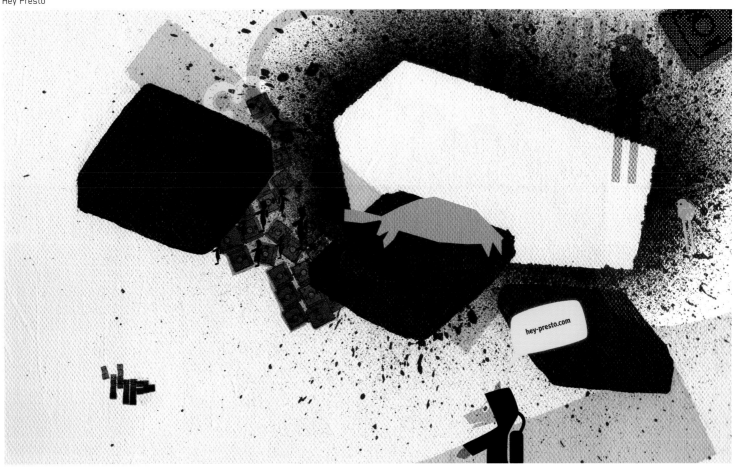

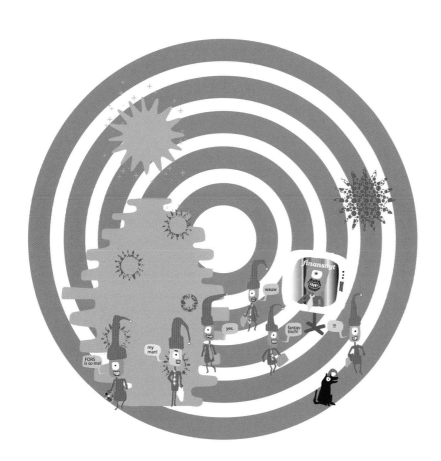

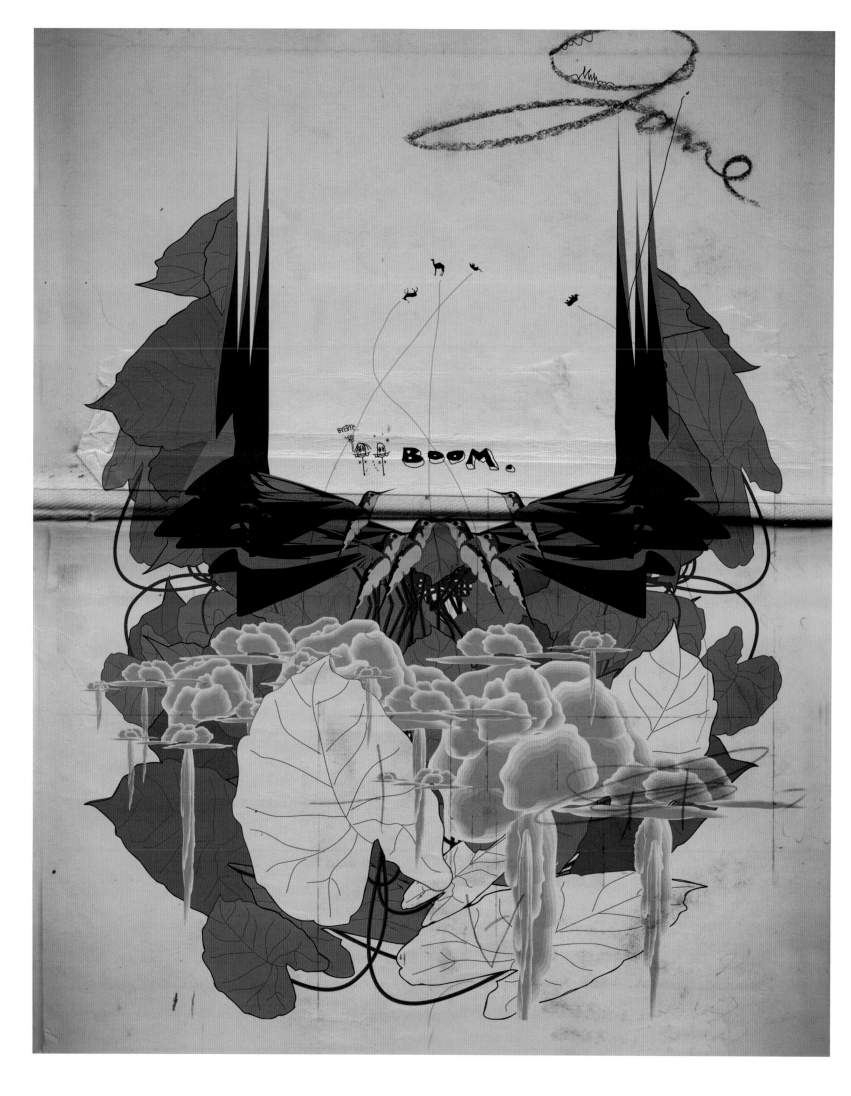

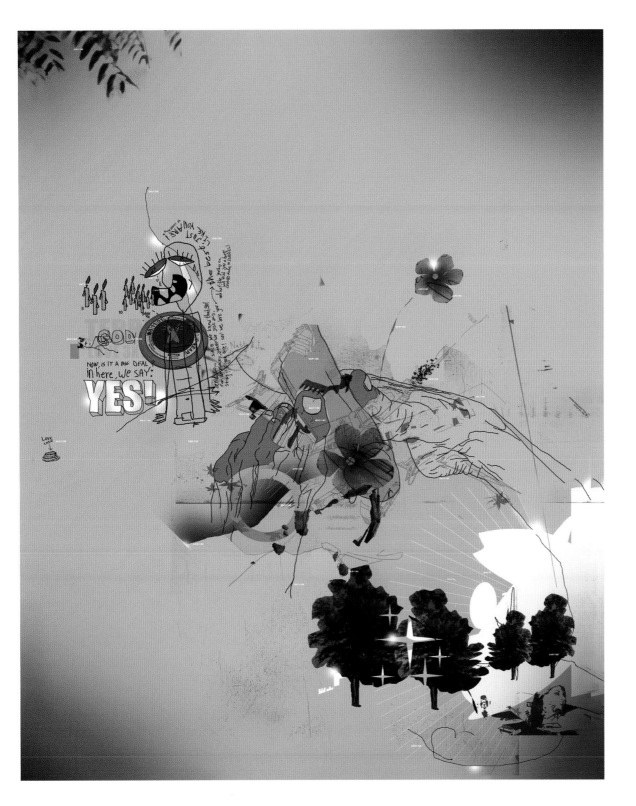

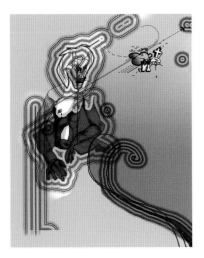

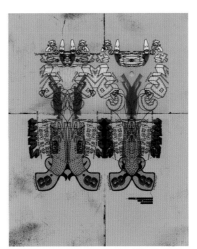

#01/2004 nok 75,-

VRENG

MAGASIN FOR MENTALT MILJØ. REKLAMEN ER LIVSFARLIG. SUKSESSFULL SHOPPING. BYROMMETS MILITARISERING.

FAIRYTALE TOURS

Container

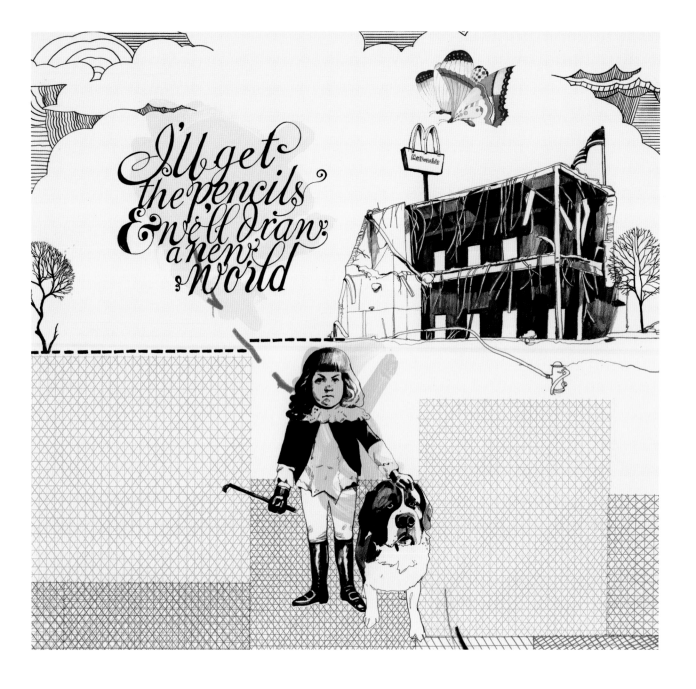

THE SOUTHERN VALLEY MAKE
SNOW
FRAGRANT

What luck!

thin wings of a dragonfly

The empty air made buzz

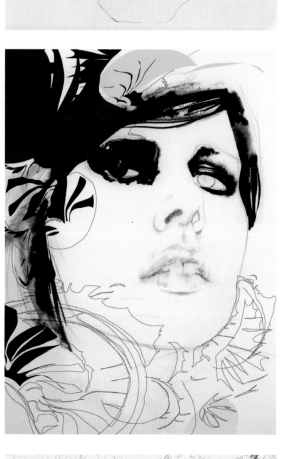
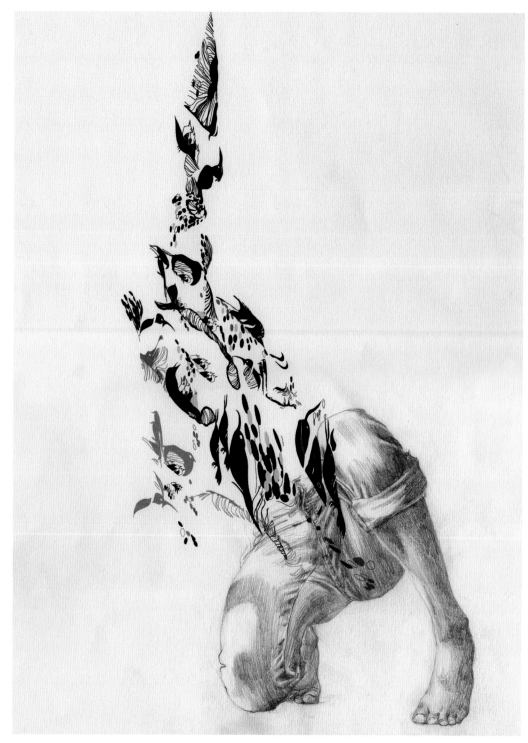
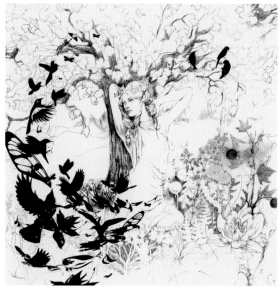

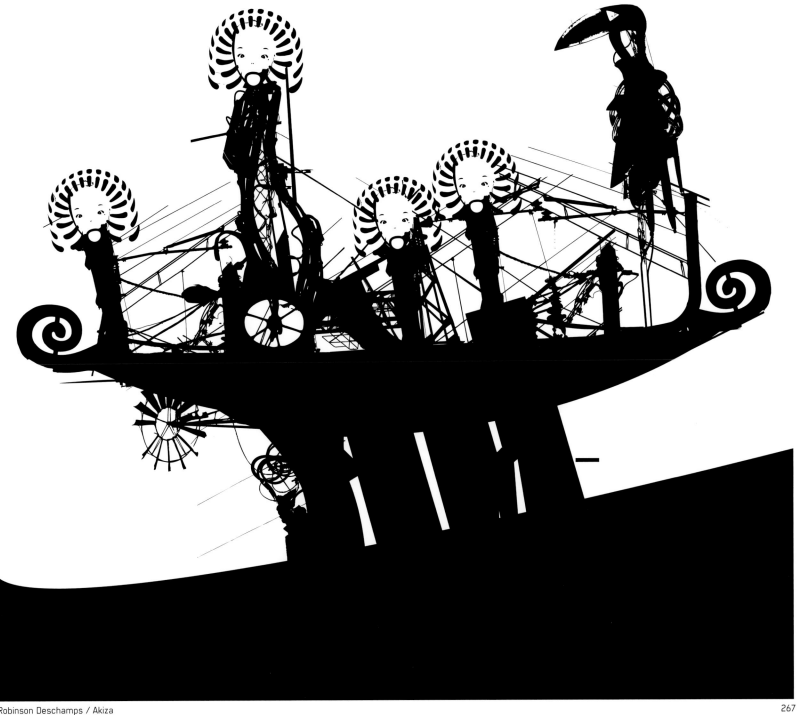

Robinson Deschamps / Akiza

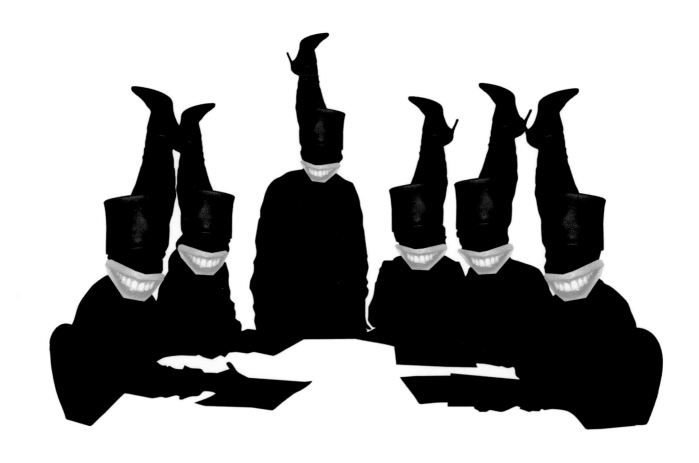

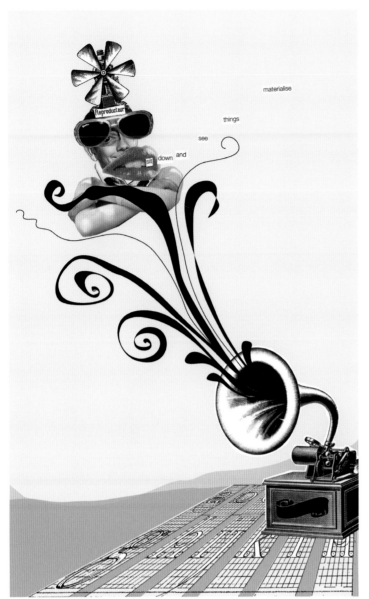

materialise

things

see

sit down and

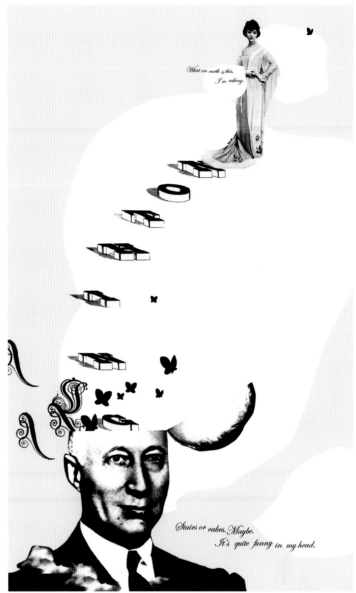

What on earth is this,
I'm asking.

Stairs or cakes. Maybe.
It's quite funny in my head.

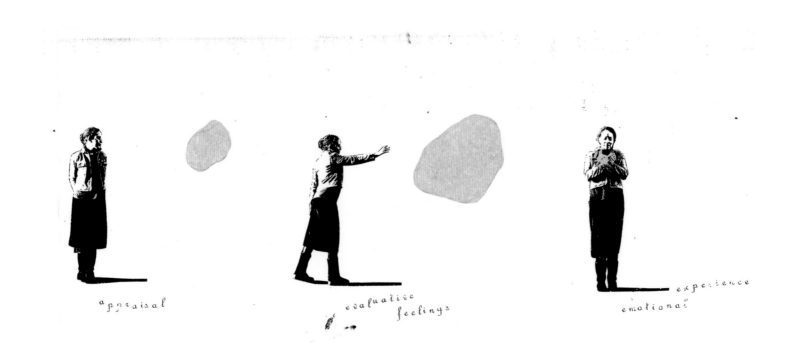

appraisal

evaluative
feelings

experience

emotional

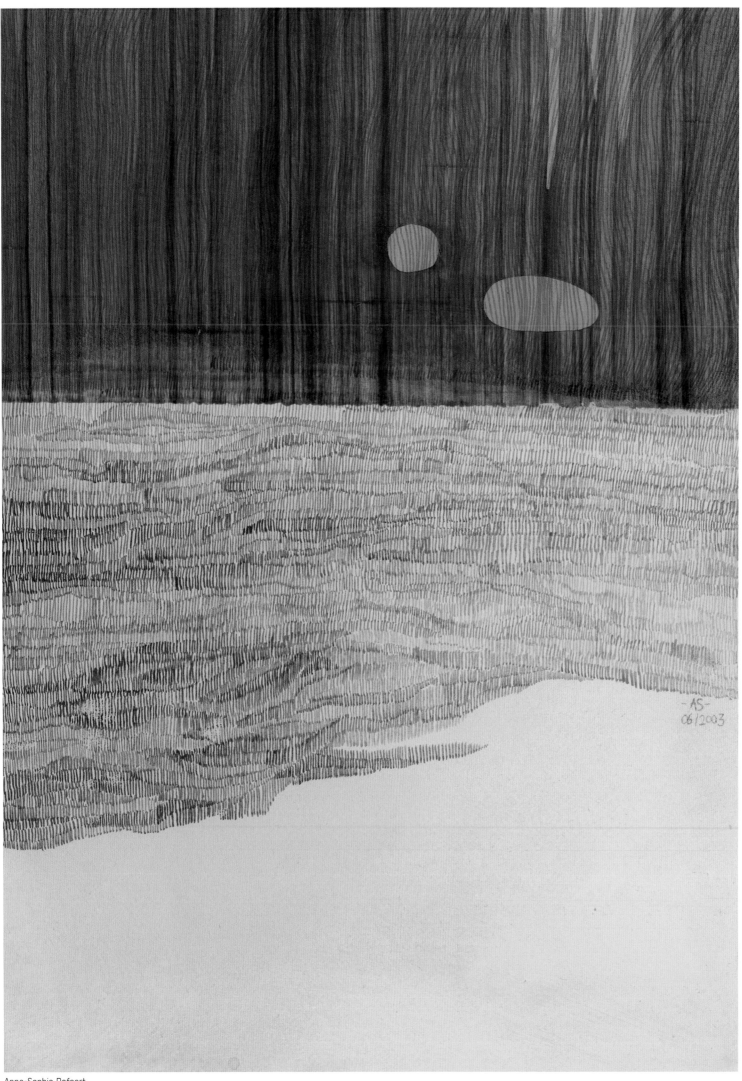

Anne-Sophie Defoort

motif

ole morten vågan
bass

håkon mjåset johansen
drums

atle nymo
saxophone

mathias eick
trumpet

håvard wiik
piano

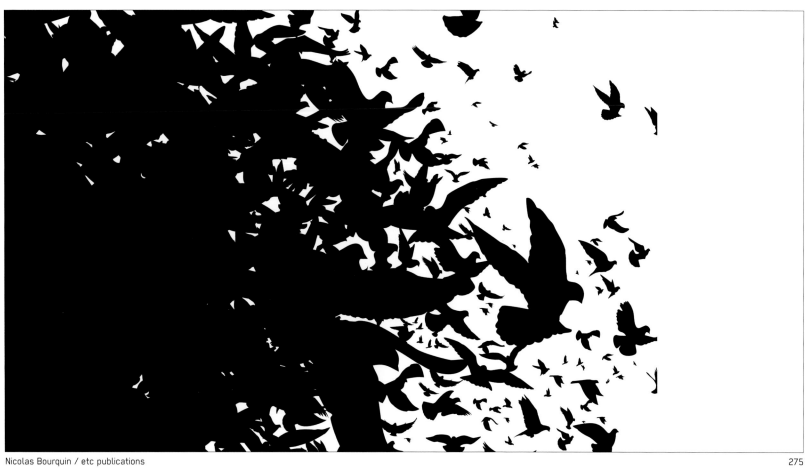

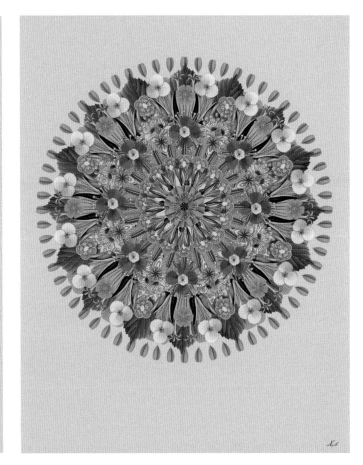

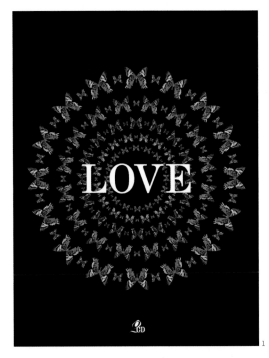

LOVE

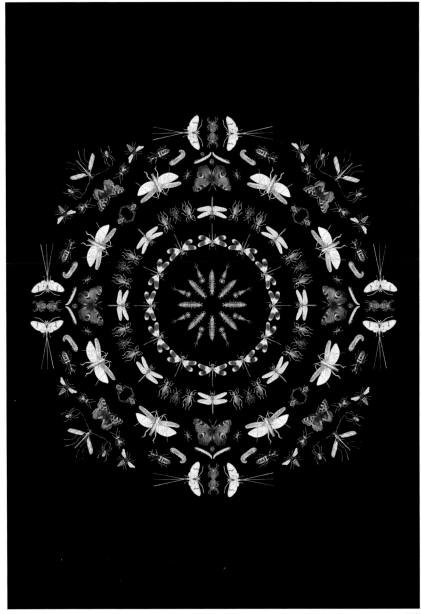

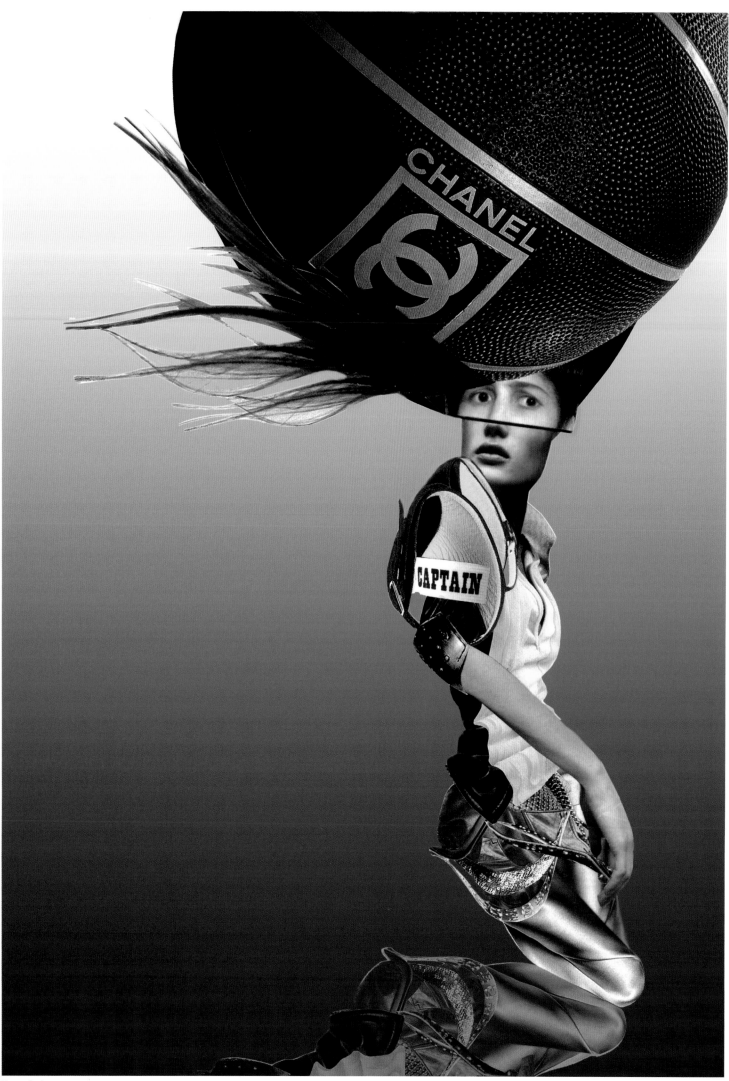

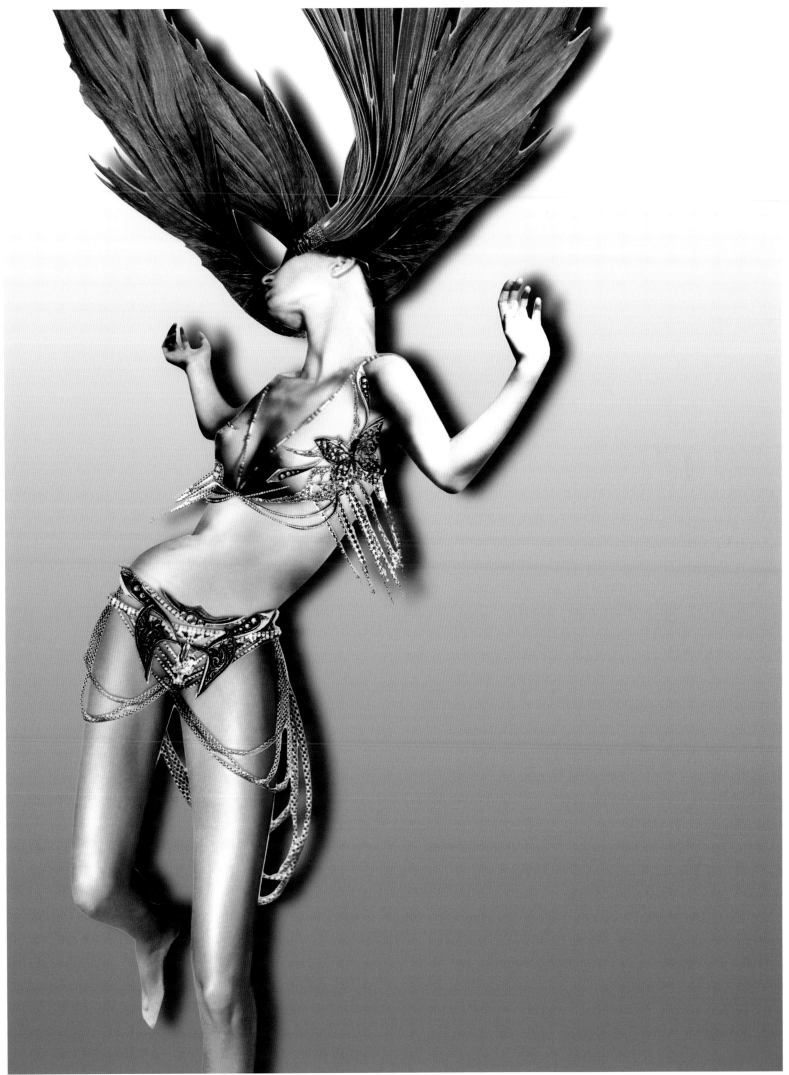

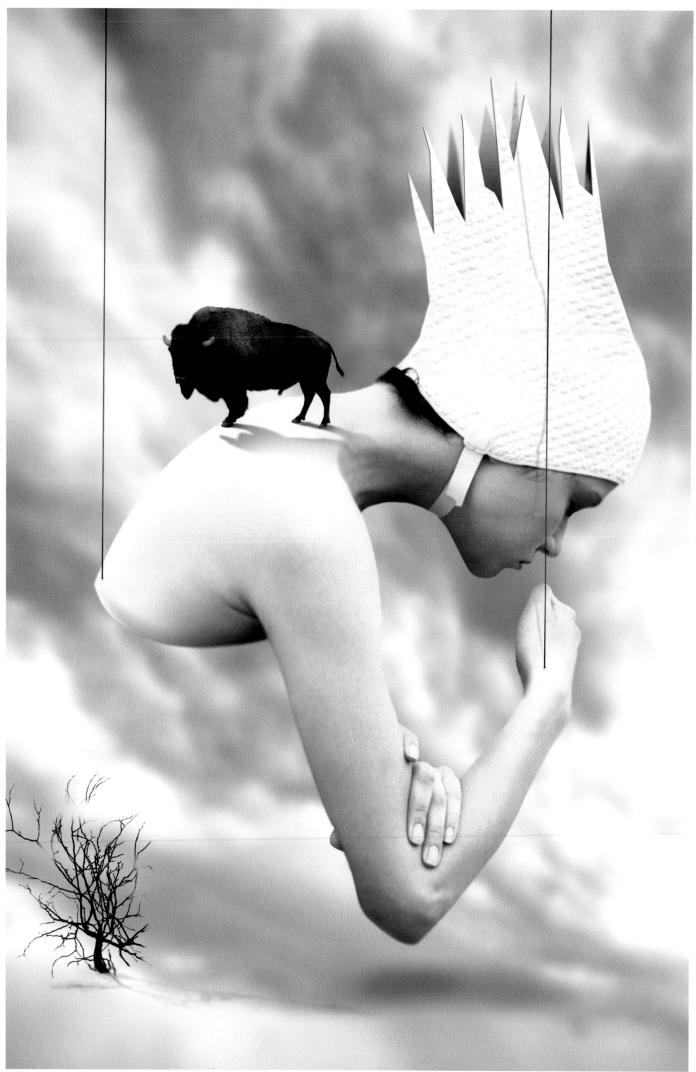

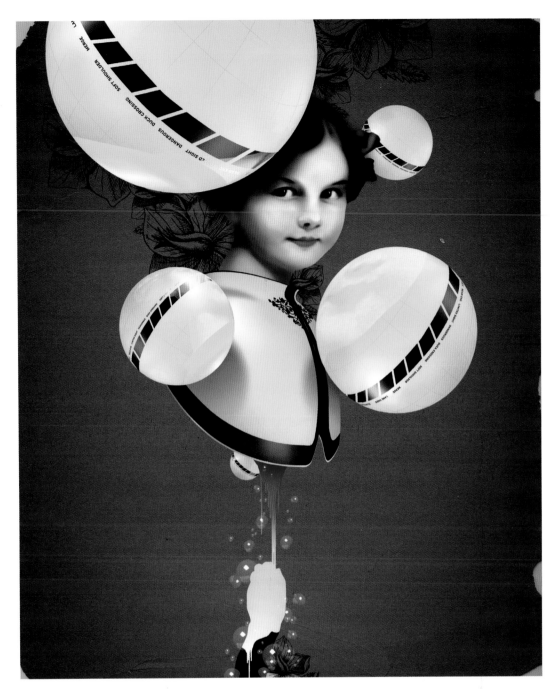

Elen Rolih

Cecilia Carlstedt

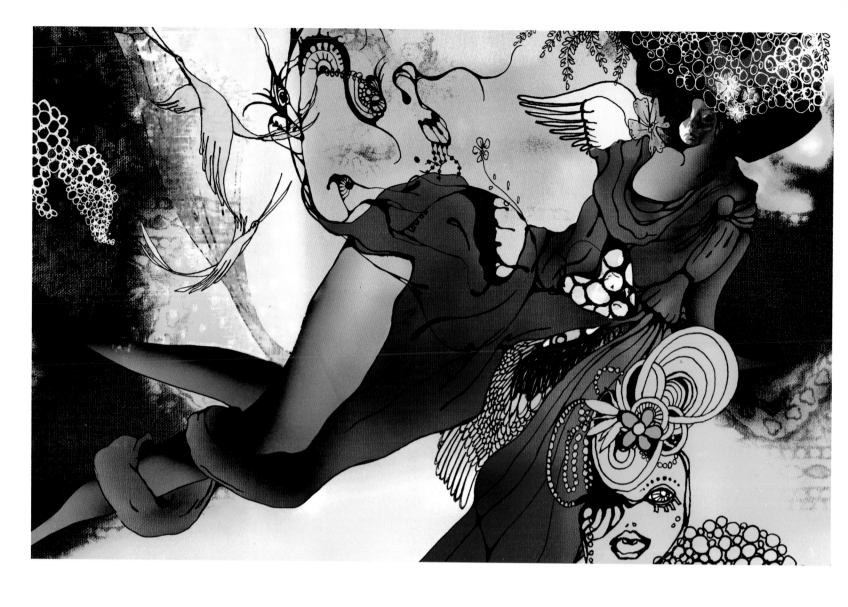

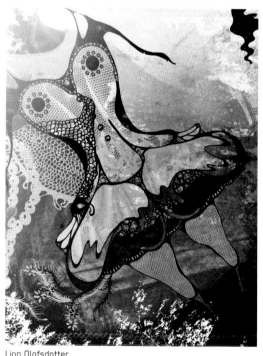

Linn Olofsdotter

Linn Olofsdotter

ISLAND ART
FILM & VIDEO
FESTIVAL '05
10TH–24TH MARCH

SPACEWITHINSPACEWIT

NSPACESPACEWITHINSPACEWITHINSPACEWITH

l'espace

SPACEWITHINSPACEWI

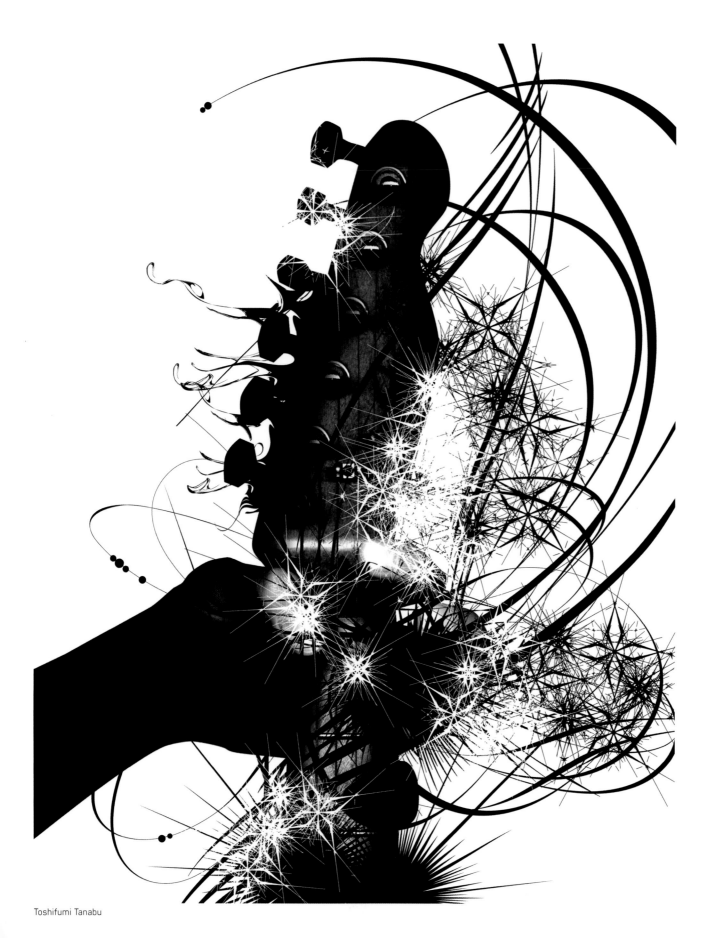

McFaul

our deerest ธ็๔ดอ็ใล้ครธ
ทอ็ the บเธ์ผตธ อ์f the ทธบคล้ต
fellอ็ฟ deธเ๑ภธrธ

123Buero
Timo Gaessner
timo@123buero.com
www.123buero.com
86, 275

18.Oktober
mk@18oktober.com
www.18oktober.com
115, 116

1kilo
Hansjakob Fehr, Dorothee Wettstein
gold@1kilo.org
www.1kilo.org
4-9

2GD Copenhagen
Ole Lund
ole@2GD.dk
www.2GD.dk
277

310k
we@310k.nl
me@310k.nl
www.310k.nl
58

A-Side Studio
Ross Imms
rossco@a-sidestudio.co.uk
www.a-sidestudio.co.uk
150, 151

Abraka
Carine Abraham
carine.abraham@free.fr
240, 251, 252

Adam Cruickshank
adam@regularproduct.com
www.regularproduct.com
225

Adapt Studio
J.Byrnes
byrnesj@adapt-studio.com
www.adapt-studio.com
189

Adrian Johnson
mail@adrianjohnson.org.uk
www.adrianjohnson.org.uk
160

Adriana Arriaga
aarriaga@ollinstudio.com
www.blu-design.com
216, 217

AKA
Annika Kaltenthaler
annika.kaltenthaler@gmx.de
www.annikakaltenthaler.de
62, 74

Akiza
Robinson Deschamps
robinson@touslesanges.com
www.akiza.net
266, 267

Alan Heighton
alheighton@hotmail.com
www.alanheighton.co.uk
206

Alexander Wise
alexander.wise@wanadoo.fr
58

Andreas Gehrke
office@noshe.de
www.noshe.de
124

Andrew Rae
www.andrewrae.org.uk
173

Anne-Sophie Defoort
anne_sophie.defoort@club-internet.fr
211, 272

ApishAngel
Nick Walker
nickwalker@apishangel.com
www.apishangel.com
155, 164

Apropos
Gareth Wild
Apropos_mail@btinternet.com
www.Apropos-site.com
165

asmallpercent
Tim Ferguson Sauder
tim@asmallpercent.com
www.asmallpercent.com
188

Asterik Studio
Don Clark
don@asterikstudio.com
www.asterikstudio.com
100, 231

Atelier télescopique
Sébastien Delobel, Xavier & Stéphane
Meurice, Guillaume Berry
atelier-telescopique@wanadoo.fr
www.ateliertelescopique.com
88, Cover Design

Attak
attak@attakweb.com
www.attakweb.com
60

Automatic Art and Design
Charles Wilkin
info@automatic-iam.com
www.automatic-iam.com
36, 37

B.ü.L.b grafix
Nicolas Robel, Mathieu Christe,
Sidonie Carillat
grafix@bulbfactory.ch
www.bulbfactory.ch
54

Backyard 10
info@backyard10.com
www.backyard10.com
61, 63, 105, 243

BeardsWithBeef Illustration Collective
Rob Hare, Kev Speck, Matt Campbell, Tinker
theguys@beardswithbeef.co.uk
www.beardswithbeef.co.uk
129

Beat 13
Lucy McLauchlan
lucy@beat13.co.uk
www.beat13.co.uk
236

Benny Box
bennybox@bennybox.dk
http://bennybox.dk
128, 183

Bilderberg
Jens Sundheim
info@bilderberg.de
www.bilderberg.de
106, 107

Bill Riley
sephrah@mac.com
209

Bleed
Eirik Seu Stokkmo, Svein Haakon Lia
eirik@bleed.no, svein@bleed.no
www.bleed.no
185, 191

BLK/MRKT
contact@blkmrkt.com
www.blkmrkt.com
229

Block
someone@BlockBranding.com
www.BlockBranding.com
100

Blue Source
Mark Tappin
www.bluesource.com
224

Blythe
Gina Garan
gina@thisisblythe.com
www.thisisblythe.com
Cross World Connections (CWC Tokyo),
Creative Producer: Junko Wong; Blythe is
a trademark of Hasbro . copyright 2005;
Blythe character is rights are licensed in
Asia to Cross World Connections,LTD.
141

Boris Hoppek
hoppek@web.de
www.borishoppek.de
136

Bufalo Club
Brian Quinlan
bufaloclub@earthlink.net
www.bufaloclub.com
144

Buffet für Gestaltung
mail@buffet.nu
www.buffet.nu
112, 144, 234

Build
Michael Place
michael@designbybuild.com
165

Bureau Ludwig
Birte Ludwig
info@bureau-ludwig.com
www.bureau-ludwig.com
200, 201

Cecilia Carlstedt
mail@ceciliacarlstedt.com
www.ceciliacarlstedt.com
264, 283

Chisato Shinya
kinpro@iacnet.ne.jp
www.kin-pro.com
214, 215

Chris Rubino
crubino@studio18hundred.com
www.chrisrubino.com
184, 228

Christian Gabriel Montenegro
montenegrochristian@hotmail.com
www.christianmontenegro.com.ar
11, 25

Christian Walden
chris@dmyk.com
www.dmyk.com
212

CODE
Page 61: Art direction: Reto Gehrig,
Grafik / Design: Ryosuke Kawaguchi Zopfi;
Page 63: Art direction: Reto Gehrig,
Grafik / Design: Sarah Lüscher
reto@code.ch
www.code.ch
61, 63

Container
info@container.me.uk
www.container.me.uk
166, 260, 261

Crashcarcity
Anni Fittkau
crashcarcity@gmx.de
www.crashcarcity.com
144

Creative Pride
Dan Huggett
dan.huggett@creativepride.com
www.creativepride.com
75

Crush Design & Art Direction
Carl Rush
carl@crushed.co.uk
www.crushed.co.uk
145, 167

Cyklon
Gytz
cyklon@cyklon.dk
http://cyklongrafik.net
113

Dag Henning Brandsaeter
dag@exclusiveandlovely.net
39, 182

Dainippon Type Organization
dainippon@type.org
http://dainippon.type.org/
68

David Nakamoto
david@multifresh.com
www.multifresh.com
59, 129

DED Ass.
info@dedass.com
www.dedass.com
12, 38

Derrick Hodgson
derrick@madreal.com
www.madreal.com
221

Designanorak
Si Billam, L'Elise
www.designanorak.com
69

DesignBum
Issara Willenskomer
issara@designbum.net
www.designbum.net
47

Devilrobots Inc
info@devilrobots.com
www.devilrobots.com
147

Don't Design
Andy Rouse
contact@dontdesign.com
www.dontdesign.com
99

Ehquestionmark
enquirehere@ehquestionmark.com
ehquestionmark.com
86, 97

Elen Rolih
eline@freesurf.ch
www.gestaltanstalt.ch
282

Ella Tjader
contact@artlaundry.com
www.artlaundry.com
223

Emek
emek@emek.net
www.emek.net
235

eP Design
Carolina Aboarrage
carolina@epwww.com
www.epwww.com
22, 23, 72, 73

Erotic Dragon
Miho Sadogawa
Courtesy of CWC Tokyo, CWC-international
she@eroticdragon.com
www.eroticdragon.com
14, 15

etc publications
Nicolas Bourquin
info@etc-publications.com
www.etc-publications.com
275

Evaq Studio
Asif Mian
asif@evaq.com
www.evaq.com
78, 89, 100, 120, 291

Everyday Icons
Shinya Inamura
shinya@everydayicons.jp
www.everydayicons.jp
121

Fellow Designers
Paul and Eva
www.fellowdesigners.com
295

Finn O'Hara
finn@finnohara.com
finnohara.com
111

FJD / fujitajirodesign
fjd@fides.dti.ne.jp
www.fjd.jp
133, 208, 209

Fons Hickmann m23
m23@ fonshickmann.com
www.fonshickmann.com
58

Fons Schiedon
office@fonztv.nl
www.fonztv.nl
16, 17

fourillusion
Flavio Almeida
fourillusion@pixaim.com
www.pixaim.com/fourillusion
104, 188, 220

Freaky Facets
Johnny Taylor
johnny@freakyfacets.com
www.freakyfacets.com
47

Frederique Daubal
frederique@daubal.com
www.daubal.com
119, 271

Friederike Preuschen
fpreuschen@hotmail.com
119, 271

FriendsWithYou
Tury & Sam
info@friendswithyou.com
www.friendswithyou.com
137, 138, 139

Frühstück
Daan, Lennard
daan@fruhstuck.nl
140, 197

Furi Furi Company
Aiko
aiko@furifuri.com
www.furifuri.com
159

:g / studio-gpop
g@gpop.co.uk
50

Genevieve Gauckler
genevieve.gauckler@wanadoo.fr
www.g2works.com
27, 248, 249

Gerwin Schmidt
mail@ gerwin-schmidt.de
www. gerwin-schmidt.de
85

Graffictraffic
Isho / Euan Duncan
euan@climateculture.co.uk
ww.graffictraffic.co.uk
62

Graphik
Teis Albers
info@graphik.nl
www.graphik.nl
244, 245

Gul Stue
Mads Berg
mads@gulstue.com
www.madsberg.dk
90

Happypets
info@happypets.ch
www.happypets.ch
63

HayonstudioBCN
Jaime Hayón
info@hayonstudio.com
www.hayonstudio.com
170

Hector Pottie
hector.pottie@cartlidgelevene.co.uk
69

Heiko Hoos
hoos@dworschakhoos.de
www.dworschakhoos.de
97

Hellebek & Lemvig
Mikkel Lemvig
mikkel@hellebeklemvig.dk
www.hellebeklemvig.dk
44

HelloBard
Bard Hole Standal
bard@hellobard.com
www.hellobard.com
129

Hey Presto
hello@hey-presto.com
www.hey-presto.com
253

Hjärta Smärta
office@woo.se
www.woo.se
31, 79, 172, 191, 238

IAAH
ness@iamalwayshungry.com
www.iamalwayshungry.com
288, 289

iLovedust
info@ilovedust.com
www.ilovedust.com
34, 147, 274, 277

Inga Liksaite
ingman72@yahoo.com
42, 134

Ink Graphix
Mattias Lundin
mattias@inkgraphix.com
www.inkgraphix.com
70

Inktank
Ruse
ruse@inktank.nu
www.inktank.nu
46

Inkypixel
Shay McCloskey
shay@inkypixel.com
www.inkypixel.com
293

Insect
info@insect.co.uk
www.insect.co.uk
246, 247

ix opus ada
Floor Wesseling
floor@ixopusada.com
www.ixopUsada.com
77

Jacklamotta
Robert Rebotti
whoo@garadinervi.com
www.garadinervi.com
181, 190

Jake Steel
jakesteel@btinternet.com
www.jake-art.com
144

James Gallagher
gallagherj@mindspring.com
www.GallagherStudio.net
180, 182

James Sutton
james@jamessutton.net
www.jamessutton.net
75

Jawa and Midwich
info@jawa-midwich.com
www.jawa-midwich.com
129, 202

Jenni Tuominen, Jukka Pylväs
jenni.tuominen@kolumbus.fi
jukka.pylvas@kolumbus.fi
198

Jeremy Ville
jeremy@jeremyville.com
www.jeremyville.com
158, 159

Jewboy Corporation™
Jewboy
i@jewboy.co.il
www.jewboy.co.il
254, 255

Jim Avignon
Jimavignon@yahoo.com
161

Jon Burgerman
jon@jonburgerman.com
www.jonburgerman.com
153

Jorge Alderete
contacto@jorgealderete.com
www.jorgealderete.com
237

Joshua Smith
joshua@hydro74.com
www.hydro74.com
146

Julia Staite
julia@juliastaite.com
www.juliastaite.com
263

Junkflea
Gerard & Agnes Tan
hello@junkflea.com
www.junkflea.com
243

Jussi Jääskeläinen
jussi.jaaskelainen@simpukka.net
189

Justin Winz
info@justinwinz.com
www.tomripleyinc.com
www.soltmanowski.com
126

Kallegraphics
Karl Martin Saetren
email@kallegraphics.com
www.kallegraphics.com
176

Karsten Schmidt
info@toxi.co.uk
toxi.co.uk
48

Kate Sutton
kate@sleepycow.com
www.sleepycow.com
142, 194, 195

Kearney Rocholl
info@kearneyrocholl.de
www.kearneyrocholl.de
81

Keiichi Shida
info@tripolli.jp
www.tripolli.jp
131

Keinom
Nicholas Ganz
info@keinom.com
www.keinom.com
155

Klaus Haapaniemi
k@tv-0.org
www.tv-0.org
28, 29

Knut Herrmann
knut@4komma5freunde.de
www.4komma5freunde.de
143

KoaDzn
koadzn@clubinternet.fr, koa@koadzn.com
www.koadzn.com
152, 162

Konstantinos Gargaletsos
costa@hvmail.co.uk
costas@pointblankinc.co.uk
287

Laura Varsky
lv@lauravarsky.com.ar
www.lauravarsky.com.ar
127

Lia, Miguel Carvalhais
lia@re-move.org
carvalhais@carvalhais.org
http://lia.sil.at
www.carvalhais.org
52

Lilli Berlin
Judith Drews
post@judithdrews.de
www.lilli-berlin.de
196

Lindedesign
Christian Lindemann
linderockt@web.de
www.lindedesign.de
74

Linn Olofsdotter
linn@olofsdotter.com
www.olofsotter.com
174, 284, 285, 286

LMAC
info@lmac.tv
www.lmac.tv
146

Luca Marchettoni
luca@w3d.it
www.w3d.it
270

Lulu Plasticpirate
Nadine Schemmann
lulu@plasticpirate.com
www.plasticpirate.com
224

Maak. AKA
Mark Lewis Hodgson
mark@maak.co.uk
www.maak.co.uk
218, 219

MAD
madtoydesign@mac.com
www.madtoydesign.com
145

Mai-Britt Amsler
mail@maibrittamsler.dk
www.maibrittamsler.dk
171, 191

Make™
Domenico Bartolo
dom@australianinfront.com.au
www.australianinfront.com.au/users/
Dom/Site/
120

Maren Esdar
MarenEsdar@web.de
278, 279

Mario Sader
mario@mariosader.com
www.mariosader.com
130

MASA
info@masa.com.ve
www.masa.com.ve
32, 33, 66

Matt Sewell
mattsewell@jacuzzi.fsnet.co.uk
www.mattsewell.co.uk
196

Matte
Yew Kee Chung, Betina Helles
yewkee@matte.nl, b_helles@get2net.dk
www.matte.nl
211

McFaul
www.mcfaul.bizjohn@mcfaul.biz
www.mcfaul.biz
292

Me, Me
Fiel Valdez , Peter Vattanatham
f@hellomeme.com, you@hellomeme.com
hellomeme.com
202

Melanie Sramek, Rosie Traina
melanie@aspaceforsomething.com
rosie@aspaceforsomething.com
www.aspaceforsomething.com
59, 62

MH Grafik
Max Henschel
info@mhg.ch
www.mhg.ch
96

Michael Gillette
m.gillette@sbcglobal.net
262

Mikko Rantanen
mikko@mikkorantanen.com
www.mikkorantanen.com
118, 206

MK12
info@mk12.com
www.mk12.com
71, 241

Mrjago
Duncan Jago
mrjago@mrjago.com
www.mrjago.com
146

Mudpub
Takashi Okamoto
mudpub.commudcorp.com
112

Nanospore, LLC
info@nanospore.org
www.nanospore.org
176

Nathalie Nystad
nn@popkorn.org
www.popkorn.org
253

National Forest Design LLC
Steven Harrington, Justin Krietemeyer
contact@nationalforestdesign.com
www.nationalforest.com
112, 175, 228

Nbstudio
Jodie Wightman
j.wightman@nbstudio.co.uk
82, 83

Neasden Control Centre
Steve Smith
studio@neasdencontrolcentre.com
www.neasdencontrolcentre.com
169

Neuarmy
Ryan Katrina
ryan@neuarmy.com
www.neuarmy.com
265

NEW Studio™
theStudio@NEW-online.co.uk
http://NEW-online.co.uk
158

No-Domain Graphic + Recordings
Joaquin Urbina
turbina@no-domain.com
www.no-domain.com
207, 243

Nothingdiluted
Grant Dickson
grant@nothingdiluted.com
nothingdiluted.com
110

Paula Castro
srtapaula@yahoo.com
www.senyoritapaula.com
30, 276

Peepshow studio
Luke Best, Chrissie Macdonald
lukebest22@hotmail.com
chrissie@chrissiemacdonald.co.uk
www.chrissiemacdonald.co.uk
www.peepshow.co.uk
43, 168, 213

Pep Karsten
www.nineaem.com
125

Pete Fowler
fowler.p@virgin.net
www.monsterism.net
224

Poke
Simon Waterfall
www.pokelondon.com
Simon@pokelondon.com
112

Positron & Shinji Naka & PH Studio
info@the-positron.com
www.the-positron.com
144, 145

Power Graphixx
support@power-graphixx.com
www.power-graphixx.com
64

Precursor
Noah Harris, Tim Swift
tim@precursorstudio.com
www.precursorstudio.com
51

Primeobjective
chris@primeobjective.co.uk
www.primeobjective.co.uk
124

protopark
Alex Fuchs
fux@protopark.com
www.protopark.com
160, 177

Pure Evil
cue@pureevilclothing.com
www.pureevilclothing.com
155

Purpura
Luis Gomes, Nuno Silva
purpura@mail.telepac.pt
www.purpura.pt
http://www.d2m.pt
242

Raffinerie
Reto Ehrbar
reto@raffinerie.com
www.raffinerie.com
135

Raquel Falkenbach
raquel@raquelfalkenbach.com
www.raquelfalkenbach.com
103

Red Design
info@red-design.co.uk
www.red-design.co.uk
13, 53, 59, 132, 133

Research and Development
Robert Olzon
info@researchanddevelopment.se
www.researchanddevelopment.se
83

Richard May
rich@richard-may.com
www.richard-may.com
269

Rinzen
they@rinzen.com
www.rinzen.com
103, 199

Romon Yang
ro@rostarr.com
www. rostarr.com
162

Rune Mortensen Design Studio
post@runemortensen.no
www.runemortensen.no
67, 275

Ryan Molloy
ryanb_6675@yahoo.com
www.workroome01107.com
80, 81

Sagmeister Inc.
Stefan Sagmeister, Matthias Ernstberger
info@sagmeister.com
www.sagmeister.com
165

Saiman Chow
saiman@saimanchow.com
www.saimanchow.com
240

Satoshi Matsuzawa
mail@salboma.com
www.salboma.com
226, 227

Seb Jarnot
contact@sebjarnot.com
www.sebjarnot.com
203

Segura Inc.
Carlos Segura
info@segura-inc.com
www.segura-inc.com
108, 109

Servicio Ejecutivo
Tatiana Arocha
tatiana@servicio-ejeutivo.com
www.servicio-ejecutivo.com
258, 259

Shrine Design
Adam Larson
shrinedesign@mindspring.com
www.shrine-design.com
186, 187, 280, 281

Sidsel Stubbe
smile@sidselstubbe.dk
www. sidselstubbe.dk
117

Signor
Matt Mayes
matt@signor.com
www.signor.com
86, 101, 120

Simen Johan
mail@simenjohan.com
www.simenjohan.com
123

Skwakcolors
Skwak
contact@skwak.com
www.skwak.com
163

Soffi Beier
soffi@soffibeier.dk
www.soffibeier.dk
79

Someoddpilot
Chris Eichenseer
eichenseer@someoddpilot.com
www.someoddpilot.com
114, 250

Sophie Toulouse
nationofangela@mac.com
www.sophietoulouse.com
18, 19

Spin
Tony Brook
tony@spin.co.uk
www.spin.co.uk
55, 57

Stavangerillustratørene
Pia Wall
pia@stavanger-illustratorene.no
www.stavanger-illustratorene.no
222

Stolen Inc.
Thomas Brodahl
t@stolen.la
231

Studio Output
Dan Moore, Rob Coke, Lydia Lapinski,
Sara Oakley
info@studio-output.com
www.studio-output.com
66, 68, 76, 77, 84

Stylo Design
Tom Lancaster
info@stylodesign.co.uk
www.stylodesign.co.uk
57

Sub-Digital Multimedia Labs
Christopher Frame
dbeamgeek@hotmail.com
www.subdigital.net
53

Sukie
Darrell Gibbs
design@sukie.co.uk
www.sukie.co.uk
210

Sunrise Studios
Fabian Fischer Sun
fabianfischer@sunrisestudios.de
ff@sunrisestudios.de
65

Superlow
Halvor Bodin
hal@superlow.com
www.superlow.com
256, 257

Syrup Helsinki
Antti Hinkula
antti@syruphelsinki.com
www.syruphelsinki.com
69, 77, 81, 100, 207

TADO
Mike, Katie
mikeandkatie@tado.co.uk
www.tado.co.uk
147

tak! design ltd
Dom Murphy
dom@taktak.net
www.taktak.net
68, 145

Taobot
Danny Franzreb
danny@taobot.com
www.taobot.com
205

The Filth
Fette
fette@the-filth.com
www.the-filth.com
291

The Royal Magazine
info@theroyalmagazine.com
www.TheRoyalMagazine.com
Art Director: Brandon Gheen / GHEENstudios
Designer: Richard Bacon / All Your Prey,
www.allyourprey.com; Thomas Schmid /
Eneone, www.eneone.com
204

The Vacuum Design
Nate Smith
nate@nsmith.com
www.vacuumsucks.com
www.nsmith.com
102, 193

ThingMaking
Harsh Patel, Ryan Waller
harsh@harshpatel.com
26, 239

Thomas Andritschke
thomas@labooo.de
www.labooo.de
268

Tim Marrs
tim@timmarrs.co.uk
184

Tokyoplastic
Sam Lanyon Jones
talk@tokyoplastic.com
www.tokyoplastic.com
49

Toshifumi Tanabu
t_tanabu@ybb.ne.jp
www.geocities.jp/t_tanabu/
122, 290

Trashyard
Daniel Althausen
info@trashyard.de
www.trashyard.de
188

Trix Barmettler, Miriam Bossard
Miriam+me, Trix+me
trix@miriam-and-me.com
www.miriam-and-me.com
miriam@tix-and-me.com
www.trix-and-me.com
35, 41, 45, 76

Tstout inc.
Tyler Stout
tyler@tstout.com
www.tstout.com
230, 231, 232, 233

typeStereo
Battlezine@aol.com
91, 92

Ümeric
Ash Bolland, Von Dekker
phojekt@phojekt.com
www.umeric.com
10

Ultra16
Richard Foster, Matt Benson, Seth Rementer
2damncheeky@gmail.com
250

Unfolded
we@unfolded.ch
www.unfolded.ch
51

Unit9
Katharina Leuzinger
katharina@unit9.com
www.unit9.com
24, 178, 179, 273, 277

Unlekker
Marius Watz
marius@unlekker.net
www.unlekker.net
51

Usugrow
usugrow@usugrow.com
www.usugrow.com
156, 157

Uwe Eger
ue@dkdl.de
192

Vasava
Lisa Schibel
welcome@lisaschibel.de
www.lisaschibel.de
www.vasava.com
245

Viagrafik Gestaltungsbüro
André Nossek
mnwrks@viagrafik.com
www.viagrafik.com
94, 95

Voxangelica.net
Gabriel Mulzer
gabriel@voxangelica.net
www.voxangelica.net
46

Webbo
Jane Webster
jwebster@surrart.ac.uk
jane.webster@blueyonder.co.uk
93

WeSayHi
Gary Horton
gary@wesayhi.com
www.wesayhi.com
98, 99

Why not Associates
Andy Altmann, Gordon Young
andy@whynotassociates.com
86, 87

Yacht Associates
Richard Bull
info@yachtassociates.com
www.yachtassociates.com
277

Yamamura Design Office
Natsuki Lee
ydj@bd6.so-net.ne.jp
www.digmeout.net/lee/
20, 21

Yippieyeah
Bauer, Borkowski
yippie@yippieyeah.co.uk
www.yippieyeah.co.uk
57

YOK
yok@theyok.com
www.theyok.com
148, 149, 221

Zetuei Fonts
mail@zetuei.com
www.zetuei.com
56, 57

Zion Graphics
Emma Megitt / Kiss & Bajs
emma@kissochbajs.com
www.kissochbajs.com
www.ziongraphics.com
142

Zorglob
Oscar Bjarnason
z@zorglob.com
http://zorglob.com
40

FIRST

CONTENT: Around 1,000 artworks by designers worldwide, printed by Druckerei Engelhardt & Bauer on BVS paper from Papierfabrik Scheufelen

A Book Designed ›
TO HELP
26.12.2004

AID+

and bound by Buchbinderei Spinner. All profits go to ease the suffering of
victims of the tsunami disaster of December 26.

www.ebdruck.de • www.scheufelen.de • www.josef-spinner.de

A BOOK DESIGNED TO HELP

Created by iLovedust and Die Gestalten Verlag

Edited by Robert Klanten, Birga Meyer, Thorsten Geiger

Foreword by Mark Sinclair (Creative Review)
Cover Design by Atelier télescopique. Lille. 2005
Layout by Birga Meyer
Production Management by Janni Milstrey and Vinzenz Geppert

Published by Die Gestalten Verlag, Berlin · London, 2005
ISBN 3-89955-077-3

Printed by Engelhardt & Bauer, Karlsruhe
Binding by Josef Spinner, Ottersweier
Printed on BVS matt by Scheufelen, Lenningen
Made in Germany.

Bibliographic information published by Die Deutsche Bibliothek
Die Deutsche Bibliothek lists this publication in the Deutsche Nationalbibliografie;
detailed bibliographic data is available in the Internet at http://dnb.ddb.de.

For more information please check: www.die-gestalten.de

Special thanks to Ernst Gärtner, Engelhardt & Bauer, Karlsruhe

iLovedust would like to thank everyone that has supported the Designed To Help project... the hard work, energy
and generosity that so many people have shown has been overwhelming. We would like to thank everyone for the
emails, advice and work contributions; all were much appreciated and well received... we only regret not being
able to respond to you all personally. You made this book happen and we are really confident that the project will
make a difference to those affected by the tsunami crisis in Asia.
A special thanks has to go to Alex at Free Range Development and the guys at TADO, and of course to DGV for all
their hard work, late nights and commitment to the project.

All profits from the sale of this book will go directly to the charity CARE, who will use the money to aid victims of
the tsunami disaster in Asia. A detailed account of all donations resulting from this project is regularly updated at
www.designedtohelp.com.

This publication was made possible by: